Yes, but...

A CRITICAL STUDY OF PHILIP GUSTON BY DORE ASHTON

Yes,

THE VIKING PRESS · NEW YORK

but...

LIBRARY OF CONGRESS CATALOGING IN PUBLICATION DATA

Ashton, Dore.
 Yes, but . . . a critical study of Philip Guston.

 Bibliography: p.
 Includes index.
 1. Guston, Philip, 1913— I. Title.
ND237.G8A82 759.13 75-43993
ISBN 0-670-79388-4

ACKNOWLEDGMENT is made to the following for permission to use the material listed:

Bantam Books, Inc.: From *Baudelaire: Flowers of Evil and Other Works*, translated by Wallace Fowlie. English language translation Copyright © 1963, 1964 by Bantam Books, Inc. By permission of the publisher.

Farrar, Straus & Giroux, Inc.: From *The Selected Letters of Gustave Flaubert*, translated and edited by Francis Steegmuller, Copyright 1953 by Francis Steegmuller. Reprinted with the permission of Farrar, Straus & Giroux, Inc.

Harper & Row, Publishers, Inc.: From *Space* by Clark Coolidge. Copyright © 1970 by Clark Coolidge. By permission of Harper & Row, Publishers.

Little, Brown and Company, and Martin Secker & Warburg Limited: From "Open the Gates" from *Selected Poems: 1928–1958* by Stanley Kunitz, Copyright © 1958 by Stanley Kunitz. From "After the Last Dynasty" from *The Testing Tree* by Stanley Kunitz, Copyright © 1962 by Stanley Kunitz. By permission of Little, Brown and Co. in association with The Atlantic Monthly Press.

And if you want biographies, do not ask for those with the refrain "Mr. So-and-So and his times" but for those on whose title-page it should say "a fighter against his time."

—Friedrich Nietzsche in
 The Use and Abuse of History
 Chapter VI

Acknowledgments

Philip Guston's acquaintances and friends have been exceptionally generous in discussing their relationships with him, and in providing information in documentary form. Among those whose help was essential were Reuben Kadish, Stephen Greene, and Fletcher Martin, all of whom I thank warmly, as well as James Brooks, Robert Phelps, Harold Lehman, JoEllen Rapee, Morton Feldman, Philip Roth, Clark Coolidge, and Mercedes Matter. I thank Harold Rosenberg and Andrew Forge for sharing my enthusiasm; Musa Guston for her unstinting assistance; Denise Hare for her uncanny ability to capture in photographs the ambiance of Guston's studio, and Gayle Ellis for her constancy as my secretary. A special thanks is reserved for Barbara Burn, a rare editor who not only saw this project through but also brought her own extensive knowledge of the artist to bear on it.

Contents

Chronology

1913 Born June 27, Montreal, Canada.

1919 Moves to Los Angeles.

1927 Begins drawing and painting.

1934 Travels in Mexico.

1936 Moves to New York.

1937 Marries Musa McKim.

1936–40 Works on WPA Federal Arts Project, New York.

1939 Mural on façade, WPA Building, New York World's Fair; awarded first prize for Outdoor Murals, New York World's Fair.

1940 Mural for Queensbridge Housing Project, New York.

1941 Mural for Forestry Building, Laconia, New Hampshire (with Musa McKim).

1941–45 Professor, State University of Iowa, Iowa City.

1942 Mural for Social Security Building, Washington, D. C.

1943 Birth of daughter, Musa Jane.

1944 One-man exhibition, State University of Iowa, Iowa City.

1945 One-man exhibition, Midtown Galleries, New York; awarded first prize, Carnegie Institute, Pittsburgh.

1945–47 Artist-in-Residence, Washington University, Saint Louis.

1946 Awarded John Barton Payne Purchase Prize, Biennial, Virginia Museum of Fine Arts, Richmond.

1947 Awarded Guggenheim Fellowship; Altman Prize, National Academy of Design, New York; Joseph Pennell Memorial Prize, Pennsylvania Academy of Fine Arts, Philadelphia; one-man exhibitions at School of Museum of Fine Arts, Boston, and Munson-Williams-Proctor Institue, Utica, New York.

1948 Awarded Purchase Prize, University of Illinois, Urbana, and a $1000 grant from the American Academy of Arts and Letters; awarded Prix de Rome, American Academy in Rome.

1948–49 Travels in Europe.

1950 Artist-in-Residence, University of Minnesota, Minneapolis, spring term; one-man exhibition, University of Minnesota, Minneapolis.

1951–58 Adjunct Professor, New York University, Fine Arts Department, Washington Square Campus.

1952 One-man exhibition, Peridot Gallery, New York.

1953 One-man exhibition, Egan Gallery, New York.

1953–58 Teacher at Pratt Institute, Brooklyn.

1956, 1958, 1960, 1961 One-man exhibitions, Sidney Janis Gallery, New York.

1959 Awarded Flora Mayer Witkowsky Prize, The Art Institute of Chicago; $10,000 Ford Foundation Grant; retrospective exhibition, V Biennal, São Paulo, Brazil.

1960 Retrospective exhibition, XXX Biennale, Venice.

1961 Exhibition with Franz Kline, Dwan Gallery, Los Angeles.

1961, 1963, 1970, 1971, 1973, 1974 Guest Critic, Yale Summer School, Norfolk, Connecticut.

1962 Retrospective exhibition, The Solomon R. Guggenheim Museum, New York (shown thereafter: Stedelijk Museum, Amsterdam; Musée des Beaux-Arts, Brussels; Whitechapel Gallery, London; Los Angeles County Museum of Art).

1966 Retrospective exhibition, Rose Art Museum, Brandeis University; one-man exhibition, Santa Barbara Museum of Art, California, and at The Jewish Museum, New York (Comprehensive Exhibition of 80 Recent Paintings and Drawings).

1967 Leaves New York City to live in Woodstock, New York.

1967–73 Seminar teacher, New York Studio School, New York.

1968 Awarded second Guggenheim Fellowship.

1969, 1973, 1974 One-man exhibition, Gertrude Kasle Gallery, Detroit.

1969, 1970, 1972 Guest Critic, Columbia University, Graduate School of Fine Arts.

1970 One-man exhibition, Marlborough Gallery, New York, and at Boston University; awarded Honorary Degree, D. F. A., Boston University.

1971 One-man exhibition, La Jolla Museum of Modern Art, La Jolla, California.

1971 Artist-in-Residence, American Academy in Rome.

1972–present University Professor and Graduate Seminar instructor, Boston University.

1973 One-man exhibition, The Metropolitan Museum of Art, New York, *Philip Guston Drawings 1938–1972.*

1974 One-man exhibition, Boston University, School of Fine and Ap-

plied Arts Gallery, *New Paintings*; one-man exhibition, David McKee Gallery, New York.

1975 Awarded Distinguished Teaching of Art Award, The College Art Association of America; one-man exhibition, Makler Gallery, Philadelphia.

Yes, but...

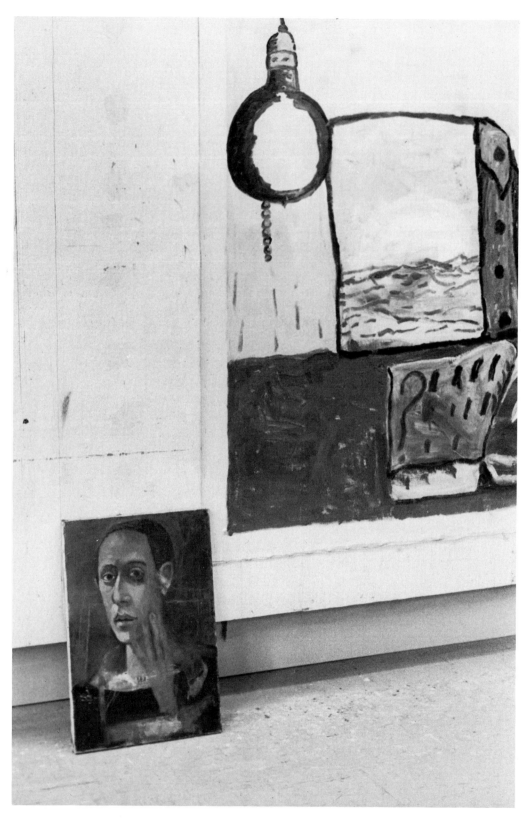

Guston's self-portrait, c. 1944, beneath an unfinished 1975 painting. (Denise Hare)

Introduction

One could write a history of art as a history of temperaments, but it would be as rigid and exclusive as a history of style alone, or of political epochs. Some temperaments, as revealed in works of art, have more or less in common, but art itself shuns commonality: while the scientist may seek the phenomenon that repeats itself, the artist seeks the exception. There are some temperaments that can be defined in terms of the questions they pose. These questions may well have been hovering in the human psyche for centuries, and they recur in the fugue of existence. Such questions are the special province of the arts.

"In the anti-historical position, each artist is . . . himself."[1] In one of his ruminations, Guston confidently maintains the singularity that marks the artists he has enshrined. But, in another, he challenges the notion of "himself" and expatiates on the relationships that bind the family of artists he admires throughout history. He is, as almost all writers on his work have recognized, a man of dialogue. His work is clearly cyclical. His painting tone alternates, now caressing, now strident. His tastes veer from the sublime equilibrium of certain fifteenth-century masters to the dark reveries of the Romantics. Irreconcilables are the staff of his life.

Guston's reflexive dialecticism is well known to those who have

followed him over the years. They have learned to be comfortable with shifts in conversation from one position to another which, in the long dialogue of his life's work, are finally not inconsistent. Others may wonder at the dualities: the calm Elysian aspiration in the early figurative paintings and the abstractions of the early 1950s juxtaposed with the eruptive abstractions of the early 1960s and the works of the 1970s. They might read a balance sheet of remarks by Guston as proof of his ambivalence. But it would be a false reading. The very basis of his art is the holding in balance of seeming antitheses.

Guston has, as he said of his friend Bradley Walker Tomlin, "a tensile—and at times precarious—balance that covers an anguished sense of alternatives."[2] He can long for experiences "more remote than I know" and dally in the regions of near-mysticism, and he can return purposively to the simplest experiences, curtly replying to his interlocutors when asked about his work, "What do I do? I eat. I drink from a cup."[3] He can exult in the remoteness of Piero della Francesca's oeuvre: "Piero—you don't want to touch it"; he can relish Rembrandt, "all flesh and paint quality." He offers abstract aphorisms such as "doubt is the sharp awareness of the validity of alternatives,"[4] but he also answers his own question "What am I working with?" wryly: "It's only colored dirt."[5] He tells an interviewer in 1965 that he wants to end with something "that will baffle me for some time,"[6] and a few months later tells the same writer, "I am only interested in the weight of the familiar." He makes a public statement that "there is something ridiculous and miserly in the myths we inherit from abstract art—that painting is autonomous, pure and for itself.... But painting is 'impure.' It is the adjustments of impurities which forces painting's continuity."[7] On the other hand, in a taped interview, he states flatly: "I don't believe in alternatives."[8] Yet, alternatives juxtaposed, pondered, worried, turned, and finally neutralized in the finished work, which temporarily dissolves them, are Guston's most familiar companions. They are what he thinks and how he thinks. Like Woyzeck, the creature of Büchner, he can exclaim:

The human being! A lot can happen.—Nice weather, Captain. Such a pretty, solid gray sky. Do you see? One is tempted to drive a log into it and hang oneself thereon, just because of the little hyphen between yes, and yes again—and no. Captain, yes and no? Is the yes to blame for the no, or the no for the yes? Let me think it over....[9]

Born in 1913, the year of the Armory Show, Guston inherited the

conflicts inherent in modern art. His has been an epoch bedeviled by dialectics. Once Hegelianism had swept the Western world, dialecticism became the habitual mode of thinking. The whole history of modern art could be boxed rather neatly in dialectical sections, and many of its protagonists have consciously adopted the modern method of rhetorical combat. One movement contravened another, one leader gave way to the next, one single purpose deposed another single purpose, and always the anticipated synthesis was held in abeyance. A man of Guston's generation could not avoid the lines of battle, where the rallying cry was always: You must take a position. And it had to be an immediate and definite position before the ground gave way.

But for a man with a sense of the full measure of human experience and an affection for what remains of the past—the works of man's imagination—the position could only be provisional. Guston has consistently maintained an eccentric position—eccentric to the mores of his culture; eccentric to the temporary enthusiasms of the art world; eccentric to, but not alienated from, the given problems of modern art.

Among the numerous dilemmas spawned by the modern tradition are the basic questions: What, after all, is a painting and who is the artist? In the early phases of modern art when Symbolism prevailed, the idea was that a painting, like a poem, was a matter of essences. An image. Something whose value resided in its memorability, its aura, its synthesis of sensations that came together in the mind of the beholder somewhere outside of its actual physical facture. Not a thing, an image.

Such idealism met its dialectical response in realism, which maintained just as positively that a painting was not so much an image or idea as an object. Realists made things, not essences. Whether they were Cubist paintings or abstract paintings, they were to be regarded as concrete entities in a world of things. The clash of the Symbolist and realist views brought a problem peculiar to the twentieth century. In the past it had been taken for granted that analogy was the primary mode of perception in the arts. Recognition sprang from the just analogy, and paint was in the service of memory and sensibility. A few strokes and *voilà* asparagus—not real asparagus but an analogy for asparagus. However, when painting became autonomous, a thing among other things, the given system of analogies was challenged. If the canvas was a thing in itself, complete, concrete, and not virtual, the dimension of analogy either had to be purged, or adjusted. Some artists simply sidestepped, while others attempted to create a new

kind of analogy, a psychological one that was not immediately apparent. But all were caught in the toils of paradox. The art of painting in the twentieth century has careened wildly between extremes that make the earnest quarrels in the last century between the Ingres and Delacroix camps seem mild by comparison.

At one time or another Guston has met with all the contradictions in the modern tradition. Like most complex artists, he has had several relationships with his time, and those not always exclusive. Yet certain of the inherited problems in his case have found more or less consistent answers, as for instance in the problem of content. Can matter alone carry expressive meaning? He says no. It is not enough to make a mark on a canvas, even if it creates radiant light or rhythmic sequence. Although he experiments constantly, his final answer is no,

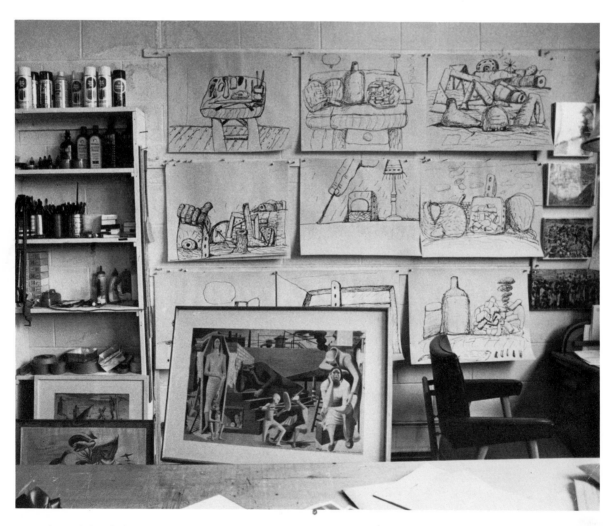

A portion of the design for a mural on housing in 1939 pictured below a group of recent drawings in the artist's studio, 1975. (Denise Hare)

paint alone is not enough. As for the problem of space as posed in our time: Is the canvas really a two-dimensional surface whose frontal plane must not be violated?—Guston again answers no. The modern shibboleth of planarity is not enough. He has devised means to suggest depth, complicated perspective, close-ups, and he has used tonal modulation to find fresh spatial illusions. He refuses to reject the long history of painting as an art of spatial illusion. The problem of color has also found him firmly rebellious. Although like many other twentieth-century painters Guston did reduce his palette, in compensation he has enriched it with countless intermediate tones with which he has been able to suggest eccentric, even occult relationships within the formal structure of his painting.

Aside from the specific and professional problems of the modern painter, Guston was faced, like all modern artists, with the general problem of modernism itself. With its overweaning demand for contemporaneity, its obliviousness to the past, and its headlong futurity, modernism reduces experience so drastically that artists are always threatened with a spiritual poverty bordering on famine. Guston's stubborn resistance to the modernist's narrow range of experience is central to his existence as an artist. His active opposition has taken many forms, for no source of inspiration has been ruled out. He reads omnivorously. He looks at paintings. He communes with artists in the fifteenth century, and he converses with the painter in the studio down the road. He may find inspiration one day in a poem by an eighteenth-century poet or in a poem created that very morning by a friend. Conversations, dialogues, letters, notes, a reminiscence, a quarrel, a reconciliation—anything may set him off. Everything enters as potential nourishment. While it might be true, as so many critics insist, that much modern art feeds on art, Guston's art must be said to feed on works of the spirit, wherever they may be encountered. Accordingly, a straightforward stylistic account of his life's work would be insufficient. His has been, and remains, a spiritual quest. His constant returns to beginnings—his own and those of others—defy linear analysis. His artistic biography must in some measure be a biography of the spirit. From works alone a great deal can be deduced about a man: his tenderness, his violence; his skill and industry; his loves (of past, of space, of ambiguity, of honesty, etc.); his hate and his self-hate. But just as certainly, his work is derived from his sorties to "life," whether they are readings, encounters, or meditations, and his other-than-working life provides for a more ample interpretation of the work

itself. How Guston's oeuvre has been fed by his life, largely a life of the spirit, is almost as significant as the oeuvre itself, for it is what he brings back from the world that is finally distilled and becomes, for himself and the world, the most significant aspect of his life.

In 1970 Guston exhibited a group of new paintings that were greeted mainly by shocked silence or blatant derision. In an unusually prominent headline, *The New York Times* broadcast its extreme disapproval by calling Guston a "Mandarin Pretending to Be a Stumblebum." This harsh judgment was upheld by most other reports on the exhibition. Even Guston's longtime defenders seemed uncertain of their own responses and either remained silent or loyally quoted Guston himself on the meaning of the new paintings. (A notable exception was a long, sympathetic review by Harold Rosenberg in *The New Yorker*.) The asperity these paintings called forth reminded many of the shrill responses made years before to the work of Guston's boyhood friend Jackson Pollock.

Remembering the delicate abstractions of the 1950s, or the dark abstractions of the 1960s, which had led the British critic David Sylvester to call Guston "Abstract Expressionism's odd man out," Guston's critics found themselves at a loss to explain his sudden plunge into a narrative realm of hooligans in hoods, naked electric light bulbs, and smoke-filled rooms. They were unstrung by the stacks of dismembered bodies and odd shoes strewn in a bleak no-man's land, the dread visions offered in a style heavily inflected with caricature, where tender passages only served to underline the irony.

Years before, in the late 1940s, when Guston abandoned the wild allegories that had even won him the approval of *Life* magazine (the issue of May 26, 1946, warmly appraised his Carnegie Prize-winning *Sentimental Moment* and reported with satisfaction that the young artist could command as much as $2,500 for a painting) for tense, rigidly composed allegories of violence, his baffled admirers asked one another: How could a man who could paint such beautiful pictures choose to paint such dreadful ones? Then, when these elaborately condensed figurative paintings had finally gained the attention and admiration of serious critics, he swerved toward abstraction, calling down the wrath of those who had seen him as the last bastion of traditional painting. And so, throughout his public painting life, Gus-

ton has known the extremes of smothering approval and acrimonious rejection. Viewers have always responded with alarm, as though Guston's habitual retrieval of ancient themes and his constant reassessments of abiding obsessions were not apparent in every phase of his work.

Had his critics in 1970 considered his entire oeuvre, they would have been obliged to recognize that Guston, far from willing to be a maverick, as one newspaper headline had it, was, in fact, resuming preoccupations that had been roused in him in his early youth. This was no posturing mandarin speaking. It was the mature artist, gathering in his resources from the beginning, seeking to express truths of which he had had an intimation while still a boy. Some forty years before, in his first exhibition at the Stanley Rose Gallery in Los Angeles, Guston had exhibited two paintings in which the motifs of the 1970 show were already stated. The seventeen-year-old painter had worked for nearly a year with characteristic ambition to paint a masterpiece. *Mother and Child*, inspired partly by Max Ernst's satirical *Virgin Chastising the Christ Child*, partly by Picasso's monumental women of the 1920s, and partly by Guston's copies of Michelangelo's drawings, bore the marks of his sources proudly. The mother's limbs swell mightily; the child is archetypal; a homely chair and a washtub stress Guston's feeling for contemporaneity. Or perhaps the chair and washtub were early evidence of Guston's instinct for plain objects as the firmly weighted constants around which his fantasy could revolve.

The other painting of 1930 is a more obvious source for his later works; even its title he was to use again in the 1970s—*The Conspirators*. It is a sharply modeled, carefully composed group of hooded figures who would have been identified immediately by contemporaries as members of the Ku Klux Klan. At the time Guston was working on this painting it was estimated that there were more than 4.5 million members of the Klan in the United States, a great many of them residing right in Los Angeles, where they burned crosses and raised hell all during Guston's childhood and youth. At the same time, Guston had already conceived his enduring love for the painters of Quattrocento Italy, many of whom had painted hooded figures in procession. It is possible that Guston had already seen reproductions of Piero della Francesca's *Madonna della Misericordia*, in which one of the kneeling figures wears a penitential hood. Like Piero, Giorgio de Chirico has stimulated Guston's imagination from his earliest studies to the present; in *The Conspirators* the milky blue sky and sharp

contrasts of light and shadow recall de Chirico's haunting metaphysical landscapes.

These two paintings, created before Guston was twenty, can literally be regarded as the first statements of themes that were to be recapitulated throughout his career. These were not only themes in the sense of narrative content but, in a more complex sense, themes that embrace his dialogue with himself, his own past, the past of the human race, and contemporary events. In Guston's life, as in a painting, the background is always related to the foreground. The present is unthinkable without a past. The work of the 1970s is a characteristic Guston mixture of autobiography, myth, and art—the work of a meditative temperament. It springs from the same artistic quest that he recognized in Paul Valéry, who could say, "For my part I have a strange and dangerous habit, in every subject, of wanting to begin at

Drawing for *Conspirators*, 1930.
Pencil on paper, 22½ x 14½ in.

8

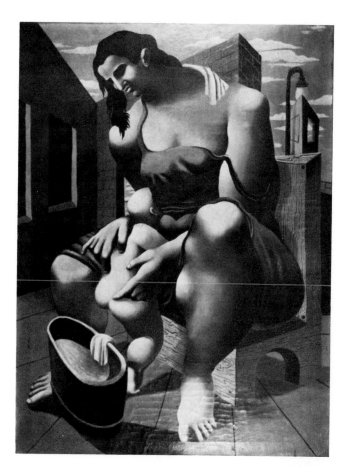

Mother and Child, c. 1930.
Oil on canvas, 40 x 30 in.

the beginning (that is, at my *own* beginning) which entails beginning again, going back over the whole road, just as though many others had not mapped and traveled it. . . ."[10]

There can be no adequate understanding of Guston's life's work unless we are prepared, as he was and is, to go back over the whole road.

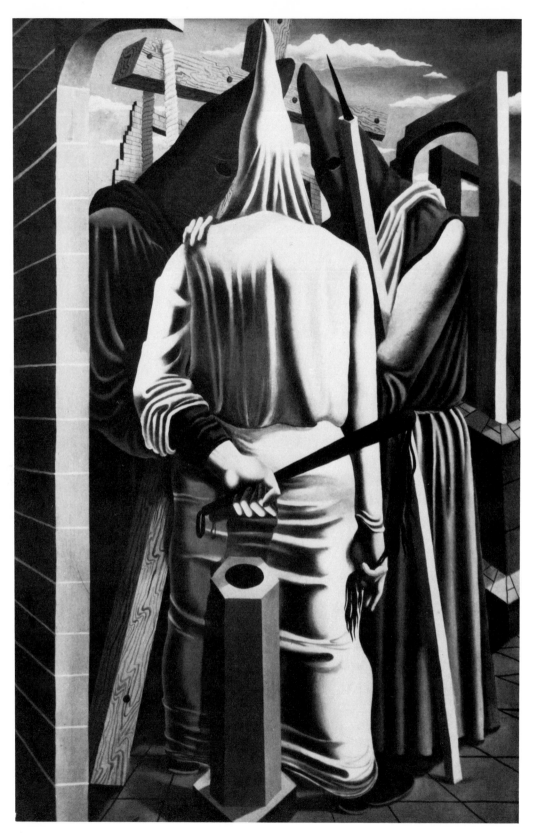

Conspirators, c. 1930. Oil on canvas, 50 x 36 in.

Conspirators 1

Eucalyptus trees and cults. Mecca of beauty queens and retired secretaries. Everyone on wheels. Nathanael West described it in *The Day of the Locust* with its "Mexican ranch houses, Samoan huts, Mediterranean villas, Egyptian and Japanese temples, Swiss chalets, Tudor cottages" all made of "plaster, lath and paper" that "know no law, not even that of gravity." This mélange brought a wry smile to West, who recognized that "it is hard to laugh at the need for beauty and romance, no matter how tasteless, even horrible, the results of that need are. But it is easy to sigh. Few things are sadder than the truly monstrous."[1]

The truly monstrous found a natural home in Hollywood and spread out over greater Los Angeles. But paradoxes abounded. Along with the freaks and worn-out dreamers described by West was West himself, and scores of other distinguished writers, composers, and painters nesting in the canyons and sometimes enjoying the favors and fortune dispensed by the film industry. Los Angeles was rich with hungry intellectuals who for various reasons settled into Pacific splendor, staring out at the great sea but also looking anxiously eastward from where their moral nourishment came. The Los Angeles bungalows with their trails of bougainvillea harbored more outsiders than most

cities, among them, the restless children of the newly arrived, including Guston, who was born in Montreal during the first stage of his parents' emigration journey and brought to Los Angeles at the age of six by hopeful parents. There, like so many others, the family did not flourish. Nor did the families of Guston's friends of his early adolescence, many of whom shared similar backgrounds: Reuben Kadish, whose father had fled persecution after the Russian Revolution of 1905, first to Chicago where Reuben was born, and then to Los Angeles when he was seven; Jackson Pollock, whose family had wandered in the Southwest for years before settling in Los Angeles when Jackson was in his early teens. Others, similarly foreign to the local mores, gathered into a small, comradely band of explorers. Like most first-generation children, they fled the aroma of their parents' alien cultures, which faded into the background but were never entirely banished. The very fact of their foreignness to the city helped them to look beyond its physical confines.

In the case of Philip Guston, whose precocity was apparent and whose quick intelligence was functioning at a level beyond his age, the years of adolescence were tremendously intense. His natural ambition emerged early. He began drawing seriously at the age of twelve, and his mother presented him on his thirteenth birthday with a full year's correspondence course from the Cleveland School of Cartooning. However, "after the initial excitement of the different crow quill pen points, the Higgins black India ink, and the several ply Strathmore paper," Guston recalls, his interest ebbed. He was quickly bored by the lessons in cross-hatching and gave up after about three lessons, which brought him repeated letters from the school urging him to continue and become a famous cartoonist. But he had already set himself higher goals. By the time he got to Manual Arts High School he was well prepared to plunge into the higher world of the intellect that he sensed to be far away from his immediate surroundings, and to ponder the events that had conditioned his early childhood.

Some of those events were of global significance. The Russian Revolution of 1917 produced ripples that soon reached even the shores of California. America, during Guston's childhood, lived through the 1920s with an unreasonable fear of Bolshevism and had taken to witch-hunting, cross-burning, and flights into otherworldly fantasy. When Guston was fourteen the death sentence was carried out on Sacco and Vanzetti, causing riots in Europe and deeply disturbing many Americans. During the early 1920s, Aimee Semple McPherson held forth in her Angelus Temple with its illuminated rotating cross visible for fifty

miles around and its five thousand seats filled to capacity—a phenomenon Guston went several times to witness. During the decade, newspapers became daily necessities, filling the world with scandal and political propaganda. Syndication helped such tycoons as William Randolph Hearst to centralize and control the news. At the same time, socialists and anarchists inspired by the Revolution took heart and stumped the land with their messages; the IWW (International Workers of the World, known as the Wobblies) flourished with its theme song, "One Big Union," and reached schoolboys through such sympathizers as Jack London. Intellectuals on the East Coast were reading Nietzsche, Spengler, H. G. Wells, Havelock Ellis, Krafft-Ebing, Freud, Chekhov, Strindberg, Dostoyevsky, T. S. Eliot, and, for those especially alert, James Joyce. They were admiring the cartoons of Art Young, with their tinge of Gustave Doré and Käthe Kollwitz, published not only in the *New Masses* but also in the *Saturday Evening Post*. On the West Coast, the child Guston was admiring George Harriman, creator of Krazy Kat, and Bud Fisher, creator of Mutt and Jeff.

Manual Arts, like most American high schools, had great faith in teams, cheerleading, athletics of all kinds, and patriotism. But in the classrooms there were a few cultured teachers, and these Guston and Pollock quickly discovered. Pollock had had the advantage of older brothers who took an interest in his education and constantly urged him to discover the way out of childhood and into the arts. Charles Pollock was already studying art in New York and Sande (Sanford) was soon to embark for the Art Students League. Guston met both brothers at the Pollocks' home when he and Jackson would come home after school, eat chili, and carry on long discussions far into the night. Often Guston had to sleep over, because he lived in Venice, much farther from school than the Pollocks.

Their signal experience in high school, by all accounts, was the encounter with a remarkable teacher, Frederick John de St. Vrain Schwankovsky. Alert to many cultural currents, he exposed his hungry charges to the latest art periodicals, *Creative Art* and *The Arts*; he showed them slides of European paintings, particularly the Cubists; he encouraged them to read Mencken's *American Mercury* and the avant-garde journal *The Dial*. He was also sensitive to the wave of mysticism that had swept the Western world after the First World War, and he took his students to Ojai to attend meetings where the charismatic Jiddu Krishnamurti preached his heterodox theory of life and love and individualism. In the light of the campfire Krishnamurti exhorted his listeners to resist authority, "the antithesis of spiritual-

ity." He said that "when you bind life to beliefs, traditions, to codes of morality, you kill life. In order to keep alive, vital, ever changing, ever growing, as the tree that is ever putting out new leaves, you must give to life the opportunities, the nourishment.... Revolt is essential in order to escape from the narrowness of tradition, from the binding influence of belief, of theories."[2]

Hearing about revolt not only in the soft night of Ojai but also in the avant-garde journals, Pollock and Guston, not surprisingly, undertook some revolutionary activity of their own. Conditions in Manual Arts High School were unsatisfactory for them: all the school's money was going to athletes, and the two boys wanted a creative arts project. They produced a broadside featuring satirical drawings attacking the English department. At dawn they stuck these mimeographed protests in faculty mailboxes and waited with some apprehension for the results. They were not discovered. Emboldened by their initial success, Guston and Pollock produced a second pamphlet, for which Guston did a drawing of a tail-wagging dog titled "Shall the Tail Wag the Dog?" This time they were caught, and both boys were brought before the principal, who promptly expelled them. (Pollock was readmitted later, but Guston never went back.) At the time of their expulsion, Guston and Pollock were Schwankovsky's star pupils. Guston recalls making "enormous drawings, foolish drawings, abstract things influenced by Cubism" while Pollock was doing abstract sculptures. Not far away, in a neighboring high school at about the same time, Reuben Kadish, who was soon to join Guston and Pollock in their rebellion, was also expelled for having led a strike against corporal punishment.

This upheaval in their schoolboy lives occurred in the academic year of 1928–29, just before the Crash, which took place in the America to which their alien parents had come dreaming of miracles. These boys were living in a society that was so truly fantastic that it could not easily be caricatured. The vision George Grosz had had in faraway Germany long before his first visit to Los Angeles in the early 1930s accurately summarized the conditions of the outward lives lived by these teen-aged students. Grosz observed that slogans such as "Service at Its Best" and "Keep Smiling" had become the new forms of soliciting customers. He had heard of a farmer in California named Luther Burbank, who, it was said, could grow plums with no pits. From America had come letters to Grosz's mother offering her membership in a worldwide "mystic" club for only $12.00. "A miraculous country this America, where business, mysticism, religion and technical progress flourished together."[3] He kept track of the teddy bear fads and of

the new sports, such as Diabolo, a kind of string game played to the tune of the new song "Since My Old Man Caught the Latest Craze of D-I-A-B-O-L-O." This America, and the America that maintained "Red Squads" that invaded private homes, including that of Reuben Kadish, tearing everything apart and destroying books with impunity, was the site of the everyday life of Philip Guston, Jackson Pollock, and the other cultural dissidents flung out of high school.

By 1930 America was slipping into the Depression. Los Angeles, thanks to Hollywood, slipped more slowly than the rest of the country. S. J. Perelman, who had gone out to make capital in the movie industry wrote home: "There is an air of false prosperity out here that makes news of breadlines and starvation unreal."[4] But the young artists were listening intently to voices of rebellion. The climate had changed since the arch and essentially apolitical 1920s, when such magazines as *The New Yorker* were founded. Now the *New Masses*, which had been a small radical journal, became a necessary source for intellectuals, and good writers such as John Dos Passos and Edmund Wilson contributed to its pages. While these high-school intellectuals still coveted *The Dial*, they were now aware of the ardor of the Left. Guston himself had met a poet, Don Brown, who had introduced him to Joyce, Pound, Cummings, the French Surrealists, and little magazines such as *transition*, but he also kept up with his young companions whose interests had turned to the literature of the Left.

The years between Guston's seventeenth and twenty-third birthdays were patterned with experiences that were to contribute to his formation as an artist. Many of his interests converged. He abandoned the charmed circles of Ouspensky and Krishnamurti, and, as he says, got in with a "bad" crowd of radicals, artists, and poets. Like most late adolescents they cruised around seeking experiences and creating minor scandals. Almost all of them were poor, having to work for a living even while going to school and feeling the pinch of the Depression.

Guston was fortunate enough to win a year's scholarship to a major Los Angeles art school, the Otis Art Institute. He entered with enthusiasm but soon discovered the limitations of Otis's tradition. "There I was, thinking about Michelangelo and Picasso and I had to study anatomy and build clay models of torsos." The revered model for painters at Otis was Frans Hals, whose work could not have been more alien to Guston at the time. In exasperation, Guston one day piled up all the plaster casts he could find in a huge mound and began to draw them when Musa McKim, who eventually became his wife,

happened upon him. Her report of Guston's heap of casts spread quickly, and Reuben Kadish, who met Guston around this time, remembers it with relish. Before long Guston, stimulated by new acquaintances in various circles, abandoned his scholarship to strike out on his own.

With fair frequency the young men and women he was now seeing gathered to read *transition*, *The Dial*, or *Cahiers d'Art*; to play Stravinsky records on a hand-cranked machine, and to study the latest theories of the filmmakers Eisenstein and Dovchenko. Jules Langsner, a young poet who was later to become a prominent art critic, brought to the group the reflected light of Bertrand Russell, with whom he was studying, and became Guston's lifelong friend. Leonard Stark, who had studied at Otis with Guston, brought his expertise as a photographer. With him Guston made a short film influenced by the new Russian pictures they had seen at the Film Art Theater, the only house showing vanguard German and Russian films.

By this time Guston's image of the artist was permanently formed. An artist worked assiduously, learned the entire history of his art, experimented, and, above all, aspired to greatness. This romantic aspiration was evident to all who knew Guston during his late adolescence. Tall, slender, with a serious mien, he already carried himself like an artist. His energies were marshaled and he knew his direction. Yet he was not indifferent to an ordinary boy's preoccupations. A school friend recalls him in 1930 as "a fashion plate and choosy about girls." His sartorial elegance was largely the result of his having to go to work and ending up with a job at a furrier. This, however, was no ordinary job, and Guston remembers it vividly:

The inner office of the furrier was lined with books, mostly philosophy and theology. Mr. Aronson, who looked like Disraeli, was an elegant, wealthy man who had lost most of his money in the 1929 stockmarket crash and was now interested in radical literature and new radical movements. But he still lived magnificently, had a limousine, and caused me to acquire better clothes. Since there was no business to speak of, I had lots of time to read, and I would discuss with Mr. Aronson the book I had read during the day. It was as if Mr. Aronson needed somebody to talk to.

This job did not last long and Guston soon found another in a large cleaning plant. He learned to live several parallel lives. During the day he drove a delivery truck or worked at a machine punching num-

Guston in 1930. (Edward Weston)

Philip Guston in 1929. (Leonard Stark)

bers on vests, while at night and on weekends he pursued his education and widened his acquaintance with the mysteries of painting. His working life brought him into contact with growing unrest as the Depression deepened. He witnessed strikes and was duly warned about strikebreakers. He heard of goons drawn from the ranks of the American Legion and the Ku Klux Klan. "While working at the plant we had terrible hours, sometimes fifteen hours a day and no unions. I got involved with a strike and saw some violence." Listening to the union men, Guston learned that Los Angeles was supposed to be clean of unions and that the local powers regarded strikes as foreign importations brought by hated eastern organizers. Later he was to hear the Los Angeles art world voice the same line of reasoning: modern art was an alien mode introduced by unwelcome easterners.

During this period Guston occasionally worked as an extra in movies. He met Fletcher Martin, son of Idaho farmers and migrant workers, who had arrived in Los angeles after a stint in the navy and found work in the film studios, though like Guston, he studied art when he could. Through Martin, whose wife was a screenwriter, Guston was able to penetrate the mysterious world of the movie lots, a world that appealed to his visual imagination, and one that paid better than factory work. He remembers earning a grand fifteen dollars a day plus overtime at 20th-Century Fox, where he also caught a fleeting glimpse of Charlie Chaplin leaning against a luxurious automobile. "I did extra

work on and off for about two years," he recalls. "I stormed the Bastille, participated in the fall of Babylon, and, in *She* by Ryder Haggard, I played the role of the high priest." His most auspicious stint, however, was during the filming of *Trilby*, in which John Barrymore starred as Svengali, where, wearing a beret and a goatee, Guston painted a nude for three whole weeks in an atelier scene.

A serious student of film, both as a visual art and as a popular art form, Guston accrued firsthand experience on the lots. In addition, he met many great directors both at Stanley Rose's, Hollywood's only avant-garde bookshop, and at Fletcher Martin's home. The bookshop, which has since become legendary, was to be very important for Philip Guston, who at eighteen had his first one-man show in its gallery, thanks to the efforts of Herman Cherry, another young painter. "Stanley," Fletcher Martin recalls, "was the least bookish person I've ever seen and I often wondered whether he ever read a book. He ran a shop which was a combination cultural center, speakeasy, and bookie joint. Stanley would get whiskey and/or girls for visiting authors and Saroyan made him his exclusive agent to the movie studios. The ambience was wonderful, something like your friendly local pool hall. He liked artists and always had a gallery in the back."[5] Through the shop Guston was able to meet Josef von Sternberg (who, he remembers, owned paintings by Rivera, Siqueiros, and Orozco, and whom George Grosz had called "Svengali Joe") and Erich von Stroheim; at dinners in Martin's house he met John Huston, Jean Negulesco, and Delmer Daves.

Guston exposed himself on the one hand to the theoretical and highly artistic aspirations underlying the film art and, on the other, to its popular, demotic power. Even then, the crude power of popular art forms impressed him. His keen interest in the comic strip and the animated cartoon was not solely artistic but sprang as well from his need to draw upon the vigor of unrefined expressions. Guston was not alone in this. Some of his older mentors (in periodicals, that is) were also watching closely for signs of native, unsophisticted vitality. When William Carlos Williams teamed up with Nathanael West to publish the little magazine *Contact*, he welcomed an article by Diego Rivera for the February 1932 issue called "Mickey Mouse and American Art." In it Rivera talked knowledgeably about "perishable" folk art and praised the concision and authenticity of the American animated cartoon.

West, whom Guston met through Fletcher Martin, after some months of collecting material for *Contact* began to notice a pattern

that worried him greatly. He noted in an editorial that manuscripts had arrived (around 1931) from every corner of the United States and that they all had violence at their core:

In America violence is idiomatic. Read our newspapers. . . . In America violence is daily . . . what is melodramatic in European writing is not necessarily so in American writing. For a European writer to make violence real, he has to do a great deal of careful psychology and some sociology. He often needs three hundred pages to motivate one little murder. But not so that American writer. His audience has been prepared and is neither surprised nor shocked if he omits artistic excuses for familiar events.[6]

Susceptible as Guston was at that time, it is not surprising that part of his developing consciousness was directed toward the increasingly obvious malaise in his society. His gravitation to a political viewpoint paralleled his rapid acclimatization as a practicing artist with notably lofty ideals.

After leaving Otis, Guston began to draw incessantly at home. Since Los Angeles had few resources for learning at first hand, he was forced to resort to books for his self-training. In the Los Angeles library he found reproductions of Michelangelo's drawings, Mantegna's prints and paintings, and frescoes of Giotto and Masaccio, and above all, Piero. Guston copied furiously; at one point he did all the heads in Masaccio's *Tribute Money*. His enthusiasm for Cubism was temporarily suspended while he immersed himself in what he thought of as the great tradition. Not yet eighteen, Guston still felt for the need for guidance, or at least confirmation. Reuben Kadish, who attended Lorser Feitelson's life classes, persuaded Guston to bring his drawings to Feitelson, whose response was gratifying. Although Guston was unable to join the class, Feitelson urged him to feel free to bring his work for criticism whenever he liked. During their first meeting, Guston recalls, Feitelson talked to him about Tintoretto and Raphael and encouraged his pursuit of Michelangelo.

Feitelson had a long professional history behind him. He had begun as an admirer of Cézanne, traveled to Paris in 1919 where he assimilated Cubist theory, and stayed there long enough to witness the beginning of Surrealism. Back in Los Angeles Feitelson assumed the role of a mentor. He was one of the few painters who had ventured to Paris, and one of the few with access to publications from abroad. At the time Guston frequented Feitelson's studio, the older painter had

begun to immerse himself in a study of the old masters, making drawings after Titian, Tintoretto, and Rubens and adopting a classical manner of chiaroscuro modeling. Like many American painters, Feitelson felt cut off from sources and far from the spiritual home of art. He tended to worry a great deal about the role of "dogma" and to rehearse the history of art, in an effort to find the key to his own situation in a decidedly provincial city. After a large one-man exhibition at the Los Angeles County Museum in 1929, Feitelson began to formulate increasingly wordy theories to defend his new work. Rejecting Cubism, he turned to what he called classicism. But it was classicism tempered by his experiences in Paris, lightly inflected with Surrealist overtones, and resolutely "modern." He could sustain his new conservative impulse by watching the tenacity of such movements as Valori Plastici in Italy and the Neue Sachlichkeit in Germany.

Despite his tendency to be a pasticheur, Feitelson had the good sense to hold himself ready to receive fresh impulses. In less dogmatic moments he would exclaim: "Ultimately, the function of the painter is to paint!" For Guston, Feitelson "opened up the vistas of the Renaissance masters when I was ready for them." And, perhaps even more important in the long run, was the fact that it was Feitelson who took Guston, Kadish, and a few other favorite students to see the only distinguished collection of modern European art on the West Coast. The privilege of seeing Walter and Louise Arensberg in their Hollywood house, graciously and (for Hollywood) modestly furnished and decked with countless masterworks of the modern period, was not wasted on Feitelson's young friends. Those who later made their way in the art world have spoken of the crucial significance the Arensberg collection had for their artistic formation.

The Arensbergs were not merely millionaires displaying their possessions; they were authentic intellectual aristocrats. Walter Conrad Arensberg was a Shakespeare scholar and an expert on Dante; he wrote poetry and had as early as 1906 translated Mallarmé's "L'Après-Midi d'un faune." He was a friend to many American poets, among them Alfred Kreymborg and Wallace Stevens, who said, "I don't suppose there is anyone to whom the Armory Show of 1913 meant more."[7] Arensberg had bought several important works from that show, including Duchamp's *Nude Descending a Staircase*. When Duchamp arrived in New York in 1915 he found Arensberg's studio on West 67th Street already well endowed with modern drawings, paintings, and primitive sculptures. He and Albert Gleizes began to frequent Arensberg's home, offering their advice and helping Arensberg

to become an authority on modern art. Arensberg in turn became a patron to many artists, above all Duchamp, and he became as passionate about modern art as he had once been about Ezra Pound and Imagist poetry. Long before 1922, when he moved to California and, characteristically, installed himself in a Frank Lloyd Wright house, Arensberg had a museum-quality collection of works by Picasso, Duchamp, Gleizes, Brancusi, and scores of other major painters and sculptors of the modern period.

When Guston first entered Arensberg's living room, probably in 1930 at the age of only seventeen, he saw Rousseau's *Merry Jesters*; Chagall's early masterpiece *Half Past Three* (also called *The Poet*) with its fresh, vigorous composition including an upside-down green head, a scarlet tilted table bearing a knife and a round shape like a fruit, and a prominent, out-of-scale cigarette as well as a letter, flowered wallpaper, and a green cat; several sculptures by Brancusi; and numerous works of Duchamp. But it was Guston's first encounter with Giorgio de Chirico that was to have lifelong consequences for him. Guston's recognition was immediate and profound. Although he was drawn to all of de Chirico's work (and is still today a fervent defender, even of the controversial later works), it was not the celebrated *Soothsayer's Recompense* of 1913 that engraved itself in his memory so much as a later work of around 1925, *The Poet and His Muse*. While the earlier painting certainly made its impact (de Chirico's wisp of smoke from the vanishing train, the arcaded piazza, the reclining classical statue, and the ubiquitous clock appear in many Guston paintings of the 1940s and the 1970s), it is to the later painting that Guston always refers. The painting shows a room interior with the door ajar, a vestige of a scaffold in the rear, and with two heavy-limbed mannequin figures inhabiting its cramped space. They have featureless heads, the poet sitting listless, dangling a monumental hand, while the muse, with machinelike breast, stands above him. When Guston recalls this painting, what he remembers are the strong, ovoid heads with their modeled contours; the muse crowding the poet's shoulder; and the pronounced floorboards. He associates the weight of these figures with his other enthusiasm of the time, the Roman women of Picasso. He likes to recount the story of the painter Yves Tanguy who while on a bus in Paris passed a small gallery window and was so struck by the sight of a painting that he nearly fell as he jumped off the bus. He had discovered de Chirico.

Guston quickly recognized de Chirico's own sources in the Renaissance, understanding that the metaphysics of the deserted piazzas, for

example, had its origin in the fifteen century. Years later, he explained his great love for both de Chirico and Piero by saying that he loved them for their muteness. "They don't demand love. They stand and hold you off." This side of Guston's personality—the part of him that admires restraint, formal decorum, and passion that stops just short of excess—was developing rapidly as he worked nights and weekends perfecting his drawing in the classical manner and working out the paintings (including *Mother and Child* and *The Conspirators*) that he was to show at the Stanley Rose Gallery. At the same time, he fed his curiosity at other tables as well.

There was, for instance, the circle around Stanton MacDonald Wright, whose fame had been assured when Guillaume Apollinaire wrote in praise of Wright's abstract experiments and dubbed him a Synchromist. The young painters in MacDonald Wright's entourage included Herman Cherry, who had persuaded Stanley Rose to open his small art gallery, and others who had the habit of gathering in Wright's studio on Saturdays where they brewed a large pot of chili and discussed art. After his Paris experiments, Wright, like Feitelson, had turned his attention to Cézanne and to figurative painting. But

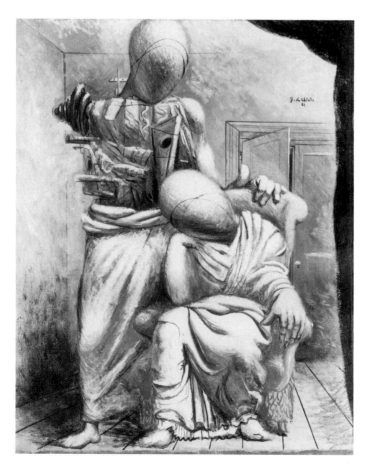

Giorgio de Chirico:
The Poet and His Muse,
c. 1925.

coupled with his classicizing interest in the figure was a parallel interest in Eastern mysticism and, above all, in Eastern visual modes, with which Guston was not in sympathy. Wright regarded invention as primarily an Occidental contribution while he thought of imagination as Oriental, and his own efforts to fuse the two strong currents were reflected in rather bizarre compositions where Chinese dragons consorted with California athletes. Along with Feitelson, Wright stood for modernism in a city dominated by what Guston always refers to as the Eucalyptus School of Painting.

No matter how avidly these young artists explored their surroundings, they were still always in hostile territory. They might absorb messages from eastern art magazines and assume that in New York, at least, there was a climate congenial to their quest, but in their native surroundings they were constantly beset by crude criticism. Poring over *Creative Art* in 1931 and 1932, they became acquainted with reproductions of work by Max Beckmann, Picasso, Derain, and the French Surrealists. They could read about a young colleague, Peter Blume, who was regarded as a "surreal precisionist"; they could read excerpts from Léger's film theories; and they could see ads for the French periodicals *Cahiers d'Art* and *L'Art Vivant*. They could read a mocking article about Los Angeles quoting Louis Bromfield's famous characterization of their hometown as "six suburbs in search of a city," and by 1933 they began to see articles about the Mexican muralists.

In Los Angeles itself, what they read in the press was almost invariably popular cant about the evils and fraudulence of modern art. Editors have long enjoyed reproducing Picasso's works (for instance, one of the Surrealist period, a spiky figure called *Bathing Beauty*) with scornful commentary. "Do you Call This Art?" a 1931 headline demands, and the lead sentences are: "Many readers seeing the line 'bathing beauty' under this picture will think it is a joke. . . . Such pictures as this are actually put in so-called 'art exhibitions' and sell for high prices to art 'patrons' with minds as queer as that of the artist." The ubiquitous and implacable Thomas Craven held forth in syndicated columns that reached Los Angeles from New York, scoring practically anything that came from Europe and not hesitating to use such diction as: "Actually, these pictures are no more than visual evidence of the strange practices of freak artists who distort and mutilate the facts of life in order to make fitting patterns for their little nightmares."

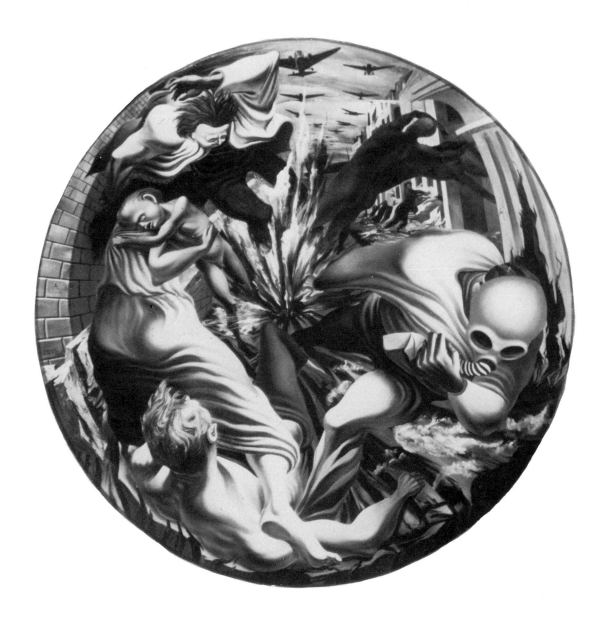

Bombardment, 1937-38.
Oil on wood,
46 in. diameter.

Bombardment II

If the general climate of cultural life was not friendly, the rebels found themselves little by little gaining allies in the intellectual community, largely because of the deepening crisis of the Depression. By 1932 it was generally understood that this economic and social disaster was not going to fade away. Artists and writers became increasingly interested in alternative social proposals, particularly leftist solutions. Manifestos on culture and crisis began to appear, signed by artists on both coasts, and study groups burgeoned, among them the Marxist John Reed Club.

The young painters were prepared to broaden their theoretical horizons under pressure from a turbulent society. One alluring source of a theory that could encompass social upheaval was right on their doorstep: the Mexican mural movement. For a seventeen-year-old boy, filled with conflicting impulses and feverishly trying to train himself for the great life of a painter, the firm rhetoric that accompanied reproductions of works by Rivera, Orozco, and Siqueiros in the art magazines was impressive. Jackson Pollock wrote excitedly to his brother in 1929 about a special issue of *Creative Art* that featured the Mexicans. He and Guston could read Orozco's declaration that the

"highest, the most logical, the purest and strongest form of painting is the mural. In this form alone, it is one with the other arts—with all the others. It is, too, the most disinterested form, for it cannot be made a matter of private gain; it cannot be hidden away for the benefit of a certain privileged few." When Orozco came in person to paint his mural *Prometheus* at Pomona College, the boys made a special trip to watch him at work.

David Alfaro Siqueiros arrived in Los Angeles in 1932 at the invitation of a local art school, the Chouinard Institute, to create a mural. Siqueiros's flamboyant personal style delighted his young admirers. He was, says Fletcher Martin, "a brilliant, eccentric, eloquent man, the most vivid personality I've ever met in my life."[1] When he came to Chouinard, "he formed a team consisting of himself and six assistants whom he called 'Mural Block Painters' and set them to paint a mural. The surface at his disposal was small and irregular—an outer wall 6×9 meters broken by three windows and a door. As the cement surface cracked almost immediately, Siqueiros decided to use spray guns, used for applying quick-drying paint to furniture and cars." Siqueiros's "assistants" changed daily, but a host of art students hung around constantly to listen to the master. His recent encounter, in 1931, with the Russian filmmaker Sergei Eisenstein had filled him with an enthusiasm for psychology, chemistry, and above all photography. As he worked (for it was Siqueiros who really executed the work) he would discourse to his attentive audience. The Chouinard mural, appropriately enough, pictures a soapbox orator addressing workers who watch him from a tiered building. Siqueiros's close study of Renaissance murals was evident in the flattened, vertical composition and in the simplicity of his forms.

From Chouinard, Siqueiros moved to a site on Olvera Street in the center of Los Angeles, where he undertook an outdoor mural for the Plaza Arts Center. As it was his habit to work largely at night, Guston could occasionally observe him after his own day's work driving a truck was over. The Olvera Street project was enormous—eighteen feet high and eighty feet long. Its central image was of a Latin-looking figure being crucified while an American eagle hovers nearby. The controversy this mural incited was not to die until two years later when the city authorities whitewashed over its inflammatory message.

All this excitement coincided with the activities of the John Reed Club, which had been originally founded late in 1929 in New York as a Marxist study group but had gained adherents in other American

cities as the Depression worsened. The Club's 1932 draft manifesto soberly noted that:

Thousands of school-teachers, engineers, chemists, newspapermen and members of other professions are unemployed. The publishing business has suffered acutely from the economic crisis. Middle-class patrons are no longer able to buy paintings as they formerly did. The movies and theatres are discharging writers, actors and artists. And in the midst of this economic crisis, the middle-class intelligentsia, nauseated by the last war, sees another one, more barbarous still, on the horizon. They see the civilization in whose tenets they were nurtured going to pieces. . . .

In late 1932 Guston, Kadish, Harold Lehman, and several of their friends decided to respond to the John Reed Club's call to "abandon decisively the treacherous illusion that art can exist for art's sake." They undertook to paint "portable" murals on the theme of the American Negro, who was seen by all liberal publications of the time as the victim of lynching and other barbarous practices. Guston's mural, based directly on accounts he had read of the trial of the Scottsboro boys, showed Ku Kluxers whipping a roped black man. The murals, executed on separate panels in a shed owned by a Mexican painter, Luis Arenal, were each about 6 × 8 feet in size and were painted in fresco on increasingly fine layers of sand and cement poured into wooden frames. This undertaking was to provide the young painters with the first confirmation of their suspicions that America was in a dangerous state of violent confusion. Early one morning a band of raiders, thought to be led by the chief of the Red Squad, a man called Hines, and abetted by members of the American Legion, entered the John Reed Club brandishing lead pipes and guns. They totally destroyed several murals and, as Guston recalls with a shudder, shot out the eyes and genitals of the figures in his completed work. An eyewitness came forward to say he had seen the police enter the premises, and the artists, almost all of them in their late teens, decided to sue. At the trial the judge looked with distaste upon these insurgent Americans, declared that the murals had been destroyed by parties unknown, and suggested that it was the painters themselves who had probably done it to call attention to their cause. This experience was Guston's first exposure to "justice" and intensified his inner debate as an artist. Forty years later he was still watching the issue of California

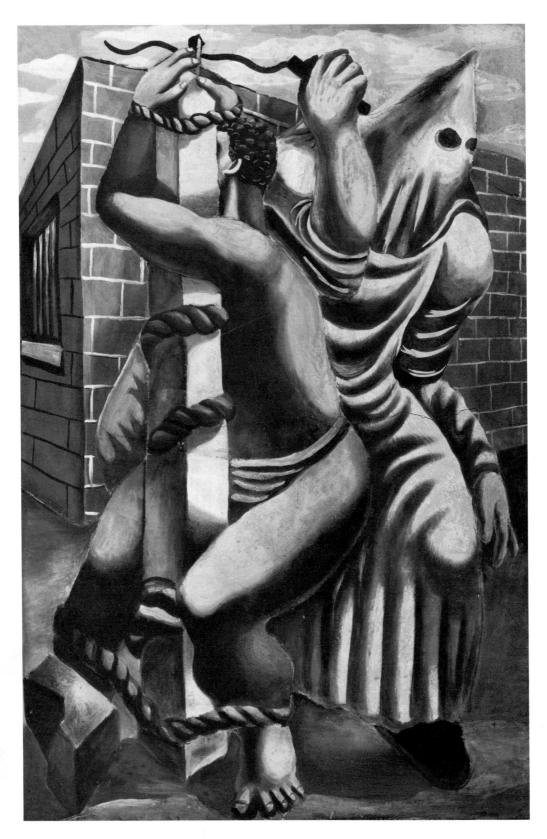

Fresco panel, 1930 or 1931.

law in the person of Nixon, whose "justice" Philip Guston has challenged in a suite of searing caricatures.

But caricature, during the high moment of true fresco painting in Guston's early career, was far from his intention. He was fired with the ambition to produce "the big wall" in a lofty symbolic style worthy of his Renaissance obsession. His concern with idealistic subjects remained, but his artistic ambitions went beyond simplistic formulas. When an older artist took an art-for-art's-sake position, saying he didn't care if a painter painted a flag with a swastika or hammer-and-sickle or fasces so long as it was well done, Guston replied scornfully that no *artist* would feel that way. But when he looked at Rivera's more bombastic works, he recoiled and sought again the magisterial calm of the murals of Masaccio and Piero della Francesca.

In April 1933 the nineteen-year-old Guston was one of fifty artists chosen from among the three hundred who submitted works to the Fourteenth Annual Exhibition at the Los Angeles Museum. He showed *Mother and Child* in the exhibition, which had firmly excluded the nature painters who had long dominated the local scene. Some two hundred artists thereupon protested "handiworks of mediocre charlatans and fashionable faddists."[2] Implicit in their attack was a hatred for the social implications in much of the work. "We raise our lances to defend the sacredness of art," they said. "Our ideals of true Americanism are endangered." Characteristically, these guardians of America associated modern art with foreigners and Bolshevism. they were deeply alarmed to find subjects made visible by the Depression represented soberly by the young modernists. Newspaper commentaries stressed the New Deal bias of the artists, and a large public thus became aware of the political aspects of recent Los Angeles art.

The climate was becoming highly charged by this time and not even artists were immune to New Deal proposals. It was in the year 1933 that the National Legion of Decency was formed to purge Hollywood of its purportedly leftist bias. This was also the year that George Biddle laid the groundwork for the forthcoming government projects for artists, writing to his old school friend Franklin D. Roosevelt that "the younger artists of America are conscious as they never have been of the social revolution that our country and civilization are going through and they would be eager to express these ideals in a permanent art form...."[3] Biddle had in mind the prototype offered by the Mexican government, which had paid artists to work at plasterers' wages "in order to express on the walls of the government buildings the social idea of the Mexican revolution."

The young artists eagerly welcomed the first government projects in California. They had assimilated enough knowledge from the Mexican muralists to undertake large wall spaces. They had responded with alacrity to the attacks of the local keepers of provincial esthetics, and they had been stimulated in innumerable ways to take a critical stand in the seething struggle between Right and Left. Guston in particular had kept his eye on *Americana*, the satirical journal that brought Gilbert Seldes and George Grosz together under the editorship of the eccentric Alexander King, who hoped to echo the extravagantly irreverent note that had once resounded throughout Germany in the journal *Simplicissimus*. Editorials, signed by "The Vigilantes," called for such measures as "Let's Shoot All the Old Men." The mores of America were illustrated in sharply satirical drawings (Guston remembers one issue in which every page carried a portrait of Hoover as an ass with a high collar) and in photomontages. One example was a suite of photographs of four student "demonstrations": the first three showing bloody street battles in Italy, Greece, and Germany, while the fourth pictured a well-dressed American student of the F. Scott Fitzgerald type "demonstrating" a vacuum cleaner to a pretty housewife with well-exposed legs.

Such visual critiques always interested Guston, who has never throughout his career stopped drawing pithy caricatures. But his greater aspiration still lay in the opportunity to master a great wall, and he was among the first young artists to be signed up, early in 1934, when California set up its first federally sponsored art project. Under the Civil Works Administration Arts Projects, he, Reuben Kadish, and Harold Lehman set to work to depict the history of crafts and trades from Egypt to the modern period on a 525-foot wall at the Frank Wiggins Trade School. This undertaking ended in a farcical quarrel with the federal administration that led to all the young artists being thrown off the job, but the tantalizing taste of possibilities set them dreaming of more congenial prospects.

Kadish, who had worked as Siqueiros's assistant in Los Angeles, decided to write him, in the faint hope that somewhere in Mexico there might be a wall for him and Guston. (Originally, Guston and Kadish had wanted to go to Italy to see the old frescoes, but when they went to the San Pedro docks and discovered how much it cost to go to Europe even on a tanker, they changed their destination, realizing that the main thing was to get out of Los Angeles.) Siqueiros answered by saying: Come, we'll find something. "Philip quit his job

and bought a Ford coupe for twenty-three dollars," Kadish remembers, "and I cashed in a life-insurance policy. We also took along Jules Langsner, the poet, who had no money." When they got to Mexico City, they found that Siqueiros and Diego Rivera had already persuaded the University to offer a huge wall in Maximilian's former summer palace in Morelia, now a museum. "We'd already wrecked the car," Kadish recalls, "so we sent Phil to see the rector of the museum and two days later we got a telegram to come."

The sharp contrast in cultures struck the two young painters who had once been thrown out of high school for their activism. Coming from Los Angeles with its stubborn resistance to governmental support for the arts and its perpetual witch-hunting, Kadish and Guston had their first taste of the transplanted European tradition of support for the arts in high places. Since Guston's previous experiences with officialdom had all been disastrous, his interview with the rector of the University, and his subsequent encounters with high officials enthusiastically involved in the artistic life of the country, astonished him. The rector, he wrote, "runs the town culturally, is an art patron, the image of Lenin, and wants to make his city a modern Florence!"

Before going to Morelia, the boys went sightseeing. "I have seen the Pyramids of the Aztecs already, also temple of Quetzalcoatl. Been to bullfights, seen much Aztec sculpture and burned up my stomach with chili," Guston wrote to Harold Lehman from Mexico City on July 14, 1934. He also described his disappointment with the "much heralded Mexican Renaissance." He especially disliked the work of Rivera and at first was not even enthusiastic about Orozco, who "is an expressionist and dominated by emotion but at least is plastic now and then." It is clear in his initial response to the mural painters of Mexico that Guston's immersion in the Italian Renaissance remained his most important impetus. All the same, despite his deepening critical attitude, he was able to enjoy nights with Siqueiros and to respond to the verve of the old master:

He brought with him photos of his Argentine fresco and there is something! It is all done in airbrush and the painting may be shitty but he is experimenting with Kinetics! The shape of the room is half-cylinder shape [here a little sketch]. Huge, and he painted the floor also. Not a bit of space unpainted. Not being a flat plane on a wall, he had the problem of distortion. So he painted his nudes very distorted so that they would not appear distorted because of the peculiar shape of the

wall.... And tremendous movement. He composed it so that as the spectator moves the figures move and rotate with him...and he waves his hand and calls it merely a plastic exercise!

Once in Morelia, Guston and Kadish were given 1,024 square feet of virgin wall with the condition that they finish the commission, in true fresco, within four months. For this they got room, board, studio space, and all materials. On October 4, Guston reported that half the fresco had already been completed. "We are trying many new things and although much is more or less unsuccessful (as far as finished and refined style is concerned) I feel it to be a great experience and have profited greatly." He also reported that Orozco, who had come to town to begin his own fresco, approved their work, and added that he himself was painting easel paintings on the side. Extending his acquaintance in Mexico, he managed to get several portrait commissions, including a six-foot portrait head of Manuel Moreno Sánchez, a Supreme Court justice who sponsored a poetry magazine. He also did woodcuts and linoleum cuts for little magazines, participating in the expansive cultural life so at variance with his own.

All the while Guston's examination of his ideals as a painter was becoming more exacting. The presence of Jules Langsner, always a keen critical intelligence, stimulated Guston's sense of speculation. In November 1934, the trio went to Mexico City for the inauguration of the President, mainly because they had been delayed with the fresco by a lack of colors. Guston, in another letter, again registered his distaste for the expressionism of the Mexican masters, and reported spending his time studying Flemish and German primitives and some drawings by Michelangelo and Raphael in the museum. He bought many reproductions and mentioned with pleasure his finding some large, clear reproductions of Masaccio's frescoes.

When the Mexican project was completed, Kadish and Guston returned to California to undertake a commission together in Duarte, near Los Angeles, for the Treasury Department. But it was not long before Guston yielded to the urging of Sande McCoy (Pollock's brother who had taken back his father's original name) and Jackson himself, to set out for New York, where the WPA mural project was getting underway. "The best thing that is new with me," Guston wrote to Kadish, now in San Francisco, in a letter dated August 27, 1935, "is that I am going to New York in 3 weeks—about the 20th of September. I saw Tolegian [one of the Manual Arts group], he is here for a

few weeks—and he tells me that I will have a better chance to get on the project around this time than later in the fall." In the next sentence, he indicates how the pull away from studies of the classics to the Mexicans, to social realism, and to modernism had thrown young painters into a state of confusion: "Tolegian claims it is all Siqueiros' fault, his influence being quite opposite to clear and sober thought. Well, I shall find out for myself what the hell all this is about."

The "sober" influence in New York was Thomas Hart Benton, who had painted murals side by side with Orozco at the New School and had already offered liberal moral support to the young Jackson Pollock. Benton's twangy American background suited his followers at the Art Students League, who were eager to participate in the program of national self-discovery sponsored by the New Deal. The rapid series of events that brought artists together, not only under federal sponsorship but also into such political associations as the Artists' Congress, had created many disturbing problems in the lives of the young artists. From 1932 when there were fifteen million unemployed to 1935 when government programs were well underway, many conflicts of conscience suddenly appeared, interfering with esthetic commitments. In Los Angeles, some artists rose to denounce the Artists' Congress as a Marxist propaganda organ, while others defended it as the first mature association devoted to artistic interests. The staunchest defenders of the modern tradition, fearful of the tendentious aspects of the Congress's activities, sometimes found themselves unhappy bedfellows with outspoken Nazi sympathizers.

New York, from a distance, seemed less vulnerable to such bitter and hopeless theoretical wrangling. For one thing, more than half of the artists in all of the United States lived there, and, for another, it was there that the WPA projects were concentrated. Yet in reality the spiritual confusion and economic pressures were as intense in New York as in Los Angeles. A letter from Sande McCoy to Reuben Kadish, dated July 16, 1935, indicates the situation:

I am at a loss as to what position to take in regards to subject matter. To say nothing of the economic piss pot in which I find myself. Conditions here in general and particularly for the artist are certainly not improving in spite of the large gestures and bullshitting from Washington. There has been and is much talk of more Projects but it is the usual circle of procrastination if and when an artist is given a chance at a wall he is bound hard by a stinking Art Commission

headed by a super patriot . . . so as a result what few murals are being done are merely flat wall decorations of the lowest order, for instance Charlot was forced to paint a "mural" with the story of Costume as his subject! As for you and Phil coming here I think it the only sane thing to do even though there is a definite movement among artists to get out of New York into the mid-west and west to develop regional art (Wood-Iowa, Benton-Missouri, Curry-Kansas, etc.) but you must be prepared to face all kinds of odds for it is truly hard living here for one without means. . . . Incidentally, Rube, notice in the July 16 issue of New Masses that they plan to make the next quarterly issue a Revolutionary Art number. . . .

When Guston arrived in New York during the winter of 1935–36, he was not quite twenty-three years old, but he had already accumulated a store of experience as a professional artist, above all as a muralist, which enabled him to move quickly into the heart of artistic activities. Staying first with Pollock and Sande McCoy in their loft at 46 East 8th Street, and later in a small loft on Christopher Street, Guston adapted rapidly to the ways of New York's artistic community. He knew what he wanted: he wanted to paint large walls, and he wanted to develop as an easel painter in his free time. He wanted to challenge New York with the grand Renaissance manner.

The first step was to get on the mural project, which did not prove difficult for Guston. In the beginning he spent nearly a year doing large cartoons on a commission for the Kings County Hospital, which ultimately rejected them. He met James Brooks, who had come up from Texas to study at the Art Students League and who at first was doing lettering in the applied arts division of the WPA. Brooks had just won a competition for a mural and spent some time working on cartoons in Sande McCoy's loft. He was a mild-mannered but intense young artist whose interests paralleled Guston's. They both worried about stylistic choices and about the obligation to uphold the modern tradition in circumstances that were becoming increasingly difficult. When the Pollock brothers, who were at the time under the sway of Benton, Picasso, and Orozco, joined Brooks and Guston in the evenings, they often thrashed out the esthetic conflicts that were growing more severe in the late 1930s. Orozco, Brooks recalls, spoke very well about Giotto; when he lectured at the New School and at the Artists' Union, they would attend and afterward discuss the lecture all night.

In 1937 Guston married Musa McKim and took a loft on 22nd

Street near Fifth Avenue. Brooks by this time was living on 21st Street. The two men partook sparingly of the multifarious activities engaging artists in those days. When the Artists' Union, which had a cultural committee, had its weekly meetings, the two young artists would usually attend, but they did not become deeply involved, according to Brooks, who laughs about the unceasing political wrangling. "I can remember trying to get a well-known analyst to speak at the Artists' Union. Before he answered, he had to know: are they Stalinists or Trotskyites?"[4] Nevertheless, Brooks recalls the "strong tide" that swept through the studios. The thing was to get a wall, and the wall should bear a social message. Not even the most vanguard artists on the project doubted that the function of murals was social.

In a sense, though, it was a quiet life. It was the first time these artists had ever had a chance to work exclusively as artists in the United States. Both Guston and Brooks had known the harassing circumstances of separating their lives into working for a living and working to become better artists. Both had a need to concentrate. "We'd work like hell," Brooks recalls. "All day we'd work on cartoons or murals, and at night we worked from a model." They often met in their studios late at night for quiet talk or to play music. Guston played the mandolin, Brooks the recorder. They listened to jazz records once in a while, or went to the movies, which were still a great lure for Guston. Brooks remembers one day standing in line with Guston waiting for their paychecks. They debated going to the movies but then agreed that they would do better to go home and work. It was an Olivia de Havilland film and after parting for their respective studios, both doubled back secretly to see it. Coming out, they ran into each other.

More often they took their recreation in the stimulating atmosphere of the Federal Theater, which Guston recalls with enthusiasm. The WPA had quickly evolved into a confraternity of all artists in all the arts, and anything worth seeing at the theater could find a natural audience in those on the rolls of the project. Despite the considerable bickering and conflicts with the administration, there was a camaraderie among artists and intellectuals during the 1930s that has never since been equaled in the United States. It was natural for a young artist eager for a cultural endowment to gravitate to this theater, so singularly experimental in the mid-1930s. Wherever there was high ambition, artistically expressed, there was a sense of belonging, or, as they liked to say in those days, of solidarity.

For Guston, who would later evince great interest in the masque, and who has at times spoken of his paintings as a species of theater, the great theatrical experiments of the mid-1930s were memorable. He could easily relate to the *Living Newspaper*—a revue in which actual topics were enacted on the stage, frequently using quotations from the day's news—and to the famous musical *Pins and Needles* sponsored by the ILGWU. Still more exciting to him was the modernization of the formal theater. The fact that he remembers Orson Welles's *Doctor Faustus*, produced in street clothes, and his extravagant *Julius Caesar*, and, above all, Marc Blitzstein's *The Cradle Will Rock*, which Aaron Copland called the first American opera making "truly indigenous opera possible,"[5] points to Guston's consistent interest in the problem of using traditional forms in fresh ways.

The production of Blitzstein's opera, with its unconventional motif of a steel strike, in many ways epitomizes the experience of the 1930s. The opera was beset with problems from the start. The hostility of Congress to the arts projects had been growing, and the Hearst press had been assiduously fanning public prejudice. Since theater was more visible than most of the other arts projects, the watchdog committees in Congress had set themselves the task of destroying dramatic projects first. The guiding spirit in the remarkable theater network extending throughout the country was a vivid and highly intelligent former professor, Hallie Flanagan, who would not compromise her high standards. Warned by friendly New Deal cabinet members that the *Living Newspaper* was particularly galling to the legislators, she

Guston on the scaffold of his WPA mural, 1937.

nonetheless attempted to brazen it out, calling upon a galaxy of enlightened dignitaries to fight for the project. But it was to be a losing struggle, and the theater project was the first to be scuttled when the reactionaries got the upper hand.

The unorthodox opera, for which Flanagan had hired John Houseman as producer and Orson Welles as director, was bound to irritate the theater's Washington enemies. For one thing, its theme was particularly timely and threatening. In 1937 the CIO succeeded in organizing General Motors and U.S. Steel, but the powers known as "Little Steel" resisted. Bitter strikes were underway when this opera, with its sympathetic view of union organizers and its stern caricatures of capitalists and police, went into rehearsal. Various forms of censorship were covertly initiated in Washington. Flanagan fought back by asking Archibald MacLeish and Virgil Thomson to intervene. After the production was well underway and hundreds of seats had been sold in advance, orders came from Washington that no opening could take place before the beginning of the new fiscal year. A last-ditch campaign in Washington failed to clear the air, and on opening night word came through that the performance was canceled.

All of the struggles during the months preceding had been widely broadcast among artists on the project, for it was an omnious warning of future tactics by the Right against all the arts projects. Moreover, Welles was already celebrated as a genius of the theater. Many artists were present for opening night, Guston at the invitation of Marc Blitzstein himself. They gathered at the Maxine Elliott Theatre, where they were met by Orson Welles, who announced the government's ban and declared his determination that the show would go on. He had just succeeded in renting another theater twenty blocks north at 58th Street and Seventh Avenue. He asked the audience and actors to join him there, and more than six hundred exhilarated spectators embarked on a historic march. Meanwhile, Welles and Blitzstein negotiated hastily with actors and musicians. It was decided that the actors would scatter themselves in the audience so as not to violate Equity orders forbidding participation in unauthorized presentations. As for the musicians, no compromise could be found and Blitzstein frantically tracked down a piano and played the entire score from the stage.

Aside from the natural excitement the exodus had produced, there was an extraordinary effect produced when the singers and actors rose from the audience to take their roles. Guston still vividly remembers Will Gear playing Mr. Mister, the steeltown owner, and Howard da Silva as the union organizer. The brilliant evening was not overlooked

by Washington. Shortly afterward, Flanagan's Federal Theater Project came under the scrutiny of the Dies Committee (predecessor of the House Un-American Activities Committee), which effectively killed it. The specter of a "Communist menace" became more pronounced as reactionary congressmen felt their power growing, and investigations of artists became routine during the late 1930s. Not even the New Deal officials most sympathetic to WPA ideals could prevent the gradual economic strangulation carried out by their opponents, who controlled the purse strings in Congress.

The sense of embattlement shared by all those in the artistic professions grew increasingly sharp as the world moved toward the Second World War. Already Mussolini and Hitler had made their intentions clear and many of the artists were among those well aware of the impending disaster. At the First American Artists' Congress in February 1936, Lewis Mumford spoke of "what is plainly a world catastrophe" and urged his listeners to meet the "emergency" with a determined resistance to the forces that are bringing on war and a conscious struggle against Fascism. At the same meeting Stuart Davis warned his colleagues that the press, which referred to artists on government projects as "Hobohemian chiselers" and "ingrates," was part of a general drive by vested interests to establish a regime founded on the repression of liberties. He too saw the urgent need for artists to resist war and Fascism. Speaker after speaker spoke uneasily of the world situation and its potential disasters for the newly established federal programs. Soon after, when the Spanish Civil War erupted, issues became even more urgent. Artists who had visited Siqueiros's experimental mural workshop on Union Square bade him good-bye as he went off to Spain to fight with the Loyalists. They attended rallies to hear such luminaries as André Malraux beg for their support in Spain. Guston painted *Bombardment*, an emotional commentary on the Spanish Civil War in tondo form, which was exhibited first in a show of the League Against War and Fascism and later at the Whitney Museum in its 1938 annual. Guston rolled the painting all the way from his studio to 8th Street for this first showing in an official place.

In spite of the overwhelming spirit of concern and ethical commitment to causes, the artistic life of New York City was by no means monolithic. Guston very quickly found colleagues who had as many misgivings as he did about the increasingly tendentious tone in contemporary American art. In 1938 he was twenty-five years old and had already begun to question his own commitment to the Renaissance

Philip Guston and
Musa McKim at a
Spanish Civil War rally,
Union Square, 1937.

vision. His questioning was deepened by contact with artists who had carefully sorted out their own positions and had chosen to work in the modern modes originating largely in France.

One of the firmest upholders of the abstract tradition was Burgoyne Diller, who in 1935 had been appointed head of the mural division of the Federal Art Project where he was Guston's supervisor. Diller was an early devotee of van Doesburg, Mondrian, and Vantongerloo, and by 1932 he had become permanently committed to total abstraction. As supervisor of the mural division, he tried to encourage his younger colleagues to experiment, and he was always quick to recognize talent regardless of the artist's style. Bohemian in his mode of existence, Diller was a magnetic force for Guston. He lived nearby, on 27th Street, in a basement apartment, and the first time Guston visited him, Diller received him wearing an overcoat instead of a bathrobe, a small detail that delighted Guston enough to repeat it to his friend James Brooks. Guston had endless discussions about modern art with the gentlemanly Diller. Guston remembers that he would say things like "Well, you're good in the ancient manner." But his knowledgeable discourse on recent trends in Paris aroused Guston's doubts. These were further inflamed by his conversations with other artists he met on the Project, among them Willem de Kooning, Arshile Gorky, and Stuart Davis. At this time Davis was a strong figure whose reputation as a militant radical was matched by his reputation as one of America's best modern painters. While Guston was working on the Kings County Hospital cartoons in a loft provided by the project, Davis was

working in the next bay on a mural for the radio station WNYC. Guston used to watch Davis through a crack in the partition and was impressed by the pounds of cadmium orange, blue, and black that he so liberally squeezed out. "He would mount his scaffold, lavishly spread paint on large areas with a large palette knife, step down, and look at the results for a while in his suspenders smoking his cigar. Then he would mount his ladder again and scrape the whole thing off onto the floor. I remember how impressed I was by this lavish use of paint, and by his willingness to change in the process while I, in my bay, still under the spell of the Renaissance, was laboriously working on my big cartoon."

Davis, and most of the other artists whom Guston took seriously, were deeply aware of the force of Cubism as an appropriate contemporary pictorial idiom. All of them were striving desperately to reconcile their presence within the socially oriented framework of the WPA and their personal longing to participate in the great tide of modern art. Gorky, who himself had many private conflicts, looked at Guston's huge cartoons, strongly modeled in the Mantegna tradition, and told him, "Never mind, just stay there, don't do flat painting." But flat painting was a subject of constant discussion, particularly between Brooks and Guston, who shared certain ideas about style at that time. (A mural Brooks did at the Woodside Public Library in New York shows their stylistic affinities: it is a choreographically composed battle, in which the figures are modeled broadly, their limbs greatly simplified, and their surroundings depicted like stage settings.)

Guston's intense and elaborate conversations with his fellow artists were augmented by strong visual experiences. A regular haunt of all ambitious painters was the A. E. Gallatin Collection, then housed in a ground-floor study hall of New York University at Washington Square. Gallatin had formed a collection of European vanguard painting during the 1920s, and he continued to add to the collection during the following decade. Guston examined the drawings and paintings closely, with particular attention to two major works: Picasso's *Three Musicians* and Léger's *The City*. Both satisfied Guston's innate appetite for the grand and complex composition—an important aspect of the Renaissance tradition—and both successfully restated that tradition in modern language. Léger's masterwork could easily be associated with the grand "machines" of the old masters, while Picasso's intricate composition, with its witty use of overlapping flat planes, set Guston's mind to challenging his own assumptions.

His concourse with Diller had suggested the possibility of dropping "subject matter" altogether and becoming "pure." But his temperament resisted, and he sought answers elsewhere. He studied the large de Chirico exhibition at the Pierre Matisse Gallery in 1936 (where he saw the master himself repainting feverishly before the opening); he went to see paintings by Mondrian and Miró, and Cubist works by Picasso whenever they were exhibited; and in 1939 he saw *Guernica*, whose rearing white horse made an indelible impression on him.

These experiences fed Guston's perpetual debate with himself, and toward the end of 1938 he had, for the moment, eschewed his exclusively Renaissance position. "I became aware of the total picture space —the total picture plane, that is—as against just using volumes in an empty space." His encounter with Léger's *The City* revived his interest in Piero and Uccello, and he began to see Cubism as a modern extension of their complex rhythms. Such thoughts were germinating rapidly for Guston when he received his first important mural commission in 1939 for the WPA Building at the New York World's Fair.

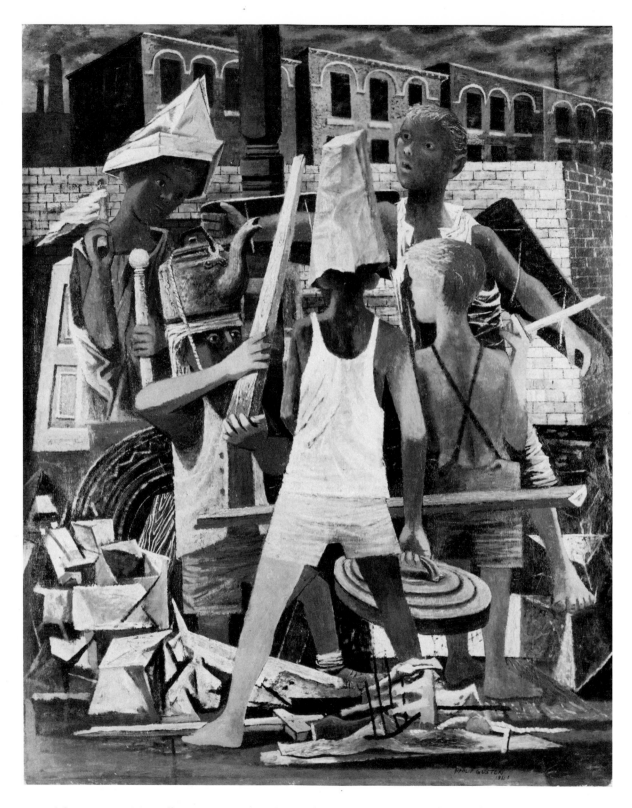

Martial Memory, 1941. Oil on canvas, 39¾ x 32 1/8 in.

Martial Memory III

Competition had been keen for the World's Fair walls, the first important opportunity for exposure for many young artists. Guston won the competition for the curving entry wall over the Federal Works Agency's own display building. He and the other project muralists were well aware that these programs were under increasing fire from Washington, and that this was an opportunity to display the high proficiency and public importance of the unit. In his diary, the muralist Anton Refregier, who was working inside the WPA Building at the Fair, noted: "Every person here is dedicated to the Project. Everyone feels and knows that we must do our utmost. . . ."[1]

Guston's theme was "Maintaining America's Skills," for which he devised a boldly simplified figure scheme portraying a woman scientist, a surveyor, an engineer, and a laborer. He had considerable difficulties, not only with the problem of a curving wall but also with the United Scenic Artists Union, which hailed him down from the scaffolding to inform him he had to have a union card. He also had to find the proper medium for outdoor exposure (rubber paint) and a means of modifying his usual tonal palette. After many adjustments, he finally settled on a strong, simplified scheme of black, red, yellow, white, and blue.

The result of Guston's mastery of the wall was the gratifying award of first prize based on a poll of the public. In addition, Guston won the first lengthy appreciation of his ability in *The New York Times*. The writer, Ruth Green Harris, extolled his clear, positive statement, his magnificent composition, and his solution of one of the most difficult intellectual and visual problems—the treatment of a concave wall: "This is achieved by two great supports, the positive movement of a workman's hand and arm on one side balanced on the other—buttressed rather—by the body of a kneeling man and the angle of a brick wall he is building."[2] This wall, recalling both Renaissance devices and de Chirico's, she calls one of the most beautiful passages in the mural because of the way it is angled from the light.

Months later the final accolade was given by an inspector from the Federal Art Project who reported to his superior: "While most of the exterior mural decorations are badly faded in color, the outstanding exception was Philip Guston's fresco over the entrance of the WPA Building. This appeared as fresh and clean as the day it was painted and has not been affected by an unusually severe winter."[3]

Guston's next big commission for the WPA was the Queensbridge mural, which he regards as his first important pictorial statement. In it he resolved, at least temporarily, a number of esthetic problems with which he had been grappling for several years. Moving decisively away from the high modeling that had characterized his large cartoons for the Kings County Hospital, Guston brought to fruition his musings on the relationships between Cubism and the Renaissance

Municipal Art Gallery in 1937 showing a cartoon by Guston; James Brooks is at the left.

A detail of Guston's
Queensbridge mural, 1940.

mural masters. The cross-patterning of verticals and diagonals in Uc-
cello's *Battle of San Romano* particularly inspired Guston's fresh ap-
proach to the picture space. He felt that in his earlier work he had
seen the pictorial space as a negative entity, a void in which the
volumes alone spoke. With the Queensbridge mural, he began his long
ascent to the sophisticated and specifically modern spatial complex-
ities.

Since the mural has long since been defaced, and few photographs
remain, the official description of *Work and Play* in the mimeographed
dedication pamphlet is useful:

The mural is placed at a focal point in the Queensbridge Housing
Project above the doorway in the lobby of the Community Center. It
covers a space of 300 square feet and is painted in the medium of
casein resin emulsion on gesso ground.

On the extreme left . . . is shown the symbolic family group. Next is
a group of young children playing near slum buildings in the process
of demolition. . . .

Over the left doorway three basketball players represent one phase

of community recreation, and a related trio of musicians and dancers is shown above the right doorway. The figure of the doctor and child at the right of this scene indicate the importance of public health, and at the far right are shown a group of youngsters engaged in various activities typical of community life—painting, reading, building model airplanes, and learning carpentry.

Of these various sections, one was to prove seminal for Guston's future work and has frequently been reproduced. It is the section showing boys in mock battle in which many of Guston's formative experiences with art are reflected. In the scudding and stylized clouds, with their emphatic horizontal bases, are echoes of the Quattrocento. In the scaffolding and the free-standing stageprop arch, the influence of the Italian primitives is seen as rehearsed by de Chirico. The X-like composition of rope and wooden pike contains an echo of Uccello's condensed play of forces. The dog, carefully rendered without high modeling and placed beneath the boy's leg, may well be a paraphrase of the cleverly installed dog in Picasso's *Three Musicians*. (Guston's dog, incidentally, was the source of a two-week delay when the ubiquitous inspectors from Washington, always alert for a Communist message, thought they spied a hammer and sickle in the way the dog's tail curved around the child's leg and ordered the artist off the scaffold until they could investigate his background.) This intricate composition, in which forms are piled up in thin layers very much in the manner of de Chirico's later metaphysical paintings, was to provide Guston with a motif and a pictorial approach that would preoccupy him for the next few years. Indeed, the careful delineation of the sole of a shoe directly parallel to the picture plane can be seen as a forecast of Guston's distant future.

His dialogue with Cubism continued to flourish and was fed by the large Picasso exhibition of 1940 at the Museum of Modern Art. Undoubtedly the range of modes Picasso permitted himself helped Guston to free himself from restricting habits of stylization. But it also fed a gathering storm of doubts that was to erupt within the next two years.

Before the pressure of these doubts became unbearable, finally propelling Guston to abandon murals and concentrate on easel painting, he was to do two more wall projects, both based on designs submitted around the time of the Queensbridge project. The first was executed in collaboration with his wife, Musa McKim, for the U. S. Forestry Building in Laconia, New Hampshire, and the second—his

final one—for the Social Security Building in Washington, completed in 1942. He had resigned from the WPA after completing the Queensbridge project in 1940, and had withdrawn to Woodstock, New York, an artists' community of long standing, where he began to focus on specific problems of easel painting. (The interplay between the demands of easel and mural painting can be seen in the Social Security Building murals, *Reconstruction and Well-Being of the Family*, a 12×17 feet work in three sections. In the central panel the tilted still life and jug recall Cézanne, while the boy's figure in a striped shirt with monomental modeling of the arms again reflects Picasso's impact.)

The result of Guston's first sojourn in Woodstock, a small town ninety miles from New York City, was the painting he now considers his first mature statement as an independent easel painter, *Martial Memory*. Painted in the winter of 1940–41, it shows the pictorial problems that were to preoccupy him for the next several years. There is a noticeable compression in the composition—the result of his long meditation on Cubist values—and his old curiosity about "plastic values," which had been aroused when he was only seventeen, has now reached its peak. Like many of Guston's notable paintings from various periods of his career, it has all the marks of a summum, relating to many earlier experiences and containing the nuclei of future works.

The motif itself recalls the Queensbridge mural, the section that showed boys in combat, using garbage-can covers for shields, sticks for lances, kitchen pots and paper hats for helmets. This was not an unusual theme during the 1930s. Several artists had undertaken to show the street fighting of urban children, among them the cartoonist and painter William Gropper, who had published a drawing of boys with garbage-can cover shields in the *New Masses*. But Guston's first use of the theme in the mural alluded not only to the social situation of boys during the Depression, which he had actually observed, but also to the paintings of Uccello.

Before *Martial Memory*, Guston worked out his first variation on the theme of fighting children in *Gladiators*, a small painting of 1940 whose modeling is pronounced but highly stylized. The draftsmanship recalls the large simplifications employed by Picasso in *Guernica*, although the color suggests the harsh contrasts favored by the Surrealists. By the time Guston undertook the next version, he had arrived at a decisive and consistent mode, one that subsumed his previous experiences and yet was particularly suited to the criteria of easel painting.

The transfiguration of the boys in *Martial Memory* calls upon Guston's longstanding desire to achieve the immutability he so much admired in the reproductions he had seen of works by Piero della Francesca. The figures are fixed in ritualistic positions, reflecting Guston's interest in the mystery of ritual games. The faces of the children are not all masked, as they are in the two previous versions, but simply stylized to suit the solemn tableau. Memories of Italian predecessors are retained in the colors Guston has employed: sienna, ocher, and slate blue. These colors also suggest another memory—that of the Turin scenes of Giorgio de Chirico—which is reinforced by the smokestacks in the distance and the procession of blind windows receding in the upper plane.

It is clear that in this painting Guston has made an ambitious move in the direction of symbolism and mythology, slowly severing the 1930s tradition of social commentary. One boy is winged like Icarus, but the carefully rendered props are contemporary (garbage-can cover, rubber tire, old door, and a detached column typical of small-town American houses). The atmosphere already engenders that sense of timelessness for which Guston so longed.

In reducing the highlighted, dramatic modeling of earlier works such as *The Conspirators*, Guston achieved the planarity he admired in Cubism. The even distribution of light has enabled him to render the major figure, a boy seen from the back, in contrasts of nearly flat value. On the other hand, Guston's need to deal with the easel format has opened up new possibilities to him. The broad simplifications of

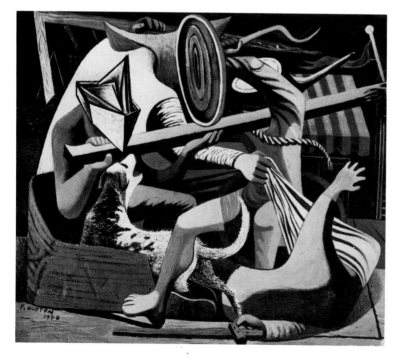

Gladiators, 1940.
Oil on canvas, 24½ x 28 in.

monumental scale were no longer suitable, so now, he could allow himself the pleasure of fine detail. In the paper hats and pasteboard boxes his brush worked with a delicate gradation of tone that brought him into his first real contact with the tradition of painterly pictorialism. This painterly lyricism was to develop rapidly during the next three years.

In *Martial Memory* Guston performed the kind of shift of emphasis that has characterized his entire life's work. The props have been carried over from earlier pictures, but the contexts in which they are set have been thoroughly revised. These contexts are both psychological and compositional—such as the brick wall that has so often appeared previously but which in this painting is brought forward to serve as a frankly theatrical backdrop. The shift in mood here is subtle but radical. Like many of the early artists of the modern tradition who worked in Paris during the mid-nineteenth century when street cries, popular entertainments, and the remnants of the *commedia dell'arte* inspired artists and writers from Flaubert and Baudelaire to Mallarmé, from Daumier and Manet to Cézanne, Guston sought to infuse his art with a vigor drawn from his experience with popular life. At the same time, he hungered for an ideal fusion of modern life and the wealth of traditions from which it had evolved. *Martial Memory* was painted at the very moment when the life of the United States had moved far away from the privations of the 1930s. The Second World War had already erupted, and war industries were flourishing. Artists were employed as illustrators of army manuals or mapmakers, and the public was becoming familiar with the propagandistic posters issued by Washington. Guston's work, on the other hand, was actually moving away from the street life he purported to illustrate, for, like his nineteenth-century forebears, he used the motifs of the modern world to transcend it. He was, as usual, out-of-phase with his contemporaries. Yet *Martial Memory*, with its firm air of resolution, made its impact; it was shown at the Carnegie Institute within the year and purchased by the City Art Museum in St. Louis in 1942. The art historian H. W. Janson wrote about the painting for the museum's spring bulletin, stressing the "spiritual" aspect of the scene and praising Guston's ability to balance the various tendencies in recent American painting. A note of contemporary significance emerges toward the end of the article, where Janson remarks that "Guston has found the true image of this war-torn world, suggesting at once the tinsel glitter of martial trappings and the deep emotional crisis that underlies every human conflict."

Sanctuary, 1944. Oil on canvas, 22 1/8 x 35 7/8 in.

Sanctuary IV

The moral and emotional climate in New York had changed rapidly with the onset of the war, and when in the fall of 1941 Guston was offered the post of Visiting Artist at the University of Iowa, he accepted with alacrity. He was twenty-eight years old, had come to the end of his adventure as a public muralist, and was eager to develop his inner life through the more intimate means of easel painting.

The move to Iowa City was the beginning of many changes for him. This high-school dropout from Los Angeles was called upon to be a professor in a small midwestern town. He armed himself with reproductions of Cubist paintings, of Piero, Uccello, and other Renaissance masters, and vowed to himself that he would extend his own education in the process of teaching. This city boy, who had known only Los Angeles and New York in any depth, was transplanted to the hermetic culture and strange landscape of the prosperous Midwest. The quaint frame houses, with their variety of porches, columns, scrollwork, and large windows, did not fail to make an impression on him, as many of his Iowa paintings attest. The confines of Main Street, familiar to all small-town denizens, seemed exotic to Guston, who had never known provincial monotony and its peculiar rhythms.

Oddly enough, Guston had moved into the very seat of the regional school of painting that had so exasperated him and his colleagues in the New York project days. The art department to which Guston came had had the distinction of playing host for years to America's best-known regionalist, Grant Wood. The Midwest had been eulogized by Wood, and one can assume that his stature as local master would have made the lot of a younger painter rather difficult. But Guston was, as his most notable student, Stephen Greene, recalls, "a man of stature by personality and by his obvious desire to be a great painter."[1] He brought to the enclave of the university the same fund of enthusiasm and restless energy that has propelled him through so many climates.

"Iowa City, which had been labeled in a long article by *Life* magazine as 'the Athens of America,'" Greene writes, "was anything but that. Other than some spots on the campus, it was a small, somewhat shabby-looking tasteless midwestern town, isolated. We had students who had never seen a single exhibition of any import. We had a gallery but it had no shows that I can remember. I remember walking on the railroad tracks late at night in sheer desperate loneliness and the need to walk someplace else. In the middle of all this Philip was a 'missionary' as an artist, simply by being a true artist." He recalls, as do other former students, how Guston's confident physical appearance impressed everyone. "He was a remarkable looking man in the sense of looking as if he had just stepped out of a Piero painting . . . I, as well as the other students, was involved with the romance of the artist, highly sensitized, romantic, giving but finally leaving you as well as himself alone."

The romantic and, at that time, "passionately outgoing" personality Guston brought to Iowa, as well as his air of confidence, had been acquired in spite of years of conflicting thoughts and desires. Certainly in some ways Iowa was a haven. Guston had left behind, in New York, a community of artists who were constrained to begin again, to reshape their destinies in wartime New York, with its new preoccupations and its clear isolation from modern Europe. During the four academic years he spent in Iowa, his erstwhile colleagues were breaking ground for a new "movement" to be known eventually as the New York School. His closest boyhood acquaintance, Jackson Pollock, was making headlines with audacious paintings; de Kooning was moving into a radical abstract mode; and Gorky was becoming known for his "biomorphic" abstractions. The long conversations about abstract art were continued in New York cafés with new em-

phasis. But Guston had left all that behind, possibly because he unconsciously recognized his need to work through the problems that had long been nagging him. His interest in symbolism, expressed in *Martial Memory*, required further meditation, and for this Iowa was a perfect situation, being thoroughly remote from the urgency of New York. Moreover, the students and teachers alike there were interested, as Greene points out, in an art "in which the human figure was the central image, and perhaps it was also central to the core of meaning intended."

Guston amply fulfilled the expectations of his students. Another of them, JoEllen Rapee, remembers how he challenged Iowan sensibilities by introducing live models into the classroom; he especially liked gymnasts and dancers.[2] He worked on his own paintings alongside his graduate students, and they were able on a day-to-day basis to watch him bring several of his celebrated works of the 1940s to completion. He also made himself available outside the classroom and would spend hours in the Student Union, conversing, drawing caricatures, and drinking beer. He introduced his students to Picasso, Piero, and, as Rapee recalls, de Chirico "about whom he was mad!" Guston himself remembers his tremendous effort to reconcile fifteenth-century artists with Picasso, Braque, and Léger. "I taught still life in which elements were constructed via Picasso and Braque." He spurred his students to study the formal values in different modes of painting and, in Greene's words, "created a world that was urgent, sensitive, and very much in the great tradition of 'man as artist.'"

Outwardly all went well in those first years at Iowa, but Guston's inward doubts continued to mount. He found himself looking at such Romantic painters as Corot with new interest. He wavered, searched, and set about expanding his education. The presence of such intellectuals as Austin Warren, then head of the English department, and H. W. Janson, who was teaching art history, was immensely important to him, aware as he was of the gaps in his educational background. With obsessive thoroughness, he set out to read the great art historians, beginning with Heinrich Wölfflin's *Principles of Art History*. The neat dialectic employed by the German historian—his description of two kinds of pictorial logic, the linear and the painterly—undoubtedly braced Guston's spirit, for it was a kind of schematic rendering of the conflicting ideas that had long been troubling his mind. As Guston was consciously teaching himself the nuances of easel painting, he must surely have been affected by Wölfflin's acute analyses of Baroque and

Classical modes. By contrast, the organic approach favored by the French historian and esthetician Henri Focillon nourished Guston's sense of the mysterious vitality lodged in "true" forms. Focillon did not limit himself to discussing historical stylistic modes; he was a warm enthusiast whose responses to various masters were poetically transcribed. He could discuss with equal fervor the intensity of Gothic stonecarvers and the infinite variety of graphic signs that Rembrandt had developed to indicate space and mood. The very title of his most celebrated work, *The Life of Forms in Art*, would certainly have inspired Guston, who had intuitively grasped the principle of vitality of form while still in his teens. In spite of their different approaches, both Wölfflin and Focillon stimulated Guston's innate interest in the formal history of art. In addition, he encountered for the first time Berenson's books on Renaissance art, Élie Faure's sensitive discussions of the spirit of forms, and Roger Fry's essays.

Erwin Panofsky, whose writings Guston also devoured at the time, amplified his knowledge and interest in the symbolic. Guston's long concourse with the Renaissance masters had naturally led him to explore the sources of their themes, and his exposure to Panofsky's lessons in iconography was essential to his dialogue in the early 1940s. Since that period, many visitors have remarked that wherever Guston has lived, there have always been three reproductions hanging in his kitchen: Piero's *Flagellation*, Uccello's *Battle of San Romano*, and Dürer's *Melancholia*. Not much has been said about Guston's interest in Dürer, yet the print is an emblem of a strong philosophical tendency on his part. Its mood of intense seriousness, and even the symbols it contains, speak to that side of Guston's imagination that brought him to Giorgio de Chirico (whose own education in German symbolism was crucial to his work).

The *Melancholia* was originally conceived as a counterpart of Dürer's image of Saint Jerome. As a linked pair, the two prints represented antithetical ideas according to Panofsky, with Jerome epitomizing the *vita comtemplativa* and *Melancholia* representing the state of "gloomy inaction." It is the account of divine bliss versus the tragic unrest of human creation. Melancholia is the eternally unhappy genius, and Dürer sets out an array of symbols to indicate her preoccupations. There are scales, an hourglass, a bell, a magic square (with hermetic numbers), and tools to measure space and time: a plane, a saw, a ruler, pincers, a hammer, nails, a turned wooden sphere, and a truncated stone rhomboid. Panofsky says that Dürer pictures a "Mel-

The Gustons' kitchen in Woodstock, 1975. (Denise Hare)

ancholia Artificialis," or Artist's Melancholy: "The mature and learned Melancholia typifies Theoretical Insight which thinks but cannot act" (in the old meaning of *Kunst* as knowledge). And he notes that in the medieval period the humanistic *furor melancholicus* was associated with Saturn. "Hers," he writes, "is the inertia of a being which renounces what it could reach because it cannot reach for what it longs."[3]

The significance of Melancholia to Guston becomes unavoidable when the cycles of his entire oeuvre are reviewed. Again and again he has encountered the roadblock of "Theoretical Insight which thinks but cannot act." His recurrent anxiety about "meaning" has always stopped him. Then he banishes the *Kunst* and paints, as he has often said, as though he were the first primitive painter in history. The

plethora of symbols, which he had so much admired when de Chirico piled them up in his later paintings, eventually emerge like old splinters in Guston's works of various periods. The tragedy of knowing and not knowing how to enact is intimately familiar to Guston, and to most artists of a romantic stamp. The disarray of potentially powerful tools in Melancholia's environment is analogous to the disarray of the restless imagination of the painter. Her isolation corresponds above all to the familiar isolation of the artist who speaks but rarely finds a respondent. Unlike Saint Jerome, comfortably installed and with a sense of place in a glowing study, calmly pursuing his scholarly interests, Melancholia sits dejectedly in a ruined site, no human within earshot. Her solitary life is cluttered with the indecisions and chaos Dürer has so carefully strewn around her. She is harassed by time, by the mysteriousness of her drives (the magic square), by the infinite mathematical complexity of apparently simple forms, the sphere and the rhomboid. No single turn of thought could simplify this eternal chaotic portrait of the conjunction and disjunction of thought and life itself. Yet curiously, Guston has responded to this image with relief: "This Dürer has always quieted me—all the world's essential forms pause for a moment." And he has made, in his mind, a different kind of diptych: "Although it is more literal, it is close in its way to the Piero *Baptism*—a certain graveness, a wisdom of forms, sweet to my eye and mind. I never tire of them."

If we consider that it was probably around this time that Guston developed his unswerving passion for the works of Franz Kafka, it is not difficult to understand the intellectual and emotional upheavals that occurred in Guston's inner life during the 1940s. What he has admired all these years in Kafka is an ability to evoke a parallel world that is utterly convincing. The room in which Gregor Samsa in *The Metamorphosis* lives, the embedded apple, the village inn in *The Castle*, and even the Great Wall of China are vivid images that achieve commonplace believability through Kafka's genius. No object in Kafka remains inert, despite the strong savor of allegory in everything he wrote. Guston's struggle with abstraction, or *Kunst*, and his instinctive regard for concrete representation in art, found myriad confirmations in Kafka's stories, diaries, and conversations. As remote as his experience was from the culture of Prague, Guston could identify with the Jewish artist working in an alien environment (like K., who longs to settle in the purlieus of the castle but never can), who sets artistic ideals in a clear and concrete framework. That "justice" was ulti-

mately an artistic ideal in Kafka would not have seemed strange to the young painter who was later to speak of himself in the Kafkaesque terms of judge and jury in the drama of his work. Kafka once told Gustave Janouch, a young student who recorded his conversation: "I am no critic. I am only a man under judgment and a spectator.... Indeed, I am also the usher of the court, yet I do not know the judge."[4] To the same young poet Kafka tried to convey the value of life itself. It is a mistake to rely entirely on books, he told Janouch; a book cannot take the place of the world. "In life, everything has its own meaning and its own purpose for which there cannot be any permanent substitute.....One tries to imprison life in a book, like a songbird in a cage, but it's no good. On the contrary! Out of the abstractions one finds in books, one can only construct systems that are cages for oneself." And again, "one huddles into one's so-called private life, because one lacks the strength to master the world.... Being is most of all a being-with-things, a dialogue. One mustn't shrink from that. . . ."

Kafka's healthy regard for the great writers in the "realist" tradition would not have escaped Guston. Kafka always maintained that the fundamental problem of all art lay between the subjective world of the "I" and the objective external world. He admired Charles Dickens and Heinrich von Kleist for their calm balance between the two poles. He urged his young admirers to study "perfectly natural" proportions in their work. Kleist, he said, was no juggler or emotionmonger. There were no verbal flourishes in his work. He used a clear, universally intelligible language.

Kafka's other great love was the work—novels, journals, and letters —of Gustave Flaubert, which he always recommended to his friends. He shared Flaubert's obsession with form and purity and his idealistic consecration of his talent to Art, a word Flaubert always, and quite seriously, spelled with a capital A. Kafka saw parallels between his own bachelor life and Flaubert's; both remained unmarried presumably because of their passion for their work. At the same time, as Max Brod mentions, Kafka was terribly excited to read in a memoir by Flaubert's niece that after a visit to a friend, whom they found in the midst of her charming children, Flaubert remarked: "*Ils sont dans le vrai*," and gravely repeated it.[5] Kafka, with his steady awareness of the importance of the external world and with his half-conviction that Art was not enough, often repeated this remark of Flaubert's to his own friends. But in all likelihood, the true significance of Flaubert for

Kafka, and for those who like Guston responded to Kafka, was his dedication to the impossible, to Art.

It may have been under the spell of Kafka, all of whose published works Guston has read and reread, that he turned to Flaubert, especially the remarkable letters in which Flaubert's esthetic is set forth in incomparably crystalline form. Flaubert's preoccupation with purity of form and precision of address could easily be transliterated by a visual artist, especially one who was beginning to turn his mind in the direction of things-in-the-world.

It was easy for the young painter, the admirer of Dürer's Melancholia, to find affinities with the man who wrote to his mistress, Louise Colet:

Because I always sense the future, the antithesis of everything is always before my eyes. I have never seen a child without thinking that it would grow old, not a cradle without thinking of a grave. . . .[6]

And:

My deplorable mania for analysis exhausts me. I doubt everything, even my doubt. . . . Take away my nervous exaltation, my fantasy of mind, the emotion of the minute, and I have little left. . . . You must not take these words in a down-to-earth sense but rather grasp their metaphysical intensity. . . .[7]

And:

There are in me, literarily speaking, two distinct persons: one who is infatuated with bombast, lyricism, eagle flights, sonoroties of phrase and the high points of ideas; and another who digs and burrows into the truth as deeply as he can, who likes to treat a humble fact as respectfully as a big one, who would like to make you feel almost *physically* the things he reproduces; this latter person likes to laugh and enjoys the animal sides of man. . . .[8]

On the other hand, the young painter who admired Piero della Francesca was certain to respond with pleasure to Flaubert's other voice, which announces:

. . . what I love above all else, is form, provided it be beautiful and nothing beyond it. . . . I admire tinsel as much as gold: indeed the poetry of tinsel is even greater, because it is sadder. The only things that exist for me in the world are beautiful verse, well-turned, har-

monious, singing sentences, beautiful sunsets, moonlight, pictures, ancient marbles, and strongly marked faces. Beyond that, nothing.[9]

Or:

What seems to me the highest and most difficult achievement of Art is not to make us laugh or cry, or to rouse our lust or our anger, but to do as nature does—that is, fill us with wonderment. The most beautiful works have indeed this quality. They are serene in aspect, incomprehensible.[10]

And to the young painter whose addiction to the past was a source of constant worry to him, and which located him in a tangent to the course of modern art, Flaubert's exclamation would have been a solace:

I love history madly. The dead are more to my taste than the living. Whence comes this seductiveness of the past? . . . Incidentally, a love of this kind is something entirely new. The historical sense dates from only yesterday, and it may well be the best thing the nineteenth century has to offer. . . .[11]

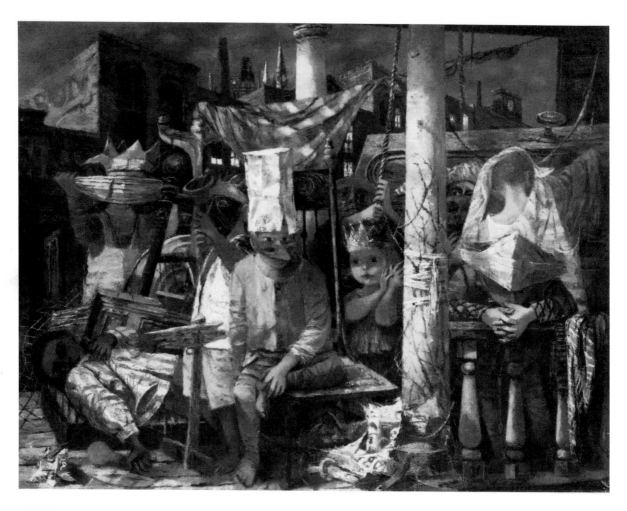

If This Be Not I, 1945. Oil on canvas, 41¾ x 55½ in.

If This Be Not I V

During the four academic years Guston spent at Iowa, he developed his historical sense in depth. His painting experiences were divided. He was in the process of completing a mural commission for the Social Security Building in Washington on the theme of public communications. His conception of the mural shows him straining away from specific "social consciousness," dissociating himself from the earlier ideological tendencies of the mural movement. Instead of a social scene, he paints a rural idyll that includes a loving description of a still life and even—something very rare for him—a landscape with formal trees. That he was intent on breaking with the mural painter's habits and commitments was confirmed in one of the increasingly frequent articles on his works, an essay appearing in the March 1943 issue of *Art News* and dealing with the Social Security murals. Guston is quoted as saying: "I would rather be a poet than a pamphleteer."

All the same, obligations remained. The United States was at war, and, as everyone without exception believed in those days, it was a just war. Guston, like many other painters, felt obliged to contribute his talents in any way possible. As it happened, he found that he could use his ability as a draftsman. Turning from his easel, he attended

classes in celestial navigation, in order to be able to produce murals as visual aids for pre-flight training in the naval air force. Gouaches reflecting his earlier mural style were used to illustrate two articles in *Fortune* magazine in 1943. Even during this period, life for him was divided. There were the long conversations in the Student Union, sorties to the movies to see Hayworth or Bogart or whatever movie came to Iowa City, and there were the long nights in the studio where the artist withdrew to revise and reconsider. In retrospect, he thinks of the entire period ruefully: "In 1941 when I didn't feel strong convictions about the kind of figuration I'd been doing for about eight years, I entered a bad, a painful period when I'd lost what I'd had and had nowhere to go. I was in a state of dismantling."

His strongest need seems to have been to rid himself of the overtones of monumentality. He began to paint studio pictures—agreeable arrangements of figures, objects, windows, still lifes, and even portraits of his wife and friends. These were pure exercises in painting, part of an attempt to overcome the challenges thrust forward by his

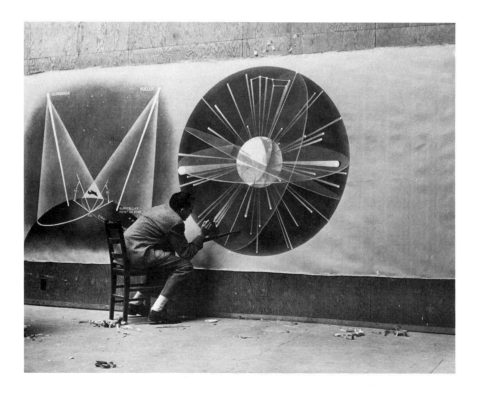

Guston in 1942, painting celestial navigation murals for the Navy.

Sunday Interior, 1941.
Oil on canvas, 38 x 24 in.

intellect. They were, for a time, rather conventional, and a shade sentimental. His determination to be a poet and not a pamphleteer led him to soften his address both to composition and to color. He painted Iowa City in elegiac terms—in *Sunday Interior* we can see a window giving on the street, its light oblique and softened by a window shade, whose string is painted with the deliquescence of a Corot. Guston's portrait of his wife and child shows faint reminders of Picasso and clear references to the shaded and graded chiaroscuros of traditional studio painting. His portrait of a student is carefully worked up and posed in an utterly stylized way.

But then comes the stirring of his old ambitions in *Sanctuary*, 1944, a complex composition with the figure of a reclining boy in a state of reverie, his face cast in deep shadow and all but masked by his hand. Behind him is the flattened Italianized profile of Iowa City, reminiscent of Guston's earlier de Chiricoesque arcades. (Years later, recalling Iowa in a letter, Guston wrote: "You say 'flat and hermetic'—yes, but also emptiness, the lonely quality of it. Not only Iowa City but

towns like Decatur, Illinois, and Des Moines, etc., with lonely empty squares, 'Gothic' City Halls, armories, big clocks illuminated at night. Railroad Stations. Trains. Soldiers moving around—the war years. . . ." His technique in this painting is emphatically in the painterly tradition, with a flutter of half-tones animating the surfaces of skin and cloth and sky, but the artist here has returned to his earlier, larger ambition. In *Holiday*, the ideals that had lain dormant for a few years have surged forward. This reprise of the children's game motif is couched in the complex language Guston relished in *Martial Memory*. The jumble of objects includes a hobby horse, a rendering of a typical midwestern house, a child looking on, and a rose on a drum; these are held in a tense balance and brought close to the picture plane. The manner is softened, but the echoes of the intricate composition are strong. In the upper section, an array of lamp posts, church spires, and housetops—the forms of Iowa City—herald the crowning work of the period, *If This Be Not I*.

Into the calm period of the portraits, during which Guston had attempted to establish his newfound ease in oil painting, has intruded his increasing suspicion that a willful turning away from the modern abstract tradition was somehow false. (When the plaudits of his happy viewers began to pour in, he reacted strongly and eventually denounced the work of this period in public.) Around 1944 he began to look back to experiences he had had in New York. He renewed his interest in the darker tradition, in the Expressionists, and thought about the work of Max Beckmann, which he had seen in 1938 at the Buchholz Gallery. At the time he had bought a monograph on Beckmann and was probably familiar with certain of Beckmann's biographical data that would have seemed significant to him. Beckmann, like Guston, had been particularly moved as a student by the works of Piero and Signorelli, and he had also made a close study of Rembrandt. Beckmann had a literary turn of mind and in addition to painting wrote four plays. He also rejected the notion of total abstraction in terms Guston would have immediately understood: "I hardly need to abstract things, for each object is so unreal that I can only make it 'real' by painting it." Beckmann did not put great emphasis on color ("Things come to me in black and white"), but he developed strong abstract means of suggesting spatial transitions, especially in his bold employment of black, which he dextrously made to serve simultaneously as delineator, modulator in space, and shadow itself. For Guston, whose determination not to fall into modernist clichés led him

Holiday, 1944.
Oil on canvas, 42 x 56 in.

away from Cubism around 1943–44, Beckmann's alternatives held special interest.

This interest was fanned by the presence of H. W. Janson and Stephen Greene, who though his student was only four years younger. Together they pored over books containing reproductions of works of the Northern Renaissance. Guston remembers studying Michael Pacher and Grünewald's Isenheim Altarpiece closely, while Greene remembers analyzing Hugo van der Goes. These were new sources for Guston, who in the past had familiarized himself only with the Italian Renaissance, and they were to prove important as he gradually pulled together his various interests and began to summarize this period in his work.

The summum, as Guston himself has said, was *If This Be Not I*, a painting that became a whole year's project, in which, for the first time, he felt he had really mastered oil painting. The title had been suggested by Musa, who told Guston the Mother Goose story about an old woman who had lost her identity. (Versions of the rhymed tale

exist in some eight languages, showing the elemental nature of this human problem.) It was the right psychological moment for Guston to undertake a synoptic exploration of his own painting history and of the motifs that had repeatedly come to the surface of his imagination. The problem of identity itself had become more pressing as Guston matured. His immersion in literature exacerbated his natural introspective quality, which had for so long led him to resist settling into a definite mold.

A new sense of the positive value of doubting becomes evident in *If This Be Not I.* The entire tableau is enacted in a round of ambiguities, one illuminating the next, but none totally dispelling a sense of mystery. In the painting Guston carries along the props already familiar from earlier works, particularly the Queensbridge mural and *Martial Memory*, but the entire psychological context is changed, and so is the content. There are the familiar paper hats, bedposts, doors, light bulb, newspapers, and ropes arrayed against the background with a Venetian blue sky and the forlorn line of spires and chimneys of the midwestern town. Yet, despite the allusions to other works of his own and to works of the masters he admired, Guston made of this picture an ambitious allegory that was widely recognized as being entirely personal.

Viewers familiar with his oeuvre to date could note that the Harlequin he had once used in his mural cartoons and in his drawings now stands leaning, in Renaissance fashion, over a balustrade, his eyes nearly obscured by his paper hat. Immediately behind him is a child changing into costume with his back to us, certainly an homage to the figure in Piero's luminous drama *The Baptism.* In the plane immediately behind these are fully masked figures. There are many arcane iconographical references, as in the child's figure in the extreme left foreground holding a tin horn and suggesting, in his rigid horizontal pose, a fallen angel, or as in the child standing behind holding a bandage across his eyes in the manner of Renaissance allegories of Justice. There is even an allusion to the Cubist interest in African masks in the figure ringing a bell. These images do not, however, add up to a painting fit only for the iconographer's mill. The overwhelming impression is one of mood and atmosphere, of stillness and mystery, of sublimated ritual.

Although Guston retrieves the closely orchestrated planar conception of his earlier *Martial Memory* (the series of horizontals reading back in highly condensed spaces held by the prominent verticals of the white columns) and remembers his admiration for the piling-up of

detail in de Chirico (as well as the latter's preoccupation with time, which we can see in the clock against the blue sky in Guston's painting), he infuses his composition with the spirit of his recent experiences. The condition of reverie, with its unaccountable images slipping one into the other, overcomes even the theme, which is still that of slum children in their ritual games. Here, as in other similar moments in his painting life, melancholy softened by memory reigns supreme and fuses objects and environment into an atmospheric whole.

The oblique character of the motif corresponds to Guston's expressed desire to stress poetic rather than topical values. He deliber-

Guston in his St. Louis studio, 1945. (Piaget)

ately softens the light in a theatrical manner. Indeed, the whole scene is placed before us as if behind a proscenium. Even the ropes dividing the intersecting planes are deployed as though they were the mechanical backstage aids. *If This Be Not I* takes its place in a tradition that filters down to Guston from the eighteenth century. He has obviously looked closely at Watteau and at the Venetians, especially the two Tiepolos. In the delicate play of whites of the prominent seated figure—hat, shirt, and trousers—there is a distinct recall of Tiepolesque delight in animating various white fabrics. In the beaked mask worn by the boy, significantly just below his transfixed eyes, the history of Italian masqued festivals as transmitted by the Venetian painters of the Rococo period springs to life. Guston has taken pleasure in numerous virtuoso passages in which textures of cloth, paper, and metal are illuminated in the pale, heightened palette of the Venetians. In the half-tones that gently shift from one minute plane to another, Guston has found a universe that reflects his perception of the ambiguities implicit in existence.

Aside from the obvious implications of the mask, including its symbolic commentary on painting itself, Guston here states an almost reflexive interest in the parallels between the process of painting and the process of producing a theatrical drama, bracketed as it is between life and illusion, between proscenium and hall. It is not so far from seeing a painting as a drama to seeing it as a trial. The oblique theatrical character of *If This Be Not I*, with its statement of allegory rather than mimesis, is germane to Guston's entire oeuvre. In 1945 he would certainly have shared the recently revived interest in the Italian *commedia dell'arte*, and in Watteau and his eternally dreaming *Gilles*, that had flowed through the entire nineteenth century and into the twentieth via the Romantic poets. Guston, like his predecessors, was in a state of rebellion against the demands of the "realists," and like them, he had undertaken an introspective quest, as the title of the painting emphasizes. (Those who know Guston's grave face will recognize his own eyes in each of the figures of the painting.) All true art, as Kafka said, is a statement of evidence.

The evidence here is softened, obscured, made to retreat behind a theatrical scrim, but it is evidence nonetheless. For those who, like Verlaine, Rimbaud, Baudelaire, Gautier, and later Apollinaire and Valéry, recognized artifice, ornament—in fact, the basic qualities of eighteenth-century art—as essentially expressive, the evidence must always be filtered through the poet's form-giving imagination. In Bau-

delaire's poem of admiration to artists, "Les Phares," he speaks of Watteau:

> *Watteau, ce carnaval où bien des coeurs illustres*
> *Comme des papillons, errent en flamboyant,*
> *Décors frais et légers éclairés par des lustres*
> *Qui versent la folie à ce bal tournoyant.*

> Watteau, that carnival where many illustrious hearts,
> Like moths, wander as flames catch them,
> Fresh, light decors illuminated by chandeliers
> Which pour madness over the turning dance.[1]

Baudelaire's recognition of the essentially theatrical quality of Watteau (the light of the torch, so bright but so oblique when compared to daylight) is echoed by other Romantic poets, who saw in the use of the theatrical metaphor a larger metaphor for art itself.[2] The poet Banville writing of Verlaine defined him thus: "*Il est des esprits affolés d'art, épris de la poésie plus que de la nature, qui, pareils au nautonier de* L'Embarquement pour Cythère, *au fond même des bois tout vivants et frémissants rêvent aux magies de la peinture et des décors.*" (He is one of the spirits mad about art, taken more with poetry than with nature, who, like the helmsman of *The Embarkation for Cythera*, even in the heart of the living and breathing woods dream of the magic of painting and decor.) There is a deep strain of this passion for painting and decor in Guston, in themselves and in their theatrical illusion. It would hardly be necessary to speak of distant nineteenth-century forebears. The interpretation of the artist as a conjurer, a clown (the broken-hearted saltimbanque), and as someone who enacts the human condition in a stylized ritual has appeared frequently in our century. Picasso dwelt for nearly seventy years on the theme, and it is prominent in the works of many other artists, including such filmmakers as Ingmar Bergman and Federico Fellini.

Drawing No. 1 (for *Tormentors*), 1947. Ink on paper, 15 x 22 1/8 in.

Tormentors VI

The majesty of *If This Be Not I* was to impress and influence many people during the next few years. A short while before his first one-man show in New York City in 1945, at the Midtown Galleries, Guston signed his name to the painting and consciously closed a period in his painting life. The exhibition, which had *If This Be Not I* as its centerpiece, began a public life that Guston needed but found disturbing at the same time. The responses to his New York exhibition were without exception enthusiastic. Yet Guston understood that his viewers responded more to the unaggressive, softly romantic themes than they did to his deeper purposes. He felt compelled to tell an interviewer that he was preoccupied with "ambiguousness" and "metaphor," and that for him, "space with its whole scale of near and far must become as charged with meaning, as inevitable to the composition as a whole as the figures themselves."[1] When, shortly afterward, Guston's *Sentimental Moment* won the coveted first prize at the Carnegie Institute's annual (not an international that year but an American event, no doubt because of the war), he was uncomfortable. The painting, described by Rosamond Frost as "an utterly frontal study of a woman who fills virtually the entire picture surface," in which "light

shifts delicately over the surface, caresses and models form," was found by another critic to have "a repose and dignity reminiscent of the old masters."[2] Guston himself dismissed it as being "too literal" but not until several months later, when he had embarked on a new course and his process of "dismantling" was fully underway. *If This Be Not I* was the end of a distinctive chapter in his oeuvre.

Guston's sense of having completed a phase in his artistic life was profound enough to fill him with uneasiness. When he was invited to teach at Washington University in St. Louis in the fall of 1945, he accepted with some misgivings. Teaching had not only undermined his sense of exclusive devotion to his art but had exhausted him. He was at a point in his work where the slightest distraction could throw him into a state of anxiety. When he left Iowa City, he told several students that he would leave much behind him. He was already mentally preparing for a struggle with himself that would end, after two academic years in St. Louis, in what Guston has at various times called a kind of breakdown.

Whatever his inner turmoil, his students did not suffer by it. Walter Barker, a former student, writing in the *St. Louis Post-Dispatch* on February 13, 1966, was to say that his students "remember Guston as a fluent, dynamic teacher who loved his subject. His knowledge of Renaissance drawing, method, and structure was prodigious. Some of his best classes were conducted in a bar on Oakland Avenue next to the Hi-Point Theatre, or the curb outside when it closed, and sometimes on rapid walks through out-of-the-way alleys, and railroad underpasses in west-end St. Louis with long-legged Guston striding ahead of a winded and bedraggled class." These students learned firsthand what a true *flaneur* could be, for, restless as always, Guston was particularly nervous during this period and spent many hours seeking relief from his gathering mental storm. It was a likely place, anyway. St. Louis was a real city. It had an exceptional museum, then directed by Perry Rathbone, who had been one of the first to recognize Guston's work and to acquire it for the collection. St. Louis had wealth and grace and a group of sophisticated art collectors. It had a symphony orchestra, directed by Vladimir Golschmann, who himself had an exemplary collection of paintings, including several excellent Picassos.

On the other hand, the city had a true proletarian quarter and a lively popular culture. In St. Louis's nightclubs and modest bars, the best jazz and blues from the South were heard, performed by venerable

black musicians of the high epoch. There were a thriving red-light district, a black ghetto, a white ghetto, and behind it all the romance of the old days of lowdown blues—an echo of that St. Louis woman with all her diamond rings. Once again in the heart of a true city, Guston remembered his first city, Los Angeles, where he himself had lived in a poor neighborhood. In St. Louis, far from the calm vistas of cornfields in Iowa, he began to do some sketching in the slums. For his forays in the jazz quarter, he had an excellent guide in William Inge, a Kansas-born writer of Guston's age who was drama editor for the *St. Louis Star-Times* and who edited the culture page until 1946 when he joined the English department of the university. Inge, later to become famous as a playwright, had long specialized in jazz and took Guston to little bars where they would eat spareribs and talk blues. Perhaps they talked about Inge's own work, which paralleled Guston's Iowa period in its description of small towns, with their "mysterious quiet that precedes a Kansas cyclone," as Inge put it.

It was also in St. Louis that classical music suddenly moved into Guston's emotional life. Through the physicist Martin Kamin, Guston was invited to chamber music evenings played by members of the St. Louis Symphony. Of all the experiences with music through the auspices of his friend, Guston remembers most (what certainly was apposite to his troubled mood) his first exposure to the late Beethoven quartets and quintets. And, of the Picassos in Golschmann's collection, he remembers the double heads, those disturbing metamorphic images that reflected Picasso's own weariness with the calm classicism that preceded them. In St. Louis there was an emphatic interest in German Expressionism, strengthened by the presence of Rathbone at the museum, Janson (who had moved from Iowa to Washington University), and a number of easily influenced collectors. It was there that Guston first saw Beckmann's monumental *Voyage* and numerous smaller originals brought personally by the New York dealer Curt Valentin. Guston returned to the monograph he had bought at Valentin's gallery years before, renewing his interest in "the compressed pictures of World War I, the 1922–23 'loaded' pictures." He also frequented the exceptional collection of the newspaper magnate Joseph Pulitzer, Jr., who specialized in modern art and had a particularly good collection of Picassos.

In 1946, a year after his arrival in St. Louis, Guston was joined by his erstwhile student Stephen Greene, who had been appointed an instructor at Washington University. They resumed their old conver-

sations, but Guston was beginning to take issue with the German Gothic painters, finding them too narrative and illustrational. His renewed interest in Picasso at the time was mounting. At the same time, both Greene and Guston were much troubled by the tragic revelations that had followed the close of the war in Europe. Guston recalls that they had seen films about the concentration camps. "Much of our talk was about the holocaust and how to allegorize it." But where Greene felt a need to be a "tragic" painter, Guston "was searching for the plastic condition, where the compressed forms and spaces themselves expressed my feeling about the holocaust." The level at which these horrifying documentaries entered Guston's consciousness was deep enough to mark his work for the rest of his life, as the paintings of the early 1970s attest. The gloomy news items flowing into St. Louis during the two painters' sojourn there affected them profoundly; Greene recalls that it was a "tortured period" in both their lives. "We had times when at 12 or 1 in the morning the two of us would sit in his car and let bus after bus go by and very often we had tales of woe to tell about ourselves."[3]

In his unsettled state, Guston was paradoxically affected by the sudden attention he received in the national press. As a result of his having won the Carnegie award, *Life* magazine compiled a feature story that appeared in the issue of May 27, 1946. On the lead page is a photograph of Guston, head thrust slightly back as though to ward off the spotlight, frowning slightly, standing before his most recent painting (which he subsequently destroyed). The details of the painting indicate a radical shift toward abstraction, noted by the headline: "Carnegie Winner's Art Is Abstract and Symbolic." A dense whirl of shapes very close to the picture plane, dissected and reassembled in small units, is reminiscent of Picasso and of those paintings by Pollock that derived from Picasso. In the story, *Life* underlines Guston's rapid rise to fame, proving it by the old American gauge—the high prices he could command.[4]

By the time the *Life* story appeared, it was old news from Guston's point of view. He had already returned to earlier interests and was thinking about de Chirico's mannequins, the frescoes in Siena, and the little panels of the Lorenzetti brothers. The endless sagas of torture and torment enclosed in the gilt frames of the Italian Quattrocento displaced once again the muted dreams of the Venetians. In the paintings finished between 1945 and the end of 1947 there are allusions to punishment by crucifixion, by quartering, or by hanging upside-down —never explicit but nevertheless unmistakable.

He adopted a new way of indicating space. Since the space he wished to depict was claustrophobic, confined as a narrow prison cell, the recession in depth had to be truncated. Forms lay on a precisely defined picture plane with only flat overlays suggesting a modicum of depth. As Janson was to write in the February 1947 issue of the *Magazine of Art*, "there is no distinction any more between figures or setting, between the formal and representational aspects of design." The adjectives Guston had found for Beckmann's earlier paintings— "compressed" and "loaded"—could now serve for his own works.

Few paintings of the St. Louis period have survived. The cast of characters from *If This Be Not I* lingers only in reproductions. The new figures are masked or paper-hatted, and they blow horns or clash cymbals. But severe frontality has forced the artist to depict them in a far more abstract way. The compositions are generally cruciform with figures grouped in a Cubist progression from the center outward. There is enormous pressure from the foreplane to the rear, flattening everything in the narrow confines of the composition. The melancholy emanating from such paintings is heightened if one recognizes the peculiar *repoussoir* used in several of them: the sole of a shoe painted as though it were affixed to the picture plane pushing the other objects

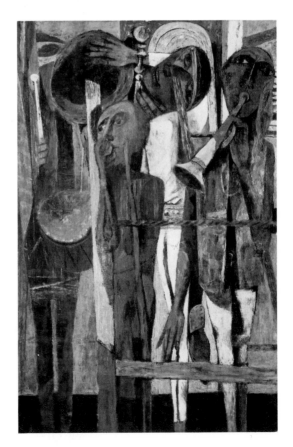

Performers, 1947.
Oil on canvas, 48 x 32 in.

back into a disturbingly indeterminate but confined space. The columns, horns, spires, and buildings (in which the windows are now barred) are steamrollered flat. Details such as moldings and architectural motifs are less readable, but there are frequent reminders that this is a painter's world of reality, an allegorical one. In *Porch*, for instance, the window shapes are clearly picture frames. In the paintings completed before he left St. Louis (he was replaced as Visiting Artist by Max Beckmann himself) shoes and masks proliferate, marking off the intervals and spaces in complex rhythms. Guston had again begun his study of Piero.

A second version of *Porch* was begun in St. Louis just before he embarked on a leave of absence in the spring of 1947 to take up a Guggenheim Fellowship. Increasingly disturbed and secretly hungering for a catharsis, Guston took his unfinished canvas with him. When he brought it to completion it was a harsh statement of emotional disequilibrium. Gestures of despair predominate, and the features of the faces recall, schematically, the unforgettable photographs of prisoners liberated from concentration camps. Jarring greens and oranges lie on the surface of the canvas in broken planes, suggesting a nightmare place. The uneasy marriage of purely formal, Cubist elements and a highly charged theme is made more obvious by a curious echo of the whole composition painted in grisaille at the extreme right, as though Guston's vision were cut off from some other reality that refuses to cede. This stiff and tortured painting was at once an end and a beginning, for afterward Guston slipped into the abyss that had long been awaiting him.

Outwardly there was every reason for Guston to feel at ease in the world. He had, by the age of thirty-four, won most of the major honors available to American artists of the time. He was deeply admired by students and colleagues. He had even had the rare luck to attract serious and authoritative writers, so that unlike many of his peers, he was not completely at the mercy of carping journalists. In fact, at about the time he left St. Louis to return to Woodstock in 1947, a long study of his recent work had just been completed by Mary Holmes, who summarized the St. Louis paintings in an article entitled "Metamorphosis and Myth in Modern Art."[5] She recognized the complex course of Guston's preoccupation with the mask, in which he had the wisdom to explore problems of identity and personality without slipping into the faddish language of his contemporaries.

In the symbol of the masked child, Miss Holmes saw the twentieth

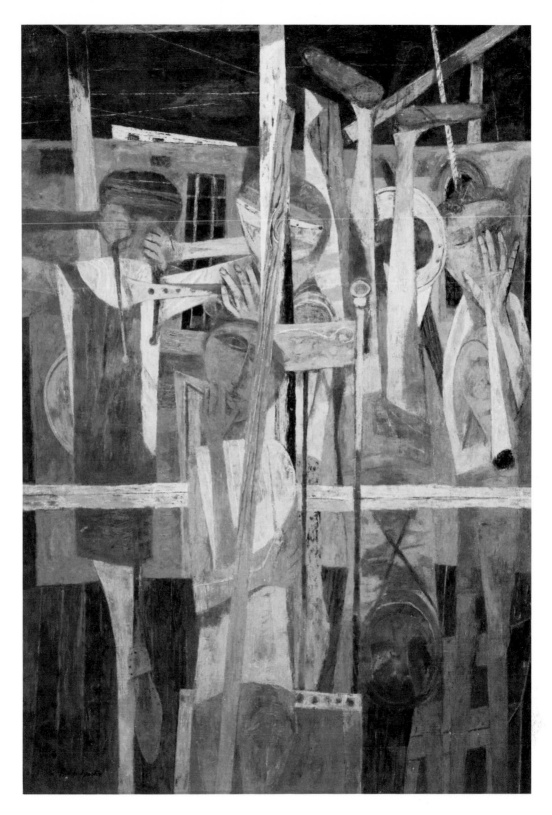

Porch II, 1947. Oil on canvas, 62½ x 43 1/8 in.

century's "fearful adoration of the child" deriving from Rousseau and Freud. She noted that in Guston's paintings the figure of a bystander recurs, unmasked, or in the act of unmasking. "He still quails before his own prophetic act, yet the day may come when the mask may be dropped, because its fearful or playful necessity has been dispelled. The self, more unfathomable than any disguise, will be nakedly acceptable. The question 'If this be not I, who then may it be?' will be answered."

Miss Holmes, in her discussion of the half-unmasked bystander, recognizes that it is the artist himself who is, in the fullest sense, at stake. If her psychological reading of Guston's paintings is too elaborate, it is not wholly idiosyncratic. There can be no doubt that Guston himself saw the implications of his obsessions. Kafka could say "I carry the bars within me all the time" and Guston understood. No amount of reassurance from the outside world could dispel his suffocating sense of insufficiency during the next couple of years.

Guston's withdrawal to Woodstock accelerated his descent. While Woodstock was a three-hour drive from New York City in those days, it was a journey that many artists undertook. Some, like Guston, even settled permanently into modest cottages near rushing brooks, with pleasant wooded vistas and gentle hills in the background. Those who stayed after the summer season still received periodic visits from their New York colleagues; both Pollock and de Kooning visited Guston there. The news from New York City in 1947 was encouraging. Critics were beginning to focus on a small band of artists—many of whom Guston had known on the Project—as an authentic vanguard, and there were new galleries devoted to contemporary work. So eminent a critic as Clement Greenberg discerned a shift of interest among painters, away from Cubist principles toward "symbological or metaphysical content." Although Greenberg disapproved, he recognized that this symbolism served to stimulate ambitious and serious painting, allowing artists to lay aside their differences of ideology. In the suddenly open situation, many painters felt a surge of psychological independence; they felt free to experiment with modes they had never approached before. A strong current of exhilaration was sweeping through the artistic community, endowing a few artists with the giddy impulse to gamble with history.

The strong reverberation of this mood hit Guston on his occasional visits to Peggy Guggenheim's gallery in New York, where he saw many artists. The painter Bradley Walker Tomlin was working nearby

Dial, 1956. Oil on canvas, 72 x 76¼ in.

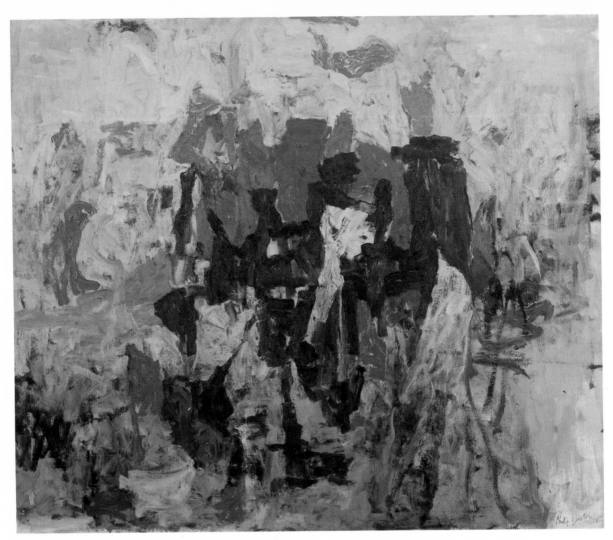

Painter's City, 1956-57. Oil on canvas, 65 x 77 in.

in Woodstock and was himself going through a conversion crisis. Guston had also come to know some other New York painters who occasionally visited—Mark Rothko, for instance, was in Woodstock when Guston had just finished *Porch II*, and when Rothko himself had taken the momentous decision to relinquish the suggestive symbols in his work of the early 1940s. Others, among them Barnett Newman, Theodoros Stamos, and Adolph Gottlieb visited Guston, bringing with them the newfound excitement of recent exhibitions and increasing public attention to what Rothko was to call their "enterprise." But when these visitors from a milieu Guston had once shared departed for the city, they left behind the sense of movement and displacement Guston was trying so hard to exorcise. During the long Woodstock winter he worked exhaustively, but it was not until spring that he had a glimmer of success.

In many ways Guston's move to Woodstock was a sign of his characteristic eccentricity. The logical place to go would have been New York. But in 1947, as on occasion in subsequent years, Guston's deepest need was to remove himself to find himself, which entailed a kind of self-imposed deprivation. He who loved to stalk the city streets was enclosed in the winter silence of Woodstock. He who had sought out people who could stimulate him in his quest for knowledge (and self-knowledge) limited himself to the company of a very few friends. Fortunately, they were exceptional people. Tomlin lived just down the road. He had evolved a delicate, quasi-Cubist mode of painting still lifes, which in the summer of 1947 was giving way to a fumbling emphasis on abstract calligraphy. Tomlin was attentive to the radical changes in mood among painters in New York and had long pondered his own work. By 1947 he had left behind his romantic semifigurative style and was about to evolve a congenial, highly individual abstract one. Guston and he met frequently, encouraged each other, and talked about painting. Occasionally they would be joined by the sculptor Raoul Hague, a rather reclusive woodcarver.

More often Guston saw the young writer Robert Phelps and his wife Rosemary Beck, a painter. Like Guston, the Phelpses had withdrawn to Woodstock to work. "We would work like mad all day and talk all night," Phelps recalls.[6] Guston, who was a fine midnight cook, would prepare various delicacies, among them potato pancakes, and they would eat and talk long into the night. Other times, they went to the movies. "We knew just about every movie house in the Hudson Valley," Phelps remembers.

Guston found in Phelps another in the long line of literary companions who have been endemic to his artistic life. Elegant, quick, full of enthusiasm, Phelps stimulated Guston's imagination. He lent Guston books, particularly ones by authors with whom he was particularly involved—Colette, Henry Green, Genet, and that curious author of some hundred works Marcel Jouhandeau. Throughout Jouhandeau's grisly epics of vice, crime, and blighted love runs a thread of Christian anger that aspires to metaphysics. The violence he portrays might have interested Guston particularly then, since he was himself casting about for ways to express his response to the Satanic events of which he was the half-unmasked witness. (It is interesting that Jouhandeau invented a leading character whom he called M. Godeau, anticipating the Godot of Beckett, soon to become another of Guston's key writers.) In addition to the French writers, to whom Guston was attracted for their superb sense of form, he and Phelps read Auden and Rilke. New translations of Rilke's poems were appearing regularly at the time, and certain of his prose writings were discussed in little magazines where the new leitmotif of the late 1940s was the problem of "alienation." Rilke's insistence that the artist must bear the inevitable isolation thrust upon him by his very success paralleled those attitudes of Kafka with which Guston was intimately familiar. Rilke outlined the stance of the romantic artist who can hope for no true solace from the outer world, and who can find only moments of emotional success in his immersion in the work of art. In Auden the notion of "anxiety" corresponded precisely to Guston's zigzag course through various literary sensibilities, which, for all its variety and divagation, seemed to cleave to the pessimistic, ultimately tragic tenor of what was to be much discussed within the next few years—existentialism.

These literary orgies (for Guston is capable of reading jags that are quite as obsessive as his painting sessions) fed his discontent and exacerbated his sense of esthetic disorder. As Phelps points out, Guston often thinks analogically. He speaks of pictures as though they were books and of books as though they were paintings. "He always talked about 'reading' a painting, and the 'language of paint.'" At the same time, he did not leave behind his old affections. There was talk about Piero, and about Watteau ("those powder blues!"), and about the American comic strip. Guston showed Phelps his paintings. "The first one I saw had that movement of feet, arms, and wrists typical of Philip himself when he talks." It also had, as Phelps recalls with amusement, the ubiquitous sole of the shoe, confirming Phelps's the-

ory that Guston was and is primarily an autobiographical painter, an American who has left nothing behind.

Toward the end of winter that year, Guston painted a small self-portrait in which he portrays himself in an unmasked condition of melancholy. Curiously, though he had long been out of touch with Gorky and de Kooning, the same grays and pinkish ochers they had used in their tentative figure studies of the early 1940s now predominate in Guston's painting. The reduction of color intensity, hinting at ineffable sadness, seems to lead directly into the nocturnal image that was to constitute the first in his extended series of abstractions. This, again, is one of the important paintings in Guston's oeuvre and was to serve as the initial impetus for many later works. Once again he reiterated a long-dormant theme—the ugly habits of the masked and hooded figures associated with the Ku Klux Klan, as he had painted them in *The Conspirators* some sixteen years before. In the preliminary drawing, fragments of representation are rendered in schematic line reminiscent of his caricature style. The sole of the shoe, its heel dotted with nails; the image of a city house in the background; a single head—these are the clues that this is, in fact, a thematic drawing. But the flattened shapes, somewhat like patterns, are by far the most telling elements. This painting, which he called *Tormentors*, car-

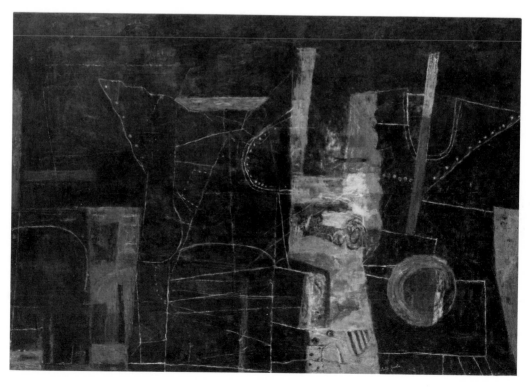

Tormentors, 1947-48. Oil on canvas, 40¾ x 60 1/8 in.

ries out the imperative of flatness and linear primacy. The claustrophobia formerly in evidence in the *Porch* paintings is excruciating here, where the artist has squeezed himself out of space entirely. The figures are disembodied—only vague, wavering lines indicate their erstwhile presence. A bell, perhaps a reminder of the horns that once played so important a part in his paintings, a crutch shape, a hint of a building are all that remain of his theme. In the darkness of this image, the thin lines, like the edges of welded plates, speak another language far removed from the preoccupations of the past few years. The human presences, both evil (the Ku Kluxers) and good (the children), have here abandoned Guston. In the murky brick red and black recesses of this painting still lay the host of questions with which Guston flogged himself like one of his own tormentors, and which would lead him to one failure after another for the few remaining months in Woodstock before he set off on his first pilgrimage to the sources. In October 1948, armed with a Prix de Rome and a grant from the American Academy of Art and Letters (his outer successes were still signal), he embarked for Italy. At a going-away party given by Jimmy Ernst, as though to foretell future associations, were a number of rediscovered friends from the Project days, and new friends who were moving rapidly into position as the progenitors of the New York School, among them de Kooning, Rothko, Gottlieb, and Stamos.

Guston's year abroad was fraught with anxious moments, but it was also a year of great excitement. For the first time he had a chance to see the originals of so many works he knew by heart from reproductions. "It was thrilling to go to Arezzo or Orvieto for the first time," he remembers. "I went to Arezzo many times, and to Florence. Seeing the frescoes, the Uffizi in Florence, and Siena excited and exhausted me."

He painted only sporadically. After the first month in Rome, he found that what he wanted above all was to walk the streets and feel free to think about what he was seeing. "In a sense I was searching for my own painting." Although he painted little, Guston drew constantly in Rome, but did not keep the drawings. A few drawings done on Ischia, where he had fled "to escape from the oppression of the masters," are extant, showing the artist in a very tentative and shifting mood. His restless wanderings in Europe took him to Spain, where he examined El Greco and Goya; to France, where he was moved by Cézanne and Manet; and to Venice where he took a long look at the "painterly painters" Tintoretto and Titian. These last he met with a newly speculative eye. Increasingly he felt the need to reconcile his two longstanding impulses—the one toward pure form, the other to-

Drawing No. 2 (*Ischia*), 1949. Ink on paper, 11¼ x 15½ in.

ward pure expression. His exposure to Europe brought his long process of dismantling to its climax. Everything conspired to make this a moment of crisis for him. His chance conversations, in which the European view of contemporary life, conveniently labeled "existentialist" predominated. His reading, which veered more and more to the "tragic" writers. His feeling that he had left unattended something vital in his painting life, and that he must come to grips with painting itself in terms he had not yet fully comprehended. He had commenced the long peregrination to another place where symbol is all but eliminated, and where the act of painting is itself symbolical; but still, he had not yet succeeded in purging himself of the past, his own, and the past of painting.

In the fall of 1949 he returned to America and settled in Woodstock again, in a primitive house with pump and outhouse. But his work was not going well. That winter he and Tomlin decided that they needed to be in the city, so they took a loft together at University Place and 13th Street, for which Franz Kline constructed the partition. Tomlin soon moved to another loft, and shortly thereafter Guston moved into 51 West 10th, where he stayed for several years. His relationship with

Tomlin remained close, and the two of them, along with the painter Mercedes Matter, often spent their evenings together. It was around this time that Guston began to feel an urgent need to "see if I could paint a picture without stepping back to look at it ... not only to suspend criticism but also to test myself, to see if my sense of structure was inherent." He had been commuting from Woodstock, but now he decided to move permanently to New York. Fortunately, his old friend Janson was now at New York University and arranged for him to take up a teaching post in the fall of 1950. At Guston's specific request, it was not a painting class, but a freshman drawing class in which Guston took attendance and gave grades; his students did not even know he was a painter. "I wanted this anonymity and noninvolvement which in time became boring." Yet, except for a spring term in 1950 when he taught graduate painting at the University of Minnesota at the invitation of H. Harvard Arnason (whose interest and support led eventually to a large show at the Guggenheim Museum in 1962), Guston refused to go back to teaching painting until the 1970s.

When the Gustons finally moved to the city late in 1950, he was fully recovered from his long depression. "I had worked for three years and ended up with a kind of ... freedom." His catharsis in this case, as in other times in his life, consisted in an overwhelming need to forget his culture, above all his painting culture, and to engage himself, almost as a drugged poet might, in the total absorption of painting itself. The two sides of his nature in their constant contention had exhausted and exasperated him. He was ready, as Flaubert had been, to gamble with the muse. "What seems beautiful to me," Flaubert once wrote, "what I should like to write, is a book about nothing, a book dependent on nothing external, which would be held together by the strength of its style, just as the earth, suspended in the void, depends on nothing external for its support; a book which would have almost no subject, or at least in which the subject would be almost invisible, if such a thing is possible."[7] Guston's personal hegira to the void, the void as Flaubert and Mallarmé understood it, and as Sartre and Camus later discussed it, coincided with the collective movement that was to be known as the New York School. One after another artists abandoned the familiar, and the nature of painting quickly converted itself into a view of existence. Painters as different as Rothko and Pollock shared in the general feeling that at last the nature of painting was undergoing a vital transformation. It could become, as they repeatedly stressed, a way of life, an expression of the

human condition—an activity rather than a horde of objects. The complex attitudes of the Abstract Expressionists, as stated in their arguments at the Artist's Club, or as quoted by their increasingly respectful critics, frequently coincided with the old preoccupations Guston had carried along for years. His sudden appearance in the midst of this energetic ferment was not unheralded.

No matter how the existence of the New York School is assessed, the fact is that a certain tremendous force of energy was propelling artists into more and more audacious activities, particularly during the late 1940s and 1950s. Guston was not immune to the nervous excitement that accelerated the pace of change in the work of so many artists. He was, on his own terms, completely ready for it. His view of the period, expressed in a lecture at Boston University in 1966, does not differ from the views of most of the others who shared in the adventure. He looks back and sees that what affected him was "a sense of embarking on something in which you didn't know the outcome." Officials, he said, tended to see it as a *style*, and in America, with its passion for change and the generation of new emotions, styles come and go. But Guston sees it as "a revolution that revolved around the issue of whether it's possible to create in our society at all—not just to make pictures, because anyone can do that." The real questions raised by the activities of the New York School were whether painting and sculpture were not in fact archaic forms in our industrial society. "The original impulse of the New York School was that you had to prove to yourself that the art of creation was still possible," Guston says. "I felt as if I were talking to myself, having a dialogue with myself. The revolutionary aspect was that nothing could really be decided. A painting would *have* to be a continuing argument." His own continuing argument merged with the arguments that were spurring his confrères. His personal need coincided with a strong cultural current that was setting everyone adrift in experience itself, in the quest for direct experience unmitigated by rational procedure. The emergence of Care, or Anxiety, as a painterly ideal (the painting being both an anodyne and a vehicle) was notable even in the vocabulary employed in numerous discussions at the Club. Later, younger artists were to smile at the earnest preoccupation with "risk" among the Abstract Expressionists, but at the time, in the early 1950s, there was a strong need to be aware of the dangers implicit in headlong rebellion. It *was* risky to leave behind the containing structures of painting tradition in order to find a new freedom that did not even have a name.

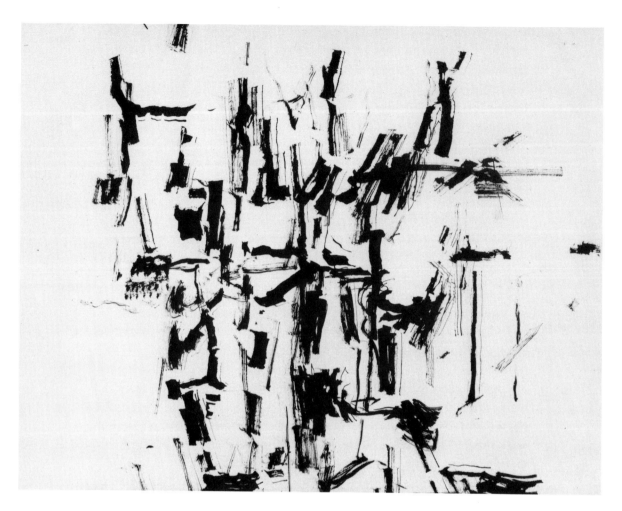

Drawing, 1953. Ink on paper, 17½ x 23¼ in.

Drawing VII

Guston threw himself into the maelstrom of New York with an alacrity bred of near-despair. He once again led a life of extremes, full of the clamoring sounds of discussions, street life, exposure to encounters of many kinds. He resumed his old city habit of night wandering, sometimes like Stephen Dedalus in Nighttown, sometimes like Bloom, participating and reflecting, and from time to time fleeing into the arms of his muse. He usually stayed up until morning, pursuing conversations in bars (not only the established Cedar Bar to which the artists went, but to other less sacrosanct places). He walked the streets, sometimes with a companion, sometimes alone. He had long painting sessions, in which he would tack up his canvas on the wall like a piece of paper, and see if he could paint a painting all at once, "without stepping back." He went fairly regularly to the Friday night meetings at the Club, staying long after the formal debates to drink whiskey from paper cups and go on talking. His pattern was determinedly random, characterized by extreme nervous tension (he was a chainsmoker and a pacer) and the high irritability that existentialist philosophers regarded as the hallmark of the artist.

He found a studio on East 10th Street, in the very heart of the new Bohemia, moved from there to Walt Kuhn's old studio on East 18th

and eventually, in 1959, to a loft over a firehouse on West 20th Street
—a long, dusty loft with deep wells of darkness between skylights, but
with islands of light in which to place his drawing tables and ample
wall space to tack up his canvas. On East 10th Street there were other
artists, among them de Kooning, coming from and going to their own
studios on the same block, and a little later, several cooperative gal-
leries installed themselves on the first floors, bringing their hosts of
young enthusiasts.

There were hours for reading, and it was a period in Guston's life
when reading again assumed a special importance. The nature of the
questions he posed to himself in the studio lay not only in the history
of painting but also in the moral institutions that certain works of
literature represented. He came naturally to Dostoyevsky, whose
questions and counter-questions led always to the kind of irresolution
Guston himself recognized when he said that a painting would *have* to
be a continuing argument. In Dostoyevsky he found stated again and
again the idea he had found so compelling in Kafka: that in one and
the same protagonist in life are the judge and the accused, the jury
and the plaintiff. Camus, whom Guston also read assiduously during
the 1950s, cites a revealing passage in Dostoyevsky's diary, to show
the genesis of the character Kirilov in *The Possessed*:

Since in reply to my questions about happiness, I am told, through the
intermediary of my consciousness, that I cannot be happy except in har-
mony with the great all, which I cannot conceive and shall never be in a
position to conceive, it is evident . . .

Since, finally, in this connection, I assume both the role of the
plaintiff and that of the defendant, of the accused and of the judge,
and since I consider this comedy perpetrated by nature altogether
stupid, and since I even deem it humiliating for me to deign to play
it . . .

In my indisputable capacity of plaintiff and defendant, of judge and
accused, I condemn that nature which, with such impudent nerve,
brought me into being in order to suffer—I condemn it to be annihi-
lated with me.[1]

Camus, though firmly anchored in a pessimistic vision of the absurd,
addressed himself to the problems that were on the surface of every
serious artist's mind in the early 1950s. Guston had not ceased think-
ing of the holocaust; he had not forgotten his early social concerns,
nor had he ever become cynical about the importance and nobility of
art in the human history. He found solace in Camus's own deep belief

in the survival of art itself. In 1953 Camus summed up his attitudes toward the conflict between social action and the notion of art-for-art's sake, which his own position had helped to inflame:

I shall certainly not choose the moment when we are beginning to leave nihilism behind to stupidly deny the values of creation in favor of the values of humanity, or vice versa. . . . Today, under the pressure of events, we are obliged to transport that tension into our lives likewise. This is why so many artists, bending under the burden, take refuge in the ivory tower, or, conversely, in the social church. But as for me, I see in both choices a like act of resignation. We must simultaneously serve suffering and beauty. The long patience, the strength, the secret cunning such service calls for are the virtues that establish the very renascence we need. . . .[2]

Such a moral charge—to serve suffering and beauty simultaneously—was perhaps more than a painter could sustain, but Guston and the others in the New York School took it on nonetheless. The shift in values from the painting as object, as it had been seen by the Cubists, to the painting as a moral undertaking was radical and extensive. Constant discussion fanned the flame of rebellion. There was to be no act of resignation. It was, under the circumstances, a time for acute questioning, and the writers who could frame the most difficult of questions were those to whom the more meditative painters gravitated. Guston, reading Sartre, Camus, and Kafka, followed them back to Kierkegaard, whose grave riddles could be transposed and made to serve the artist. His recent friendship with Robert Motherwell, who had once studied philosophy at Harvard, gave him an opportunity to compare reactions. Both artists, concerned with problems of choice and risk, were struck by Kierkegaard's dramatic parable of Abraham (who had attracted earlier painters; Rembrandt, for instance). But Guston, perhaps, was more attracted to Kierkegaard as discerned by Kafka, the Kierkegaard who had more than a little in common with the questioners of the Talmud. Max Brod, in his biography of Kafka, points to a passage in a letter Kafka wrote to him which emphasizes a side of "hopefulness" in Kafka that existentialism in general seemed to abjure. Kafka quotes the following sentence from Kierkegaard:

As soon as a man appears who brings something of the primitive along with him, so that he doesn't say, "you must take the world as you find it" but rather "Let the world be what it likes, I take my stand on a

primitiveness which I have no intention of changing to meet with the approval of the world" at that moment, as these words are heard, a metamorphosis takes place in the whole of nature. . . .[3]

It was this Kierkegaard, and this Kafka, who bolstered Guston's resolve to paint without "standing back," to find a kind of primitiveness that would, like the magical words Kierkegaard hears, symbolically change everything in the universe.

Guston's conversations with Robert Motherwell, which were intensive during the mid-1950s, centered on the difficult distinctions that now had to be made between art as a set of coveted objects and art as the direct expression of an emotional and moral quest. Motherwell had a broad knowledge of philosophy and a deep interest in modern French poetry. His need to formulate a position was as urgent as Guston's, and during the 1950s he frequently sought to crystallize his speculations in writing. For the catalogue of the New Decade show at the Whitney Museum in 1955, Motherwell wrote a statement in which he asserted that pictures are vehicles of passions and not pretty luxuries: ". . . the act of painting is a deep human necessity, not the production of a hand-made commodity." Putting the stamp of ethics on his aspirations, he concluded: "True painting is a lot more than 'picture-making.' A man is neither a decoration nor an anecdote."

While both Guston and Motherwell frequently turned to the writings of philosophers for support during this period, they did not limit themselves to that. With rare exceptions philosophers are not close enough to an artist's sensibility to provide nourishment for the imagination. Between an artist, his speculative thought, and his beholder lies a work, which is a fusion of all three, yet alive to still other factors and incapable of being schematized. The writings of artists themselves (poets particularly) held important questions in more delicate balance and with less rigidity. Guston at this time was reading essays by poets, among them Baudelaire, Henri Michaux, Jean Cocteau, and Wallace Stevens. And he was reading newly translated poems and essays by the Russian Boris Pasternak, at that time known to very few Americans. In Pasternak, as soon after in Isaac Babel, Guston found affinities that were based as much on his own distant identification with Russia that occasionally asserts itself (although he was not always aware of it) as it was based on the intense nature of the questions posed. In Pasternak (as also in Paul Valéry) the primary question is always: What is creation? By probing again and again the

Robert Motherwell, 1955.
Pencil on paper, 10½ x 8½ in.

process of his own poetic behavior, Pasternak was able to frame certain tentative responses to his own questions, and these were eagerly absorbed by Guston. At the moment when Guston relinquished the consolations of tradition, Pasternak's attitude toward the act of creation itself was important to him. Pasternak, in his memoir *Safe Conduct*, muses:

> Yet all art in its conception in particular is experienced more directly than anything else and on this point there is no need to indulge in guesswork.
> We cease to recognize reality. It appears in some new form. This form appears to be a quality inherent in it, and not in us. Apart from this quality, everything in the world has its name.
> It alone is new and without name. . . .
> The clearest, most memorable and important part about art is the conception, and the world's best creators, those which tell us the most diverse things, in reality, describe their own birth.[4]

There can be no question that in the 1950s Guston's most pressing need, which sprang from the deepest recesses of his imagination, was to experience what he hesitantly called "freedom." The experience he longed for—recorded so often by Pasternak's "world's best creators"—

was to feel a reality in the work more vital than any known emotion, and more seductive. The craving for this experience is as insistent in an artist who has known one such moment of "freedom" as the most primordial erotic impulse.

Behind Pasternak, and all other twentieth-century artists, lay the potent Symbolist tradition that had lured Flaubert, just as it had lured Rimbaud, to the edge of the abyss, to the Void. Certainly no single word has borne so much complex discussion over so long a period of time as the Void. It was as much a part of the modern consciousness, which was straining away from the solid materialism that had preceded it, as the notion of rebellion itself. And the Void was really a name for something that had no name, a vessel into which the artist pondering the nature of his activity could pour endless questions, and which silently enclosed them.

In the twentieth century, the Void transformed itself into Nothingness, which as Sartre saw it was the opposite of Being. The notion of Nothingness became an important ambiguity in the arsenal of ambiguities employed by poets and artists (many more, indeed, than the seven types described by William Empson). Guston was drawn, along with his contemporaries, into this web of speculation. Here he found close companions in two composers whom he saw regularly, the already celebrated John Cage and the younger Morton Feldman. Guston had met Cage around 1948 while attending a concert of prepared piano pieces at the American Academy in Rome. The two had conversed briefly at the time about Zen Buddhism, and later, when they renewed their acquaintance in New York, Guston went several times with Cage to hear the Zen philosopher Suzuki at Columbia University. Cage's sparsely furnished loft bordering the East River on the Lower East Side became a meeting ground for vanguard artists in both music and painting. It was there that Guston met Cage's admirer Feldman, who had studied with the older composer Stefan Wolpe.

Cage brought to the painters his ready wit, and his inveterate habits of rejection. He was a master at rejection, a model. And Nothing was his special province. He gave a lecture at the Club entitled "Lecture on Nothing." He spoke constantly of the Eastern vision of the universe, with its assumption of the significance of the Void. The old definition of the fence as the spaces between the palings, or of the cup as the space it encloses, was enlarged imaginatively by Cage, who saw its application to almost every experience in the universe. In his own work he sought to express it explicitly. Cage enforced his Oriental

perceptions of the void through what Henry Cowell called "the dynamics of silence, a relativity of silence as well as of sound, expressed by rests and extreme *pianissimi*...."[5] Feldman concentrated on the *pianissimi*, tracing delicate configurations that Guston was to find analogous to his own drawings at the time.

Cage held musical soirées in his Grand Street loft, to which many painters were invited and where they heard, most of them for the first time, the strange music that Cage evolved from his various sources, including the Eastern philosophers. The emphasis on silence (the Void) and on isolated "events" within Cage's compositions at the time

Painting No. 9, 1952. Oil on canvas, 48¼ x 36 in.

was not lost on his visual admirers. They too sought large areas of expressive silence in their work, particularly those who had taken to large formats. In Guston's case, Cage's interest in other sources, particularly those from the East, served a momentary need. Earlier in his life Guston had sought relief from the demands of his analytic mind by looking briefly into the mysticism of Ouspensky and Krishnamurti. Now he retreated from the rigors of his dialectic by seeking both in Zen and in Hasidic thought a kind of sanction for dialectic irresolution. Yet these modes of thinking were ultimately not congenial to him. There was too much of the formal artist in him to accept the chronically open vision sponsored by Zen. The Void had to be named at all costs, or it would be meaningless. There was, and is, in him a sense of irony that is foreign to the Zen mystic. Like Paul Valéry, Guston did not care to sink too far into the endless; his need for form was always to check that impulse. As James Lawler has written of Valéry, "Doubt leads to form, form to doubt, as criticism and creation become intimately reciprocal."[6] This kind of dialectic, so inherently Western, was much closer to Guston. Valéry, Lawler tells us, "once put this method succinctly in painterly terms in answering a critic who had sent him a commentary on his work: 'It seems to me,' he writes, 'that you have found in my verse more 'nothingness' than I had thought I put; perhaps I used that word as a painter uses a certain color: he needs a black so he paints one.'"

At the time when Guston was seeing a great deal of Morton Feldman, he was susceptible to the "nothingness" that could be used unthinkingly, as when a painter needs a black and paints one. But Feldman's exploration of aleatory music, with its attenuated forms, its horizontal, disembodied generalizations, its persistent flirtation with the Absolute Void, was a source of contention for Guston. Feldman's sensibility had peculiarities that could not fail to interest him, for Feldman saw himself related more to the painterly esthetic than to music, which he felt had become academic and institutionalized. At one of his concerts, which were attended primarily by artists, he told the audience: "I have always been interested in *touch* rather than musical forms." His "touch" was rendered in delicate, sparse compositions that often receded almost to inaudibility, played caressingly on a piano. The trailing short phrases could easily be apprehended with the same sensibility that read the pale, trembling calligraphy of Guston's paintings at the time. Feldman saw the affinities and was an enthusiastic, ideal audience for Guston's work. The two spent hours in the studio comparing visions. Occasionally Feldman would bring

Cellar, 1970. Oil on canvas, 78 x 110 in.

Painter's Table, 1973. Oil on canvas, 77¼ x 90¼ in.

Drawing No. 9, 1951. Ink on paper, 17 x 23½ in.

other friends, among them the genial master of vanguard music, Edgard Varèse. Once Cage came with Feldman at a time when Guston had completed one of his sparsest abstractions. He responded with an exclamation, "My God, it's possible to paint a magnificent picture about nothing." To which Feldman replied, with characteristic speed, "But, John, it's about everything."

If one part of Guston was drawing closer to ethereality, pondering the weightlessness of spiritual existence, another part of him continued to ramble among the solid obstacles in everyday life. The old moviegoer in him had ample opportunities in New York City and Guston was a steady customer at the 42nd Street theaters that until late in the night would offer films of varying quality from all over the world. A confirmed addict, Guston sat through everything from third-rate Westerns to continental thrillers, smoking his way through the night and sharing the theaters with homeless bums. His early experience as a film extra gave him a special appreciation for the technical accomplishments of even Grade B productions.

In his youth Guston had studied film theory and discerned the inevitable parallels with painting. His early enthusiasm for V. I. Pudovkin, whom he read conscientiously at the age of eighteen, was

undoubtedly based on Pudovkin's own awareness of the affinities between modern painting and film. Pudovkin repeatedly wrote that a film is not *shot* but *built*. His preoccupation with structure answered Guston's own need at that time. Pudovkin recognized that an artist, using materials drawn from life (objects and people), was nonetheless functioning as a creator, that the composition of forms was central to his art. "Between the natural event and its appearance upon the screen there is a marked difference. *It is exactly this difference that makes the film an art.*"[7] In his rather elementary way, Pudovkin set forth the themes that later filmmakers were to pursue assiduously. He raised questions about the differences between "filmic" time and space and "real" time and space that were to become central to the modern esthetic.

The extensions of Russian film theory, especially its preoccupation with the transformation of real situations and objects, could be seen in the late 1940s and 1950s in the works of Italian filmmakers. For Guston, the most important film artist during the 1950s was Federico Fellini. He relished Fellini's sharp, observing eye, which could draw meaning out of the "taste and flavor of life." He could appreciate a sensibility that recognized the importance of the concrete detail in order to weave an ambiguous pattern of meanings that could go far beyond the pretext of the model. When *The White Sheik* appeared in 1952, followed by *I Vitelloni* in 1953, Guston saw them several times, marveling at Fellini's "emotional tone, in which there is never anything direct or simple." He admired Fellini's ability in the later films to explore his own possibilities, to keep moving toward the fusion of autobiography, myth, and art. Perhaps Guston was also drawn by Fellini's use of small Italian towns, with their magical central piazzas and the narrow vistas that had been so important to Giorgio de Chirico.

Fellini's works, with their passages of realistic event and image sliding into passages of fantasy and their irregular rhythms, would have impressed Guston particularly in the early 1950s when he too was working for openness and inconclusiveness. Fellini's working method was highly improvisatory, and he himself has said that his pictures never end. "If I knew everything from the start," he told an interviewer in 1959, "I would no longer be interested in doing it.... Because for me to make a picture is like leaving on a trip. And the most interesting part of a trip is what you discover on the way."[8]

The rhetoric of the Romantic poet, to whom the voyage is the

archetypal analogue of creativity, recurs among artists of the 1950s, and Fellini masterfully translated the old Baudelairean vision into modern terms. Guston had also embarked on the inspired journey and was moving from picture to picture with the sense that there could be no predetermined destination. The "primitiveness" of which Kierkegaard had spoken asserted itself.

In his ink drawings, copiously produced in the early 1950s, Guston explored spaces that were not bound by systems of perspective but rather corresponded to the vast dislocations that occur in dreamlike mental conditions. He denuded his old forms, reducing them to their most elemental signs. He constrained them, turned them, made them rush like torrents on the white of the page, or form arabesques flowing into nowhere at the edges. In place of symbol, with its burden of memory, he found the sign—an acute contraction that is swiftly registered in relation to a whole constellation of signs. At times, the mark of his reed pen would be disembodied, seeming to fall from nowhere. At times, it would half describe some distant recall of a solid form. But always these ink drawings seemed to conjure a space in which the familiar could not long survive. This process, which Guston thought of as "dissolving form," led him naturally back to certain initial questions he had asked himself as a young painter. In Piero he had understood that composition was based on extreme attention to the location of forms in space. In painting nothing is more difficult than that. What he sought to do in this long series of drawings, in which forms are released from specific context and yet are made to subsist in a small universe created by the artist all at once on the page, was to "locate" an image. The old dialogue persists: While he was "dissolving" form, he was at the same time seeking to "locate" the traces of form in space.

Attar, 1953. Oil on canvas, 48½ x 46 in.

Attar VIII

As Guston's drawings piled up in the studio they helped immeasurably in his formulation of a new painting vocabulary. Around 1950 the last echoes of the *Porch* paintings occurred in *Red Painting*, in which deep red rectangular shapes align themselves on the picture plane in a largely vertical progression, only to be obscured and at times erased almost completely by deep red impastos laid on in irregular passages, allowing almost no recession. This airless, choked image was the last of Guston's expressions of imprisonment. Air and light and free movement suddenly became imperative, appearing in a painting that Guston regards as one of the central works of his life. During the summer of 1951 he made *White Painting*, rapidly laying on the tentative shivering forms much as he has done in his drawings. These forms traced a network of interweaving spaces that were all light and flow. The clusters of strokes establishing minute but shimmering contrasts suggested to Guston a rich vein of exploration that released him from his old commitments; they coincided with his great need for direct expression. The analytic requirements of "structure" receded; the structure would speak from within, and without mediation. The sensuous element in painting, which he had always carefully balanced against the

Red Painting, 1950. Oil on canvas, 34 x 62 1/8 in.

structural, became suddenly irresistible. This occurrence is not so unusual in the dialectic history of painting—the pure sensuous experience is always lying in wait for the painter. The weight and magic of paint itself, the mysterious felicity inherent in color, the sheer eurythmic pleasures of texturing all lie on one side of the painter's dialectic. Even the most idealistic or rationalistic painters, such as Mondrian, never completely suppressed the "other" experience. Guston entered this psychological realm with wholehearted enthusiasm. He could truly say, in those days, that he concurred with Valéry (whom he was always reading, and often quoted to others):

I believe there exists a sort of mysticism of the senses, an "Exterior Life" of a depth and intensity at least equalling those which we attribute to the inner darkness and secret illuminations of the ascetics, the Sufis, those who are concentrated on God, all those who know and practice a system of inner withdrawal, creating a whole interior life to which everyday existence can only bring obstacles, interruptions, and occasions for loss or strife—as do also all those images and means of expressing them without which the ineffable itself would be indistinguishable from nothingness. The intrusions of the sensible world are its source of supply.[1]

Guston keenly felt the intrusions of the sensible world. When he was working in Woodstock he was aware of the "forces of natural forms" and observed "sky and earth, the inert and the moving, weights

and gravities, wind through the trees, resistances and flow." He set up these basic experiences in opposition to Cage's void, thereby avoiding what he felt to be the "didactic, conceptual, and programmatic" aspects of Cage's philosophy.

In January 1952 at the Peridot Gallery Guston offered his first one-man exhibition in New York since 1945. The calligraphic lightness of these paintings was quickly perceived by other painters as an innovative mode of great promise. The silvery sparseness and the effect of vibrato were tremendously moving. The show was a significant event and, as a result, Guston joined the Egan Gallery which, at the time, was regarded as an important showplace for artists of the New York School. He was working intensely then, tacking up his canvas and working up close, not stepping back, carried by a *furor* not unrelated to the exaltation of the mystics mentioned by Valéry. From one canvas to another there was no time to lose and, for a while, Guston found blessed relief in his almost total surrender to intuitive and sensuous preoccupations. *Almost* total, for Guston's inner inquisitor can never be entirely silenced. Gradually, his old concern for articulate structure began to get the upper hand and, by the time of his 1953 exhibition at Egan, there were paintings with distinctive organization that implied structural reflection. Guston's *état d'âme* may have been wholly inspired, even intoxicated, by this new voyage into an abstract realm, but his mature, long-trained hand retained the indispensable discipline of pictorial organization.

The exhibition in 1953 was widely discussed. It set the small gallery aglow with reverberations of light that led many to talk about Guston's work in terms of "Abstract Impressionism." Guston had enriched his whites with color, chiefly rose-madder and a few ochers, oranges, and apple greens. He had worked out systems of form (grouped verticals contrasted with clusters of horizontals) in which spaces seemed to dilate from an invisible core and were made ambiguous by the almost invisible movements of the linear shapes. The organization of roughly vertical shapes, intersected by horizontals, reminded some serious viewers of Mondrian's plus-and-minus paintings—an association by no means far-fetched given Guston's mood at the time. In the art journals, Guston's new work was regarded with sympathy, although newspaper reports were hostile. A young painter, Paul Brach, wrote that the Egan exhibition was a show of affirmation rather than a denial. He saw "searching and extremely tactile brush work" used to create "an organic centripetal movement—a movement which starts at the silent white periphery of the canvas (where almost any action is a

possibility) then shifts inward to the warm grey mass (with its suggestion of a specific action), then reaches central notations of the strongest color and tension."[2] Another painter, Fairfield Porter, writing in *Art News*, sees the paintings as descendants of Cézanne's watercolors, but with less air. "Where he weaves the paint again and again the color gets pinkish and translucent, like a bit of sky from a landscape by Sisley or Pissarro. In the middle there are a few bright red or orange strands that center the weight and the color. He seems to have gone beyond Cézanne to Impressionism thereby developing what could be an essential of this style."[3]

The reference to Cézanne is apt, but those to Impressionism and Sisley are somewhat misleading. Until roughly 1954, several critics

White Painting, 1951. Oil on canvas, 57 7/8 x 61 7/8 in.

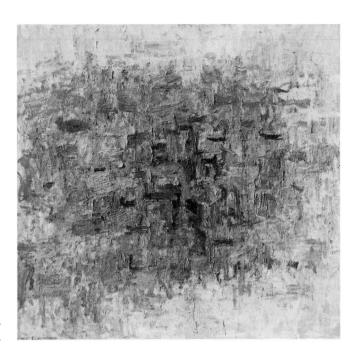

To B.W.T., 1952.
Oil on canvas, 48 x 51 in.

placed Guston more precisely in the radical perspective of the whole Abstract Expressionist movement. Lawrence Alloway noted that these "pink paintings" were works "in which, under the mask of discreet lyricism, he has been most radical, presenting paintings that are the sum of their discrete visible parts. In this structural candor he can be likened to Pollock in his open drip paintings (though not the densely textured ones)."[4] William Seitz noted that "by 1951 the individual brush stroke breaks free to become a primary pictorial element.... It is these pictures that, quite wrongly, were once said to derive from Monet. The illumination and pulsation that radiates through a fog of muted tones is more akin to the mystical light of Rembrandt than to the sunlight of Impressionism."[5] Seitz caught the mood and intention more nearly than did those who persisted in seeing a kind of abstract version of Impressionist esthetics. In the last paintings completed before the Egan show, Guston had developed his "signs"—those ghosts of real solids—in patterns that suggested Cézanne's late works. He worked close to the canvas, grouping, in vibrating units, bundles of verticals or shelves of horizontals. Just as Cézanne had made a schematic system for indicating alterations of light on surfaces, or the angle of perception, so Guston schematized his new vision of a kind of charged atmosphere. But the trembling brushstrokes, which lean to-

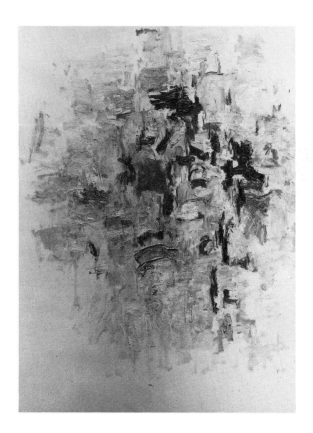

Painting No. 6, 1952.
Oil on canvas, 48¼ x 60 in.

gether in uncertain spaces, are totally different in character from the lucid observations of Cézanne. And in these, Guston harks back to the painterly tradition. He retrieves the half-tone and builds up from the putative depths of his image the slow transitions of atmosphere that always mark the Romantic painter's deepest will. Nothing could be more volatile than these delicately differentiated grays, blue-grays, ocher-grays, moving from the depth to the foreground, struggling up to visibility through, as Seitz had said, "a fog of muted tones." They are crowned, as in the painting *To B.W.T.* (dedicated to Tomlin who, arriving in the studio just as Guston was finishing the painting, had exclaimed, "That's it!"), with floating accents of orange, ocher, or sienna that bring the image forward. The latticelike configuration of stronger tones seems to gather itself into a convex pattern. This circularity of form occurs in other paintings made at around this time, suggesting Guston's desire to draw from the amorphous atmosphere the image of a self-contained universe—to create, as Flaubert had said, something that would be held together by the strength of its

style, "just as the earth, suspended in the void, depends on nothing external for its support." These paintings were to speak through the inner murmuring of near-form, of entities nearing completion but never quite distinct.

"Look at any inspired painting," Guston told a *Time* reporter in 1952. "It's like a gong sounding; it puts you in a state of reverberation."[6] After the Egan show, the gong sounded close to the ear, and the sharp address can be felt in the way Guston gathered together his forms and began to mass them in emphatic patterns. He was now fully immersed in the absorbing contest with chaos. Abstraction was an intoxicating experience. Like a glider pilot, he could not resist the silences and unknown spaces he had never known before. The rules that had once contained his imagery had fallen away. Now, everything was pitched to successive acts of discovery, and the process itself was the voyage. The brush was quick to transmit the tides of unnamed emotion, but the search, as always, was for the name, the particular form. The emphasis on process that Guston shared with his friend Feldman was described by the latter in an anecdote:

Some years ago, Guston and I made plans to have dinner together. I was to meet him at his studio. When I arrived he was painting and reluctant to leave off. "I'll take a nap," I told him. "Wake me up when you are ready."

I opened my eyes after an hour or so. He was still painting, standing almost on top of the canvas, lost in it, too close really to see it, his only reality the innate feel of the material he was using. As I awoke he made a stroke on the canvas, then turned to me, confused, almost laughing because he was confused, and said with a certain humorous helplessness, "Where is it?"[7]

Feldman, who himself was ineffably attracted to absolutes, shared with Guston in those long conversations in the studio the kinds of speculations that were coursing through Guston's imagination. When years later he sums up their long relationship, he speaks unabashedly of abstract experience, stressing it by his use of capital letters:

The sense of unease we feel when we look at a Guston painting is that we have no idea that we must now make a leap into this Abstract emotion; we look for the painting in what we think is its reality—on the canvas. Yet the penetrating thought, the unbearable creative pres-

sure inherent in the Abstract Experience reveals itself constantly as a *unified emotion.*...[8]

Guston's own thoughts, as he expressed them in the late 1950s, traveled along uncharted paths, stumbling, groping, trying to seize the essence of his adventure without losing its spontaneity. In 1958 he wrote for the artists' magazine *It Is* that "only our surprise that the unforeseen was fated, allows the arbitrary to disappear. The delights and anguish of the paradoxes on this imagined plane resist the threat of painting's reducibility."[9] He courted these delights and anguishes, he awaited their appearance with longing; and he knew that in them there came a kind of momentary resolution that could be called freedom. As he wrote in the Museum of Modern Art's catalogue for *12 Americans* in 1956, "Even as one travels in painting towards a state of 'un-freedom' where only certain things can happen, unaccountably the unknown and free must appear."

Late in 1953 Guston's statement of paradox—the sighting of boundaries between form and nonform became more emphatic. Working from painting to painting, he produced a readable vocabulary of his dialectic in which the trembling ambiguities of the atmosphere were dominated by increasingly dense forms. The transition begins with *Attar*, where the strokes are laid on thickly, forming moving units within the pinkish haze and moving upward to what could almost be an horizon. Shortly afterward he painted *Zone*, where a thicket of rose-madder strokes defined a central form, coalescing to make a complex web on the surface through which glints of a vague and slipping space can be read. The intensity with which Guston brushed on his short verticals and horizontals is heightened in *Painting*, 1954, where movement and countermovement in a cross-hatch sequence mobilize the massed forms, which seem to move diagonally upward and inward. The increasing use of impasto in these paintings of 1954 indicated Guston's growing need to work with masses to heighten his painterly approach. By 1955 he had evolved a distinctive manner of suggesting vital forms within the still-amorphous atmosphere.

The paintings of 1955 and 1956 move clearly forward toward articulate form. The hesitant, trailing calligraphic notes are reserved for the edges of his paintings, while the centers are orchestrated with increasingly dense masses of strokes. Certain, almost reflexive, movements of the brush appear from painting to painting—a twist to form a rosette, a thrust to build an arch, a series of strokes to plait the thick, scored

strokes, a commalike line to glide out into the infinite of the roseate atmosphere. Convergence becomes more important. In *Beggar's Joys* (Plate 1), the scribbles converge in an off-center totality that, by its internal interplay, suggests that it partakes of some of the uncertainty of its environment but has finally defined itself as a mass nonetheless. In *The Room*, very broad red strokes palpitate heavily while a new value is introduced: the rose underpainting is now partly obscured by broad sweeps of charcoal gray. Dense and unavoidably disturbing, these dark shapes are built into a firm network which, like the shoe in his early work, presses up against the picture plane. The whole central form, with glimpses of air behind its massed strokes, rides firmly in the glowing space; a hint of its potential for separating again is offered in a few echoes of gray and red, floating in different planes in the surround.

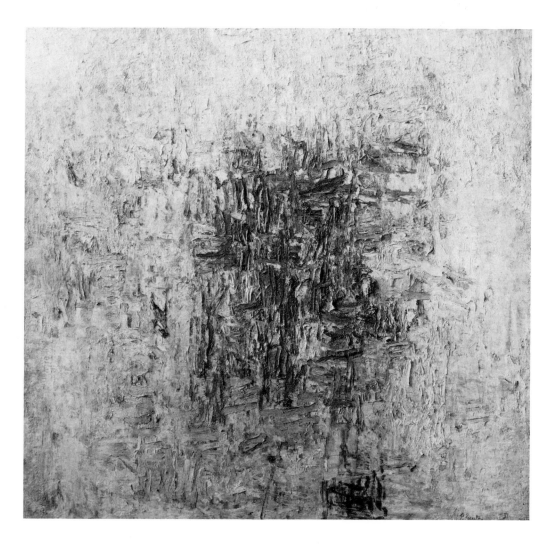

Zone, 1953-54. Oil on canvas, 46 x 48 in.

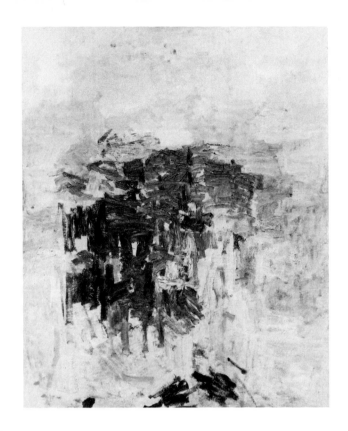

The Room, 1954-55.
Oil on canvas, 71 7/8 x 60 in.

Guston's intention of creating a complex organism of coalescing units to partake of the atmosphere and rise to a climax is best seen in *For M*, where the charcoal flourishes are very dense, emphasized by cold, whitish surroundings. A single orange accent locates this image in a place wholly resident in reveries—a place infinitely extensive and in which unexpected events can occur. The cool light here, and the suggestion of emotional shadows in the grays, herald the change of Guston's mood. From soft Venetian stage lighting he had derived a genial light that marked his early abstractions as purely lyrical. As he moved into denser color and more complex textures, the light becomes increasingly abstract and arbitrarily emphasizes an awareness of conflict.

This sense of conflict in Guston's work emerges fully in the next two or three years. A painting such as *Voyage* is not as gracious even in emotional tone. The dense balls of rose, ocher, and orange are massed into an almost impermeable sphere, where nests and pockets are unaccountably congealed to form a convex surface related to the earlier

To B.W.T. As if to make their incongruous union more emphatic, Guston leaves the four edges of the canvas white and only lightly scores the surrounding spaces with neutrals, terra-cottas, and washes of blue. Fibrous lines waver uncertainly in this atmosphere, as though they had broken away from their interlocking matrix in the center. The whole throbbing surface can be read in several sequences (for instance, there is a group of forms that seem like stepping stones to infinity, reading from bottom right to upper left), and yet the impression is finally one of mass displacing the encroaching space. The same is true of *Dial*, where even the background neutrals have thickened

For M, 1955. Oil on canvas, 76 3/8 x 72¼ in.

Voyage, 1956. Oil on canvas, 71 7/8 x 76 1/8 in.

and in which arbitrary squared blues suggest a sky that rightly belongs within other vistas of a surreal universe where associations are made to be disrupted. The move from density and volume to pure ether is not simple, and it is certainly not direct.

Guston was puzzling again and questioning. He questioned largely on the canvas, where, painting by painting, suggestive shapes began to reappear. A crutch here, the memory of a wing, or a root, or the oval of a head emerged as he painted. He was forced, almost in spite of himself, to reconsider his assumptions. The title of a 1956–57 painting, *Fable*, indicates the drift of his thoughts. The evocation of atmosphere was no longer his primary need. Now he works again to suggest drama, with its cast of characters and its "parallel" potency. Strong orange and green accents appear, as well as shapes that lie on the threshold of meaning. The blue is a blue of full daylight, unal-

tered. These lusty scrawls show Guston's confidence that the abstract forms springing from his imagination would be significant.

He had been turning over in his mind the problem of the "loss of the object" in modern painting, and he needed to reintroduce not objects themselves, but the sense of objectness. Diffuseness—an abstract quality—had been the subject of almost two years' work. Now, corporeality was to take its place. Not totally, of course, since it could be expressed only through the existence of its opposite, amorphousness. Small details, interspersed at various levels in the imaginary space he created, served to make the contrast acute. Guston was, for all his enthusiasm and spontaneity, always very attentive to detail. Wholeness of mood was his final goal. If we remember how moved he had been in St. Louis when he first heard the late Beethoven quartets, it is not difficult to find a truth in Morton Feldman's assessment of the particular nature of Guston's abstraction at the time: "In Beethoven," he wrote, "we don't know where the passage begins, and where it

Fable I, 1956-57. Oil on canvas, 64 7/8 x 76 in.

ends; we don't know we are in a passage. His motifs are often so brief, of such short duration that they disappear almost immediately into the larger idea. The overall experience of the whole composition becomes the passage."[10]

The "overall experience" was to remain Guston's pronounced goal during the next few years, but, as in the late Beethoven, it was to be fraught with hints of *agon*. Brief intrusions of extreme anxiety can be increasingly sensed. Agitation disrupts, darkness erupts. There are works still in a light key or a lyrical, melancholy mood, but there are others in which the reverberations are staccato, sometimes even harsh.

The restlessness that overtook Guston again in 1957 is evident in

Beggar's Joys, 1954-55. Oil on canvas, 71 7/8 x 68 1/8 in.

Willem de Kooning, 1955.
Ink on paper, 10½ x 8½ in.

Painter's City (Plate 2), where there is a profusion of interrupted solids with channels leading out of the centered morass. Here turbid massed forms announce a direction he was soon to pursue almost exclusively. But before he became totally absorbed, he painted *The Clock*, with a tremendous vibrato resounding in the charged atmosphere, and *Natives' Return*, with gay, bright blue accents, and *Passage*, its surface awash with long, loping strokes that seem laden with moisture. Then in 1958, in *To Fellini*, he remembers *Painter's City* again. *To Fellini* (he chose the title after one of his mind-clearing expeditions to the movies) is "packed," as he once said Beckmann's paintings were. The image does not huddle in a central site, but spreads aggressively from corner to corner, its darkish passages moving restlessly in every direction. Small details lead the eye into ambushes and dead ends, as large forces spread ominously. Lavish, free brushstrokes escape from the pack, only to be scraped down to thin memories by the excited painter. This is a mazelike mass of directions in which something of the suffocating anxiety of the late 1940s begins to reappear. *Painter's City*, which existed in a middle-ground, where

paths of escape were clearly marked, is here transformed into a place where agitated forms cannot discharge their energy except within their tenuous constellation, and in which they struggle forward, living in a foreground that conceals unnamed experiences beneath.

There is a sense of crisis in Guston's works that follow this period. Crisis in its basic etymology implies separation and carries with it an implication of things straining away from each other. Around 1956 Guston's outward life as a painter improved. In the fall of 1955 he had joined, along with other major painters in New York—Franz Kline, de Kooning, Rothko, Pollock, and later Motherwell—the Sidney Janis Gallery, where he was to show regularly until 1961. His paintings were bought. He had a good studio on 18th Street. Yet his inner life was more turbulent than ever. The far reaches of abstraction into which he had hurled all his emotional energies were beginning to seem too rarefied; the ether was too thin. But the sense of amplitude that his increasingly wild inventions provided filled him with exhilaration. The very matter of paint itself took on qualities he found irre-

Franz Kline, 1955.
Ink on paper,
10½ x 8½ in.

To Fellini, 1958. Oil on canvas, 69 x 74 in.

sistible. But nagging at the center of his imagination was the still unformulated anxiety that as a painter he had somehow transgressed. He began to muse about angelism and the whole history of Romantic art. Sometimes he would speak of the classical myths in which feats of transformation were performed, as when Galatea turned her crushed lover into a flowing river. "There is an ancient taboo against an artist's trying to make a living thing," he said, adding that the artist is some-

thing of a demigod, perpetually condemned. "I feel I have made a Golem." The old injunctions against such Promethean activities could not be easily disposed of. Guston looked again at the works of Expressionist painters. He thought about Chaim Soutine, who "was trying to wrest life from his images, to make living things," and felt a deep sympathy with him. But also resistance. It became increasingly clear that the choices Guston had to make lay somewhere in the no-man's land between two kinds of painting he discerned in history, that based on pain and that based on beauty and pleasure. Poussin, he said, didn't give a damn about subjects. Between a Rembrandt and a Poussin lay

Painter I, 1959. Oil on canvas, 65 x 69 in.

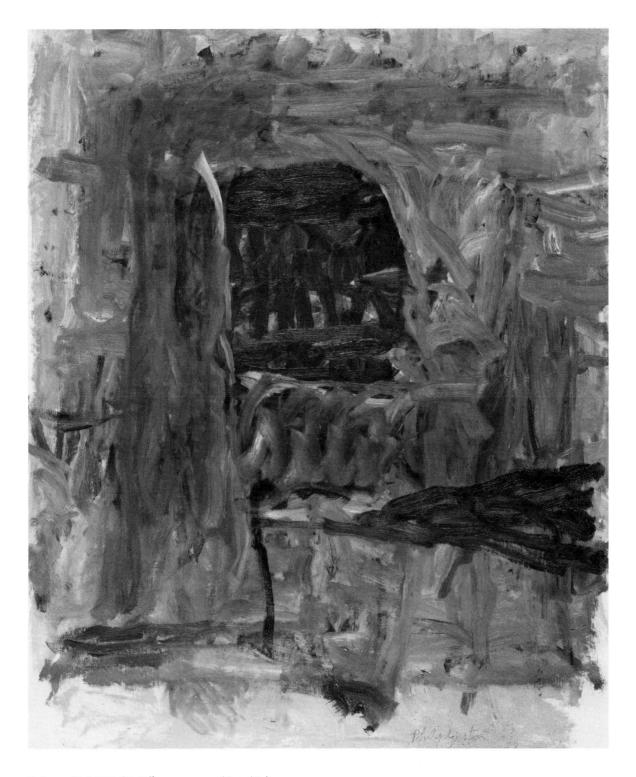

Painter II, 1959-60. Oil on canvas, 49 x 47 in.

conflict and the path of his own crisis. On the one hand, as he exclaimed in 1958, "corporeality is what art seeks" and, on the other, he saw forms in a perpetual state of metamorphosis, dissolving constantly in their peregrinations.

The mounting crisis in Guston's attitudes toward his work was announced in the work itself before he was even aware of it. At the same time that he was wrestling with the "packed" and hectic large-scale paintings, he was making a group of small oils and gouaches in which a very few forms of highly suggestive character are brought up very close to the picture plane. Squarish black shapes formed by closely adhering strokes loom up and occupy a space that is dense, corporeal, and no longer suggestive of infinity. The curious shapes that had once come forth from his reed pen in a whole lexicon of small signs reappear greatly magnified and begin to assume a corporeality and "thingness" that shifts the focus of Guston's work. A small, simple gouache such as *Actor* startles the eye with its curious central mushrooming volume, propped up incongruously by another leglike form. Hints of the later satiric impulse recur regularly in 1958 and 1959, particularly in the small works.

Guston's shift in emphasis is seen even in the titles, which began to focus on the protagonist. His old question, "if this be not I," is now

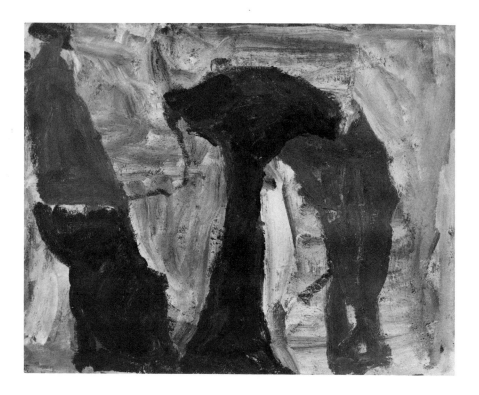

118 *Actor*, 1958. Gouache on paper, 22 5/8 x 28 5/8 in.

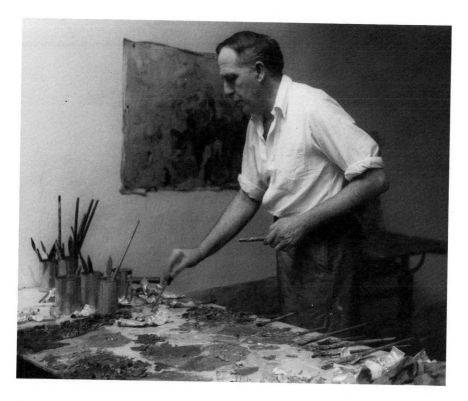

Guston in his loft on 18th Street, New York City, 1957. (Arthur Swoger)

posed in frankly subjective terms, and the "actor" or the "poet" or the "painter" is the innermost mystery that the quickness of his brush hopes to reveal. In *Poet*, his brush traces the nervous rhythms of an artist's existence and conjures strange shapes that collide, depart, and tear away from a ground no longer gently ethereal but turbidly intermingled with the chaotic forms themselves. The precarious balances suggest not an association with the movement of a poet's imagination but a homologue of the imagination itself. A Golem perhaps. An acute feeling of separation seeps into the painting, which is held together by the most tenuous of washy strokes, and the most hesitant tonal relations. Precariousness is still more evident in *Painter I* of 1959. Not even the black central forms exist in a state of equilibrium; they teeter on their axes and are curiously hedged by neighboring shapes that cleave to their edges like barnacles. Except for a glimpse or two of bare canvas, a marshy tangle of long, dirtied strokes, the "events" in this portrayal of an alienated artist are inchoate. Struggle and disquietude prevail.

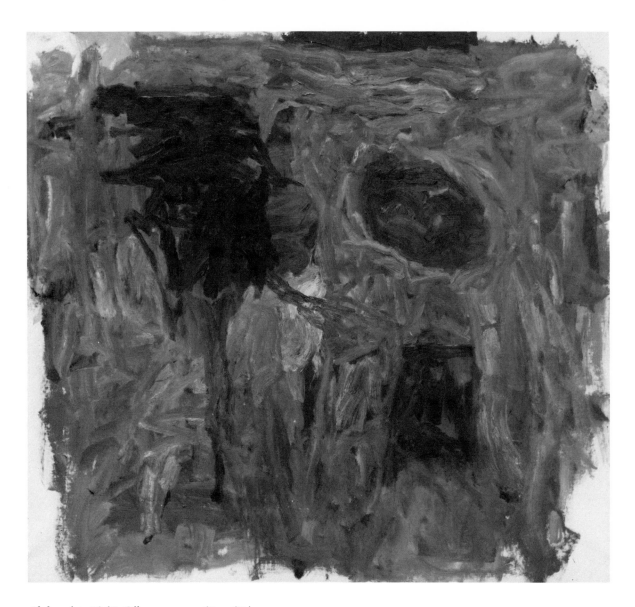

Alchemist, 1960. Oil on canvas, 61 x 67 in.

Alchemist IX

The search now for a vision of the nature of creativity and the question—what, finally, is an artist?—became Guston's obsession. Pushing matter around on his canvas, thinning it, shaping it, and twisting it, while groping for the most precise expression of his *état d'âme*, had brought him up short before the very questions he had posed to himself as a youth—those metaphysical preoccupations that Melancholia seemed to summarize. Since matter and form assumed a life of their own as soon as they were deployed on his canvas, Guston's suspicion that he could create a parallel universe had a certain justness. But, since his imagination could not be braked once the forms were there, transpiring in the total environment he had created almost without thinking, the old dichotomy between the structured mental exercise called thinking and his intuitive participation in natural processes rose sharply in his consciousness. His reading now served to elucidate the confused accumulation of insights the abstract experience had brought him. He began to search among the philosophers, particularly those who brought a scientific background to their speculations. In 1960 he remarked how much he was struck with Einstein's statement that, at the end, he had discovered the universe to be contentless. "Density is man's

invention," Einstein had concluded. Such density was all too familiar to Guston. The question for him was, and remains, the evaluation of the possibilities of man's inventive imagination. Was he, in fact, creating images of the functioning of the emotions? Was he making a homologue for the whole complex of human experiences groups under such abstract categories as tragedy and comedy? Where was the dividing line between "man's invention" and the contentless universe? In his countless returns to Kierkegaard, Guston found his questions amplified. Kierkegaard and Kafka were his constant goads. But in other writers he found temporary solace. For a while he had been inspired by Teilhard de Chardin's *The Phenomenon of Man*. Teilhard's approach to the question of consciousness was consonant with Valéry's and yet it opened out beyond the isolated problem of the individual. For Guston, it must have been a source of excitement to find, even in Teilhard's diction, a reflection of his own intuitive discoveries on canvas. Teilhard, in outlining the evolutionary process, speaks of the "ramifications of the living mass," saying that considered as a whole, the advances of life go hand in hand with segmentation. "As life expands, it splits spontaneously into large, natural, hierarchical units. It *ramifies*." He goes on to speak of "aggregates of growth," and in his explanation seems almost to be describing one of Guston's paintings:

Let us return to the living element in the process of reproduction and multiplication. From this element, taken as a centre, we have seen different lines radiating orthogenetically, each recognizable by the accentuation of certain characters. By their construction these lines diverge and tend to separate. Yet, so far, we have no reason to suppose that they may not meet with other lines radiating from neighboring elements, become enmeshed with them and so form an impenetrable network.[1]

Ramifications (those splitting movements in Guston's heavy, loosely plaited forms), convergences, aggregations—all these had appeared quite spontaneously in the artist's evolution as an abstract painter. Teilhard's speculations on the implications of evolution were even more exciting. He recognized the distinctive nature of modernity. "What makes the world in which we live specifically modern is our discovery in it and around it of evolution. And I can now add that what disconcerts the modern world at its very roots is not being sure, and not seeing how it ever could be sure, that there is an outcome—*a*

suitable outcome—to that evolution." He then makes an audacious leap which, in retrospect, seemed to Guston to be the essential one. He suggests that man, contrary to Darwin's hypothesis, is as yet unfinished, that man's capacity for thought is yet to be fulfilled. Guston was struck by the idea of the continuing evolution of man. "Teilhard talks about what a great leap it must have been when man started becoming fully conscious of his actions and *judging* them—to be conscious that you're conscious is an evolutionary process that leads to new content in art. It has to." Such speculations, expressed in other terms by Valéry in *Monsieur Teste*, and in *La Jeune Parque* where he says "I saw me seeing myself," accompanied Guston daily during the years leading up to his large retrospective exhibition at the Guggenheim Museum in 1962. They continued to trouble him until the late 1960s.

His concern with the aboriginal impulse to art was readily related to the tendency during the 1950s and early 1960s to see painting in terms of process or, as Harold Rosenberg said, "action." The cultivation of anxiety as a method of artistic discourse was practiced by many in various arts. Guston himself began an article on Piero with the sentence: "A certain anxiety persists in the painting of Piero della Francesca," and, echoing Valéry, added: "What we see is the wonder of what it is that is being seen. Perhaps it is the anxiety of painting itself."[2] Years later, his closest intellectual companion of those years, Morton Feldman, wrote an essay entitled "The Anxiety of Art," speaking of it as "a special condition" that comes about "when art becomes separate from what we know, when it speaks from its own emotion."[3] The poet Robert Creeley, writing about Guston's work as early as 1956, spoke of "care" in its old Anglo-Saxon connotation of sorrow and anxiety.

I think—in that denseness of anxieties, and sorrows, like a nightmare world, of forms which are all exact and there, yet *not* the forms? What *are* the forms, one says. It is not possible that one should not arrive at them. Somehow not to be accidental, not even enough or too much "accidental." No one understands, but some know. It is a very articulate determination which can, at last "...take care by the throat & throttle it..." with such care.[4]

Far more familiar with "care" in its long literary tradition was the poet Stanley Kunitz, with whom Guston shared many affinities. Since the mid-1950s Kunitz has maintained relationships with many artists,

among them Franz Kline, Mark Rothko, Giorgio Cavallon, and Adja Yunkers. At his home on West 12th Street, and often at the home of Yunkers, long conversations wound around themes in Kunitz's poetry that were often the themes of deepest consequence to the painters. Guston found his conversations with Kunitz inspiring. They shared a passion for the poetry of William Butler Yeats and Gerard Manley Hopkins. They sought to refine their views of form and meaning in both poetry and painting. Kunitz's poetry reflected his preoccupation with the cosmic motifs long held sacred in the Romantic tradition. The reverberations of history in Kunitz's work, and his reverence for the mythic, found a deep response in the painter who was struggling to wrest form from chaos, and to mitigate the terror, so deeply ingrained in the human psyche, of unform.

On another level, Guston found a companionable element in Kunitz's work that few other American poets shared: the element of irony. Kunitz could invoke the great tradition of Rimbaud (as when the American poet begins "Journal for My Daughter" with the line: "Your turn. Grass of confusion," recalling Rimbaud's "Illumination" beginning "*A moi*"). He could remember Apollinaire and Baudelaire and Blake and Coleridge. But he could also slash through to the present with trenchant ironic diction as when he begins "After the Last Dynasty":

> Reading in Li Po
> how "the peach blossom follows the water"
> I keep thinking of you
> because you were so much like
> Chairman Mao. . . .[5]

Still, it was the Yeats-like echo of ancient tragic wisdom in Kunitz's work that probably nourished Guston most during those difficult years of the late 1950s and early 1960s, the voice that spoke of "care":

> Within the city of the burning cloud,
> Dragging my life behind me in a sack,
> Naked I prowl, scourged by the black
> Temptation of the blood grown proud. . . .[6]

For Guston the master of anxiety was still Kafka, and he gradually defined for himself what it was that so enthralled him in that writer. It was Kafka's ability to create a world parallel to our own—"parallel,

124

Stanley Kunitz, 1955. Pencil on paper, 10½ x 8½ in.

but not this world," as Guston emphasizes. "Fantasy would be something else." Guston read Kafka as Kafka read others, and even cited Kafka's own statement on reading in an interview with another of his close literary friends, the poet Bill Berkson:

The books we need are of the kind that act upon us like a misfortune, that make us suffer like the death of someone we loved more than ourselves, that make us feel as if we were on the verge of suicide or lost in a forest remote from all human adaptation. A book should serve as an axe for the frozen sea within us.[7]

A deep preoccupation with Kafka is reflected in Guston's way of posing to himself the nature of the activity in which he engages. In an

Drawing, 1960. Ink on paper, 18¾ x 23 7/8 in.

article he wrote entitled "Faith, Hope, and Impossibility," he adopts the metaphor of judgment again: "The canvas is a court where the artist is prosecutor, defendant, jury, and judge. Art without a trial disappears at a glance. It is too primitive or hopeful, or mere notions, or simply startling, or just another means to make life bearable."[8] The attenuated trial Guston describes was fully underway by 1960 when he revisited his visual sources in Italy. He cross-examined himself mercilessly, accusing himself and his peers of "hiding" from the implications of the third dimension, and he ransacked his store of visual images for justifications. Once again he challenged his premises, and began the long, inevitable, but not necessarily conscious, alteration of his approach. A disaffection appears in the work that followed his return from Europe. It appeared in the forms even before his mind was aware of it. Kafka had said that truth is the mountain, the rock, the blade of grass, but man is always masked "without knowing or

desiring it." Guston knows, has always known, but he defies the judgment. In the fall of 1960 he was deep at work, rephrasing, shifting. He spoke of "the last mask" and of how close he was to tearing it away. (James Ensor, whose rusty orange, pale watery blue, and scarlet palette is similar to Guston's, had once written in pencil on an etching, "*Ensor, l'arracheur des masques*.") Guston demanded of himself: Why is it that I can't paint the *real* object? He slipped into reveries in which the tormented paint coalesced into simple forms: cups, cans, jars, heads. Long trailing verticals became hints of the strings and

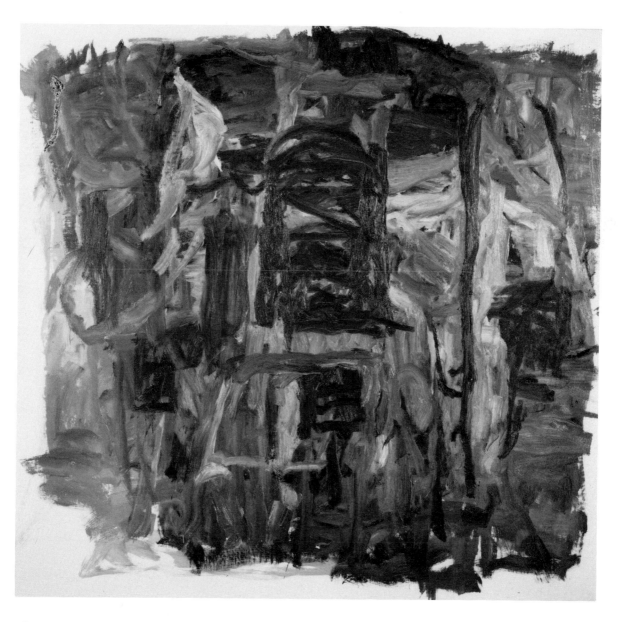

Close-Up III, 1961. Oil on canvas, 70 x 72 in.

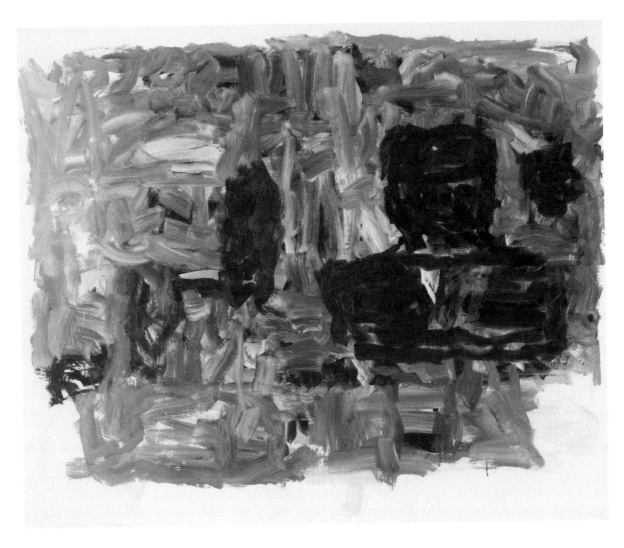

Looking, 1964. Oil on canvas, 67 7/8 x 80 in.

dangling ropes that constituted the theater of earlier dreams. The unmasking process was gradually pulling him back to sensations and visions that had once been uppermost in his imagination.

He set the stage in *Alchemist*, a mass of tangled, darkened strokes engulfing densities struggling to be forms. The blue ball, uneasily ensconced in a nest of kneaded strokes, grows almost into a head (or boulder?) while to its left is a form that could be a winged chariot or the tottering shape of a saltimbanque. It cannot be exactly known what these protagonists are up to yet, but a gathering storm of an-

thropomorphized activity is clearly developing in this and subsequent paintings of the early 1960s. The light darkens. There are rusty oranges, dark reds, many shades of gray. Guston lived in a blustery atmosphere at this time, preparing for his first major retrospective exhibition—at the Guggenheim Museum in the spring of 1962—where he saw for the first time the complete range of his work up until that moment. In several works entitled *Painter*, he has images of himself, usually as a clump of dark strokes—head?—buffeted by the seething environment. He moves ever closer to his canvas, painting furiously and building his surface. He is enacting. There is a painting called *The Tale*, and one called *Close-Up III*. Both propose new structures and a staged atmosphere. They are cast in a silvery light, oblique, with just a few highlights of rusty orange or apple green. The activities of the strokes are designed to weave themselves into semblances. A strange shape that can be read as a great masked head or as a

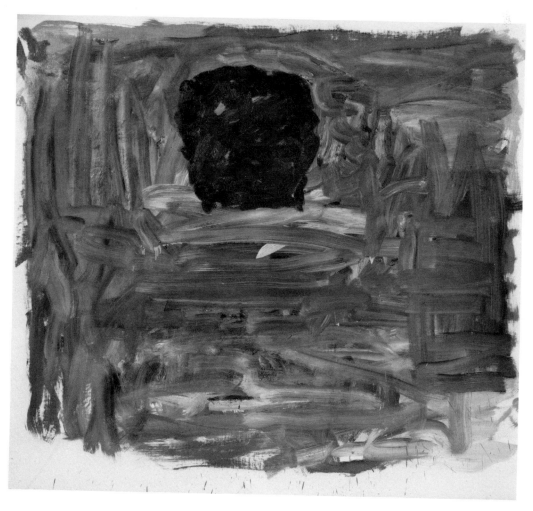

Air II, 1965. Oil on canvas, 69 x 78 in.

Harold Rosenberg, 1955.
Pencil on paper, 10½ x 8½ in.

cupola predominates in both paintings, and barely survives the onslaught of the loping interwoven strokes. There is no stasis here, and only a few hints left of the empyrean that once illuminated his abstractions. Within months, even the warm glimpses of sky blue disappear. Forms become fewer and denser, hanging together in clumps of two or three, in a closely woven matrix (literally woven, for, as Guston concedes, he was obsessed with his brushstrokes at that moment) that barely supports them. They are writhing masses of thick black strokes, congealed by their own weight, but they are somehow entrapped in the encroaching silvered network.

Guston had found another plane of feeling, as one of his titles, *New Place*, suggests, and by 1965 when he was painting his most hermetic abstractions, he was calling them by elemental names like *Looking*, *Path*, or *Air*. At the same time, the smaller gouaches were taking on the character of things, reflecting his many exercises drawn in India

ink during the mid-1960s. These drawings are memories of still lifes or heads, and they freely extrapolate on the ambiguous character of form in space. Traces of his old caricatural line appear more frequently, wavering but inexorable. Analogies to stones, heads, cups, and fruits are suggested, played upon sometimes with outright humor, sometimes with a touch of savagery. Brooding, disquieting forms emerge in the gouaches, on the verge of metamorphosis.

Throughout the period of the gray paintings following the Guggenheim exhibition, Guston worked with increasing momentum, seizing upon whatever means he could to encompass the full range of his feelings. Since his feelings seemed always in a state of emerging, he worked from image to image, trapping now one state of mind, now another. The throbbing, heaving surfaces often mirrored both thought and thing instantaneously, in a way that many viewers found difficult to understand. But that is because the nature of feeling is so thoughtlessly consigned to pure subjectivity. If feeling were perceived to be, as Susanne Langer has pointed out, *anything* that may be felt, "the felt responses of our sense organs to the environment, of our proprioceptive mechanisms to internal changes, and of the organism as a whole to its situation as a whole,"[9] it would not be difficult to understand the flow from thought to feeling and back in a painter's work. Feeling, Langer says, seems to be the generic basis of all experience— sensation, emotion, imagination, recollection, and reasoning. Some experiences, it follows, are *felt as thought*. It is in this complicated realm that Guston navigated with such intense excitement; in these paintings he discovered avenues to feelings of anguish, humor, tragedy, comedy. Thoughts are felt as situations of comic despair or of tragic levity. Huge doses of paradox, in which things felt as unformed were juxtaposed with things felt as volumes, overwhelmed him.

The direction of Guston's "thoughts" emerged in a dialogue with Harold Rosenberg held in 1966 and published as an introduction to his large one-man exhibition at the Jewish Museum in January 1966. (Since the late 1950s, and continuing to this day, Guston and Rosenberg have explored areas of mutual interest in lengthy discussions, often leading to published statements. Rosenberg was one of those close intellectual companions on whose responses Guston greatly depended over the years.) Guston still held to the notion of process: "To preconceive an image or even to dwell on an image, and then to go ahead and paint it is an impossibility for me . . . it's intolerable—and also irrelevant—because it's too abstract. By that I mean that it's simply and only recognizable. The artist had a thought and then pro-

ceeded to paint the thought." He went on to cite a phrase from Valéry that he had often mentioned before: "A bad poem is one that vanishes into meaning." The trouble with recognizable art, he said, is that it excludes too much. "I want my work to include more. And 'more' also comprises one's doubts about the object, plus the problem, the dilemma, of recognizing it." Still adhering to traditional Romantic views of the detachment of the work from the personality of the artist, Guston mentions the Other (Rimbaud's "I is another" was firmly lodged in the imaginations of many painters of Guston's generation.):

There is the canvas and there is you. There is also something else, a third thing. In the beginning it's a dialogue—between you and the surface. As you work, you think and you do. In my way of working, I work to eliminate the distance or the time between my thinking and doing. Then there comes a point of existing for a long time in a negative state, when you are willing to eliminate things that have been looking good all the time: you have as a measure—and once you've experienced it, nothing less will satisfy you—that some other being or force is commanding you: only *this* shall you, can you accept at this moment.

Later in the dialogue, he comes back to the Other:

I know that my saying that the Other does it can easily be misinterpreted as a kind of subjective self-indulgence. Yet paradoxical as it may sound, the more subjective you become, you also become, in those moments, more critical, hence more objective. There is done a work which is recognized by yourself at some point as a separate organism.

The notion of the "separate organism" was not new for Guston, who had always striven, even in his most "objective" works, for a totality that could, as he says, live its own life. What was new in this discourse was his emphasis on displacement and ambiguity—his need to create a separate organism that was a container for such a multitude of experiences, thoughts, emotions, and yet could be returned to the basic problems of the painter: how to describe and locate form on the plane surface. Guston saw in his own work, as he told Rosenberg, certain definite characteristics:

. . . in the last years there's been, obviously, no color. Simply black and white or gray and white, gray and black. I did this very deliber-

ately, and I'll tell you why. Painting became more crucial to me. By "crucial" I mean that the only measure now was precisely to see whether it was really possible to achieve—to make this voyage, this adventure and to arrive at this release that we have been talking about without any seductive aids like color, for example. Now I've become involved in images and the location of those images, usually a single form, or a few forms. It becomes more important to me to simply locate the form. . . . But this form has to emerge, to grow, out of the working of it, so there's a paradox. I like a form against a background —I mean, simply empty space—but the paradox is that the form must emerge from this background. It's not just executed there. You are trying to bring your forces, so to speak, to converge all at once into some point.

This convergence of forces, which had become the central problem for him by 1966, had been evident in his work for several years and had been recognized by a few perceptive critics writing at the time of the Guggenheim exhibition. (The daily press, as usual, had not been enthusiastic.) By the time Guston had his Jewish Museum exhibition the climate in New York had changed. There was a new generation who favored "hard-edged" paint application and a host of critics who were tired of the conundrums of highly personal Abstract Expressionism, of which Guston was one of the most arcane exponents. One of the strongest attacks came from Hilton Kramer, critic for *The New York Times*, who wrote of the Jewish Museum show that Guston's style was "genteel," but that "a painter so limited in range of feeling, who restricts himself so severely to slender and much repeated vocabulary is not an ideal candidate for an exhibition of the sort currently installed." He insisted that the show was "an attempt to re-inflate a reputation that has admittedly grown a little flat in the op-pop hurly-burly of the sixties."[10] Kramer's hostility, directed at almost all the painters of the New York School, reflected a mood of irritation that had crept into the art world in the mid-1960s. A hunger for the immediate, stimulated by the enormous increase in marketplace activity, was answered by younger artists who shunned the notion of slow emergence and frankly abhorred the psychological foundation of Guston's art. Guston was not alone in keenly feeling the shift in values. In a taped interview in the spring of 1966, he spoke of how isolated he felt because his contemporaries had either died (Pollock, Kline, Baziotes) or scattered. "Rothko thought too that the smoke that existed ten years ago was a false situation; that this is the *real* situation."[11]

If the subtleties of Guston's abstractions of the early 1960s had merely irritated the American critics, they assumed considerable significance for most British critics who had seen a large part of the Guggenheim exhibition at the Whitechapel Gallery in London early in 1963. David Sylvester praised Guston's ability to encompass both exquisite gradations and violent juxtapositions in a single painting. He recognized that "a Guston is a fragment of a world apart," and that the paintings "are intensely withdrawn and private, with the privacy of the dark not of the ivory tower." Best of all, Sylvester accurately identified the character of Guston's painterly meditation: "What matters is that these paintings are palpably about a man's struggle with himself and reflect its reality and urgency...the more recent works (which seem to me the finest) are so packed with doubts and denials as to have gone far beyond the brink of what we think of as coherence...."[12] John Russell, writing in the London *Sunday Times*, sympathized with Guston's situation: "Guston is now in a position in which every move he makes is scrutinised, dissected, and where possible held up to ridicule. This is always an unpleasant position, and it is espe-

Drawing, 1966. Ink on paper, 18 x 23 in.

cially so in the case of one who is essentially a scrupulous and introspective artist."[13]

Russell's observation about ridicule was accurate enough. The very works in which Guston found the means for continuing—those paintings which had, as Sylvester said, gone beyond the brink of coherence—were the paintings that most mystified and angered critics who above all instinctively mistrusted the elements—not quite apparent as yet—of self-irony. The bobbing headlike forms and the teetering balances of the last paintings in the Jewish Museum show were an announcement of Guston's future works. The comic, the grotesque, and the ironic were waiting in the wings of Guston's drama, just as they had done in previous periods of his life. Those drunken shapes, shambling through the large paintings or sitting incongruously in the midst of nowhere in the small gouaches, were the prototypes of later, frankly satirical works. And they themselves had prototypes in Guston's earlier work both as a caricaturist and as a respondent to the scandal of human savagery in the twentieth century.

Inside Out, 1970. Ink on paper, 18 x 24 in.

Inside Out X

There was always a tendency to caricature in Guston's drawing, which departed freely from mimetic description in order to stress the character of the action in his compositions. Caricature is at its best a *characterizing* gesture. If the objects staggering to the fore in disguise in the last abstractions were not precisely identifiable in their lineaments, they could be sensed in the character of Guston's line. His characterizations of cups, heads, and even figures, can be read in the massed brushstrokes and identified. As they emerge more and more insistently, these inhabitants of Guston's "other" world partake of the grotesque.

The shift from the lyrical to the grotesque is always potential in Guston's oeuvre and, in this, he belongs to a substantial family in the history of art that knew both impulses (the most obvious being the Spanish painters Velázquez and Goya). The grotesque was within his painting culture, built from the foundations of the early Italian Renaissance, and the word itself, as Wolfgang Kayser tells us, derives from the Italian word *grotta*, or cave, because the grotesque as a style was discovered during fifteenth-century excavations. Vasari had quoted Vitruvius's *De architectura*, in which the contemporary of Augustus characterizes and condemns the new barbarian manner:

All these motifs taken from reality are now rejected by an unreasonable fashion. For our contemporary artists decorate the walls with monstrous forms rather than reproducing clear images of the familiar world. Instead of columns they paint fluted stems with oddly shaped leaves and volutes, and instead of pediments arabesques, the same with candelabra and painted educules, on the pediments of which grow dainty flowers unrolling out of roots and topped, without rhyme or reason by figurines. The little stems, finally, support half-figures of human or animal heads. Such things, however, never existed, do not now exist, and shall never come into being. . . .[1]

Kayser finds that the most influential ornamental grotesques were the ones Raphael applied to the pillars of the Papal loggias, in which "slender vertical lines . . . are made to support either masks or candelabra or temples, thereby negating the law of statics." The novelty, he says, consists "not in the fact that, in contrast with the abstract ornamental style, Raphael painted objects from the familiar world (for ornamental combinations of stylized flowers, leaves, and animals had long been used by artists like Ghiberti and his followers) but rather in the circumstance that in this world the natural order of things has been subverted."

This "subversion" is at the heart of the esthetic of the grotesque, which the Italians referred to quite naturally as *sogni dei pittori*. Painters' dreams are very often peopled with objects and creatures that defy the natural order. The transmigrations and transmogrifications that occur in outright artists of the grotesque are always latent in other artists, for metaphor partakes of such distillations. As Dürer said, "If a person wants to create the stuff that dreams are made of, let him freely mix all sorts of creatures." But, in another sense, if a person wants to create stuff that reality is made of, he very often must have recourse to the grotesque with its ominous displacements and its affinity for the absurd.

Guston's interest in the grotesque had appeared early in his life. It embraced the Renaissance metamorphoses so sharply prefigured in Dante, as well as eighteenth- and nineteenth-century visions from the *commedia dell'arte*, and the Surrealist extensions and eccentric phenomena of the twentieth century. In Guston's earlier work, there were identifiable allusions to eighteenth-century conceptions of the *commedia dell'arte*, in which, as Diderot pointed out, physical actions and gestures carry the burden of meaning. The figures in Guston's paint-

ings of the 1940s wear the half-masks of Harlequin, Pantalone, and Columbine. They are caught in moments of arrested motion, just as Watteau had caught his Gilles. In Guston's subsequent reprises of the harlequin theme, there are hints of stylized gesture that relate to Venetian *commedia dell'arte* portrayals, particularly those of the Tiepolos. In the later Venetian paintings the physical actions and exaggerated gestures of the actors are always orchestrated, as in real performances. If Pantalone stumbles, Harlequin glides—no matter how richly diverse the characteristic gestures may be, they are designed to be answering gestures. Meanings are drawn from the specific movements performed by the actors. Such movements, traced for years by a hand that feels the urge to caricature, naturally form themselves even in the rarefied atmosphere of Guston's abstractions. It is always the context—the interrelation of forms in bizarre or conflicting action— that establishes the nature of the grotesque.

During the nineteenth century the grotesque as a style won adherents among the Romantic poets, who saw an adequate mode of portraying the "modern" sensibility by the use of everyday subjects in bizarre contexts. The tragic saltimbanque emerged, with his aspects of absurdity and shades of comic ridiculousness. Much thought was given to the demonic urge that leads to ambiguous laughter, and poets and painters alike produced *capriccios* that carried the dark side of the grotesque into a superficially lighthearted motif. The extent of their preoccupation with the grotesque can be judged by Baudelaire's constant return to the subject. His attempts to define caricature in "On the Essence of Laughter," and in his writings on Goya and Daumier, range wide and allow for the larger interpretation that has shadowed twentieth-century art. Baudelaire understood the distinctiness of the comic and the grotesque: "From the artistic point of view, the comic is an imitation: the grotesque a creation . . . laughter caused by the grotesque has something profound, primitive, axiomatic. . . ." And going still further in his analysis of the "modern" spirit in Goya, he wrote, "I mean a love of the ungraspable, a feeling for violent contrasts, for the blank horrors of nature and for human countenances weirdly animalized by circumstances."[2]

Laughter caused by the grotesque, as he said, has something profound about it, and many artists have understood the world in terms of a finally absurd puppet play, a Punch-and-Judy spectacle in which forces of stupidity and violence work mysteriously. The world as a puppet play is one side of the grotesque vision, and there is a liberal

amount of Punch-and-Judy battering and senseless activity in the dark abstractions Guston produced in the mid-1960s. Even Kafka can easily be seen in the tradition of the German grotesque. The forces that subdue K. in *The Castle* are never clearly identified, but they exist and are sometimes darkly comic. All the characters in Count West-West's domain keep telling K. he does not seem to understand their language, and yet their language seems to be structured like his own. Unaccountably, it is the surveyor K. who is disturbing a natural order, but that order, from his and our points of view, is so unnatural as to verge on the grotesque. The sinister side emerges not in the homely little scenes in the inn, nor in K.'s visits to various stuffy domiciles, but in the gradual unmanning of K. He who was a proud land surveyor—a man with a place in a logically ordered world—is reduced to the ridiculous position of being the janitor of a country school, and inexorably the "forces" push him into more and more hopelessly blundering acts. Yet, as Baudelaire had noticed, while mediocre caricature is nothing but "an immense gallery of anecdote," the true grotesque contains a mysterious, lasting, eternal element. It is this element that appears in all of Kafka's stories and which had attracted Guston with such force from the start. The "subversion" of Joseph K. and K. and the Country Doctor represents the Faustian quest, which, no matter how much it is disguised in masquerades, slapstick, and absurdity, remains a serious and inescapable matter.

But there are other sources closer to home, and one of them, Nathanael West, Guston had met casually in his youth in Los Angeles and had recognized as a spiritual confrère. In the fall of 1960 Guston had been thinking again about West, who "saw the grotesque mass as it was but preserved his compassion." As a young boy, Guston had already registered the impressions of Los Angeles that West was to epitomize in *The Day of the Locust*, and he had thrived on the same literary sources (Pound, Joyce, Eliot, and above all Flaubert). He had, through his love for de Chirico, brushed past the precincts of Surrealism, while West had invaded the Surrealist visual arts to draw out his own motifs. The epigraph for his first novel, *The Dream Life of Balso Snell*, published in 1930, was to have been a quotation from the artist Kurt Schwitters: "*Tout ce que l'artiste crache, c'est l'art*" (everything the artist spits out is art). And, like Guston, West's first works were partly inspired by his contact with the visions of Max Ernst. West's attraction to Surrealism, like Guston's, was only partial, for his conflict of choices—between the fine estheticism of Flaubert and the rowdy mocking of the Surrealists—was organic and necessary to

(Denise Hare)

his style. West's early vision of his own work, as reflected in the advertising copy he himself wrote for his first book, showed that he wished to be a part of the movement:

In his use of the violently disassociated, the dehumanized marvellous, the deliberately criminal and imbecilic, he is much like Guillaume Apollinaire, Jarry, Ribemont-Dessaignes, Raymond Roussel and certain of the surrealists.[3]

West's "compassion" was later to dim these influences. In *Miss Lonelyhearts*, he plays upon Christian themes with a sobriety that belies his Surrealist fancies. His allusions to the visual arts are no longer to Dada impieties, but to such philosophical preoccupations as those found in de Chirico. The dream of his protagonist (who is suffering from the "flu") is familiar: "Later a train rolled into a station where he

was a reclining statue holding a stopped clock, a coach rumbled into the yard of an inn where he was sitting over a guitar, cap in hand, shedding the rain with his hump."

While this was a nightmare, the daydreams in *Miss Lonelyhearts* also hint at West's search for motives in the history of the visual arts. He must have certainly seen and reflected upon the work of James Ensor, for occasionally there are passages that read like inventories of Ensor's Ostend dream shop:

He could not go on with it and turned again to the imagined desert where Desperate, Broken-hearted and the others were still building his name. They had run out of sea shells and were using faded photographs, soiled fans, timetables, playing cards, broken toys, imitation jewelry—junk that memory had made precious, far more precious than anything the sea might yield.[4]

The Ensor image is even more forcible in West's masterpiece, *The Day of the Locust*, whose protagonist is a painter. Tod Hackett, as West tells us in the first chapter, seemed with his slow blue eyes and his sloppy grin almost doltish. "Yet, despite his appearance, he was really a very complicated young man with a whole set of personalities, one inside the other like a nest of Chinese boxes. And 'The Burning of Los Angeles,' a picture he was soon to paint, definitely proved his talent." The burning of Los Angeles, which is the leitmotiv of the book, is conceived as a mass scene, in which the grotesque personages described by West surge upon us like the masked figures in Ensor's *Christ's Entry into Brussels*, each distinct, yet together forming a mob that cannot be contained. "It is hard to laugh at the need for beauty and romance," West reminds us, "no matter how tasteless, even horrible, the results of that need are. But it is easy to sigh. Few things are sadder than the truly monstrous."[5]

The writers who "never really masked their humanity," as Guston once put it, and who yet could register the unflinching cruelty of so much human existence, were the ones necessary to Guston during the 1960s as he sought to "tear off the last mask." He had a natural affinity for writers who could draw a universe down to the last detail and convince us of the most outrageous improbabilities. He was no stranger to Gogol, who could animate objects as unlikely as noses and overcoats, and whose very style was based on the exchange of identities among things and people. In a masterpiece of the essayist's art,

Vladimir Nabokov stresses the importance of context in Gogol's work:

> As in the scaling of insects the wonderful color effect may be due not to the pigment of the scales but to their position and refractive power, so Gogol's genius deals not in the intrinsic qualities of computable chemical matter (the "real life" of literary critics) but in the mimetic capacities of the physical phenomena produced by almost intangible particles of re-created life.

That life is filled with both animate and inanimate matter that become hopelessly entangled:

> Not only live creatures swarm in that irrational background but numerous objects are made to play a part as important as that of the characters: the hatbox which the Mayor places upon his head instead of his hat when stamping out in official splendor and absent-minded haste to meet a threatening phantom, is a Gogolian symbol of the sham world where hats are heads, hatboxes hats, and braided collars the backbones of men.

(Denise Hare)

Nabokov, in a chapter entitled "The Apotheosis of a Mask," speaks of the story he regards as Gogol's masterpiece, *The Overcoat* as "a grotesque and grim nightmare making black holes in the dim pattern of life." In discussing Gogol's peculiar mode of slanting the rational plane of life, Nabokov provides brilliant insights into the nature of the grotesque in art:

The absurd was Gogol's favorite muse—but when I say "the absurd" I do not mean the quaint or the comic. The absurd has as many shades and degrees as the tragic has, and moreover, in Gogol's case, it borders on the latter. . . .

On the lid of the tailor's snuff-box there was "a portrait of a General; I do not know what general because the tailor's thumb had made a hole in the general's face and a square of paper had been gummed over the hole." Thus with the absurdity of Akaky Akakyevkich Bashmachkin. We did not expect that, amid the whirling masks, one mask would turn out to be a real face, or at least the place where that face ought to be. The essence of mankind is irrationally derived from the chaos of fakes which form Gogol's world.

Chiding readers who saw only the pathetic or comic aspects of Gogol's absurd, and who could not see the "real" world Gogol created, Nabokov tells us that "the gaps and black holes in the texture of Gogol's style imply flaws in the texture of life itself. Something is very wrong and all men are mild lunatics engaged in pursuits that seem to them very important while an absurdly logical force keeps them at their futile jobs—this is the real 'message' of the story."

Nabokov's schematized descriptions of Gogol's style reach out to the fourth dimension. "If parallel lines do not meet it is not because meet they cannot, but because they have other things to do. Gogol's art as disclosed in *The Overcoat* suggests that parallel lines not only may meet, but that they can wriggle and get most extravagantly entangled, just as two pillars reflected in water indulge in the most wobbly contortions if the necessary ripple is there. . . ."[6] Such a description could easily serve, and superbly so, as a parallel to the images in Guston's work in the late 1960s.

But Gogol was in the background, and Isaac Babel was the writer in the foreground for Guston after the Jewish Museum exhibition. It is easy to understand why Guston, who has said again and again that his

quarrel with modern art is that "it needs too much sympathy," would welcome the laconic voice of Babel, which speaks out, as Babel himself said, with the precision of a bank check or a military communiqué. His stories hit us in the face like seltzer, as Konstantin Paustovsky has said. He quotes Babel as saying that if there is no accurate simile, he would rather let the noun live by itself in its simplicity. "A simile must be as precise as a slide rule and as natural as the smell of dill."[7] But Babel's consuming interest in style, much like Flaubert's, did not mask for him the importance of content. Style and language he thought of as simply high-quality building materials for art. He pondered his art with incessant anxiety, even within his stories. In one of his best images of life in Saint Petersburg, in the story "Guy de Maupassant," he tells of correcting a translation of the French master. "A phrase is born into the world both good and bad at the same time. The secret lies in a slight, an almost invisible twist." He talks to his patroness "of style, of the army of words, of the army in which all kinds of weapons may come into play. No iron can stab the heart with such force as a period put just the right place."[8]

Babel's compassion appears in small doses but with huge aftereffects. His narratives are filled with cruel images, and yet they rouse in the reader the agonies of compassion with which Babel struggled in order to tell his tales. The atrocities committed in the Red Cavalry stories are at once savagely graphic and distanced, as though Babel's innate humanity forbade him to indulge in sentimental comments. His descriptions of violence are detached in mode, but passionate in effect. Grotesque truths rattle through his story like machine-gun fire. His compassion cannot be overwhelmed. In one of his lesser stories, "Kolyvushka," he comes close to yielding his secret sentiment. Kolyvushka is a peasant whose farm has just been taken away by the collective. He goes into his field, where his horse "nudges him playfully." Kolyvushka lifts his ax and cleaves the horse's skull. "I didn't mean it," he says, "I didn't mean it, little one," and brokenheartedly adds: "I'm a man."[9] This is as close as Babel ever comes to pathos.

Guston's resurgence of interest in the narrative aspects of his own work encouraged him to forage among artists, such as Babel in literature and Picasso in painting, who had come face to face with the violent currents in human existence. He saw again his affinities with Picasso, who had so often appropriated the caricaturist's line in order to speak of violent human affairs: not only in *Guernica* and the unforgettable sketches for it, but also in the sharply modeled double-

portraits, the savagely accurate characterizations of animals, and the highlighted images of monstrous visions—fusions of forms that conveyed violence itself not only in the world as Picasso saw it, but in himself as a part of that world. Artists who had availed themselves of wild distortion vied in Guston's imagination with those who had sought to move far from the sordid, demeaning events that offered a vision of man as a victim of dark forces.

Paradoxically—or possibly not so paradoxically—it was during these troubled years after the Jewish Museum exhibition that Guston began to reflect ever more intensely on the most Olympian artist in his pantheon, Piero della Francesca. The great silent mystery of Piero's oeuvre lingered always in his consciousness, even while the sound of blows and violence echoed there. The extremes do touch in Guston's universe, and as time goes by, his vision of Piero becomes more complicated, and even potentially assimilable in his dialectic soul. His straining toward the reconciliation of the beauteous and the monstrous finds its expression in his rereading, year after year, of the "evidence" in Piero's work.

In his twenties Guston, as Stephen Greene remembers, saw in Piero "the mysterious relationships of forms." He read Piero as Piero himself dictated in his treatise on painting: "Painting is nothing else but a demonstration of planes and solids made smaller or greater according to their term." Guston seized upon Piero's felicities of composition and large planar juxtapositions. He saw, as he later reported, that Piero, largely neglected for centuries, was revived thanks to the twentieth century's interest in Cézanne, Picasso, and Cubism. "It must have been the whole interest in painting as structure and the preservation of the picture plane in painting that revived Piero. We saw that all expressive values only come into play on this plane, and that the rhythm of these planes is what's valid." He was in those days concerned with the intentions—the stated intentions—of the Renaissance masters, and understood that "they sought systematically to give the illusion but in such a way that all the forms are readable and rhythmically stated on the plane."

But as he grew more experienced on the plane himself, he began to see in Piero what Nabokov saw in Gogol, those "gaps and black holes in the texture of [his] style." Gradually, the ineffable in Piero became his obsession. His allusions to Piero become increasingly arcane, matching Piero's own invulnerability to verbal description. Guston began to see that in Piero's illusions there was something other, something

(Denise Hare)

that was not, in fact, "readable and rhythmically stated on the plane."
During the 1960s he pursued these elusive qualities relentlessly, trying
always to define for himself the nature of Piero's peculiar ambiguity.
Like a Cabalist, he meditated on the parts, and then on the whole, watch-
ing things slip in and out of focus, seizing an insight only to have it
dissolve in renewed doubts. He concentrated on the air of "promise"
always contained in a Piero, trying to find its cognate in his own esthetic.
In 1964, when he had reduced his own palette to qualities of gray, and
was all but mired in problems of spatial ambiguity, he spoke to the poet
Bill Berkson about Piero's *Flagellation of Christ*, a reproduction of
which was pinned to his kitchen wall: "It continues to provoke in-

finite questions of what it is that is being seen," he said. "You can spend your life puzzling out what the actual intentions of a picture like that are. We are always at the beginning of seeing." Soon after, he published his essay "Piero della Francesca: The Impossibility of Painting" in *Art News*. He asks the essential question that all painters must ask: Where can everything be located, and in what conditions can everything exist? Speaking of the *Baptism of Christ*, he says, "We are suspended between the order we see and an apprehension that something may again move. And yet not."[10]

It is this ambiguity of interpretation that preoccupied Guston at this time. He has moved beyond Piero's own treatise to isolate what was peculiar to Piero: "He is so remote from other masters; without their 'completeness' of personality. A different fervor, grave and delicate, moves in the daylight of his pictures. Without our familiar passions, he is like a visitor to the earth, reflecting on distances, gravity and positions of essential forms." Yet, there is more, and more that was akin go the "incompleteness" of Guston's own personality, and this he reveals in his discussion of *The Flagellation*, in which he finds Piero's thought "diffuse" and that a "play has been set in motion." He notes that the picture has been sliced almost in half, yet both parts act on each other to repel and attract, absorb and enlarge one another. "At times, there seems to be no structure at all. No direction. We can move spatially everywhere, as in life." He moves on from here to his affirmation of doubt, so often expressed in other contexts: "Is this painting a vast precaution to avoid total immobility, a wisdom which can include the partial doubt of the final destiny of its forms? It may be this doubt which moves and locates everything."

These thoughts were further developed a year later in the essay "Faith, Hope, and Impossibility," in which he poses again the questions of "location." He asks "What can be Where? Erasures and destructions, criticisms and judgments of one's acts, even as they force change in oneself, are still preparations merely reflecting the mind's will and movement. There is a burden here, and it is the weight of the familiar."[11]

Guston's thoughts on Piero became intricately interlaced with thoughts about his own work. He speaks in 1966 of the point when something comes to grips with the canvas. "I don't know *what* it is. You can put paint on the surface most of the time and it just looks like paint. Then there comes a point when it doesn't feel just like paint. That's what I mean about coming to grips—some kind of psychic rhythm." He says that paint on the floor is just inert matter. On the

canvas, it becomes a "peculiar miracle." He wants to be like Piero who, as he had said in his article, worked as though he were opening his eyes for the first time. "I want to paint a world that's never been seen before, for the first time." And he notes that where before he had seen the readable architecture of Piero's paintings, he now sees that they are on the verge of chaos. They are the most peculiar paintings ever painted, more unclear than most modern paintings.

Five years later he was still bemused by Piero. In a lecture given in 1971 at the Studio School, Guston told his audience that "like a needle on a compass I always return to Piero. I'm under the spell of his majesty." He used diction that stressed the majesty of Piero. He spoke of the murals at San Francesco in Arezzo and of his most recent visit there:

Before you see the subject matter, what you see are big soaring verticals and very full circles. Color. Dull reds, milky blues, liver umber, dirty whites. All in a geometry that I never quite saw before. Piero seems cosmic. In all these forms the way in which distances are located, the slowness of spaces moving up and down, at the same time spaces across moving in and out make them seem like planets, Celestial.

Now, in this fully developed meditation, he can speak of the meaning of these murals in which he finds "a feeling of wisdom, an emotion of wisdom." He can extrapolate on his earlier apprehension of the meaning of the picture plane: "By the picture plane I don't mean just *surface*. This rectangle on which we project an image is a surface upon which you can make a fixation, but that isn't what I mean. It doesn't exist physically. It is totally an imaginary plane which has to be created by illusions."

As he had said in his Piero article, it is not a picture we are seeing but "a generous law." It is on the imaginary plane where the forms of this world momentarily come to pause. "In Piero, you have a sense of pauses, as if all these figures *could* have an existence beyond these momentary pauses." Since, in his own work, Guston was hovering among such pauses, he was able to say that his only interest in painting is in the metaphysical plane "where conditions exist of infinite continuity." What he now sensed in Piero is the mysterious promise. He returned to the problem in 1973, speaking again of *The Flagellation*: "The mystery when you deal with forms in front of forms is

149

paradoxical because something is hidden like a deck of cards. Here, it's the unfolding of these planes on the picture plane so that there is a unified rhythm on the plane as well as coordinated depth in space. The whole question is: when does it pause? The pause in time is a mysterious situation, because *it can't be final*. It must promise future conditions." And he repeated that the anxiety in painting is essentially based on the question: where can everything be located? In what condition can everything exist? Everything is moving through and up and down and in and out in Piero. Where do you stop? "If there is a settling, it can only be a pause. . . ."

Undoubtedly Guston's insistence on Piero was heightened by the peculiar circumstances in which he found himself. Always very sensitive to the currents of thought eddying on the local scene and emanating from the art press, he would naturally have been repelled by the hyperbole that flourished during the 1960s, and by the widespread dependence on doctrine. It was a moment when painting was being discussed as if it were a product of a long materialistic process that found its apogee in the lean and schematic works of the "color field" artists. He would undoubtedly have been highly irritated by the new tone of academic scholarship lavished on thin, abstract illustrations of the scholars' own doctrines. The problem with modern painting, he insisted, was not that it was hermetic, but, on the contrary, that it was all too clear. Unlike Piero. And then there was the growing indifference to the past, which Guston noted and, like many other thoughtful intellectuals, knew to be unhealthy. The avant-garde mystique of no-yesterday and no-tomorrow had reached the banal level of much of American life. The avant-garde itself was unconsciously living by the rules of the technocratic society and had lost the dimensions of existence that art had always served to exemplify (the evocation of time, the strange continuity of past and present, the sense of futurity). For Guston, the vulgarity of much art talk was intolerable. Better to return to Piero and the full measure of mystery that painting had always defended. Moreover, Guston had long been a student of de Chirico, whose critique of modern history must have etched itself on his mind. Despite de Chirico's occasional rants against modern art, his cranky and often ridiculous statements about it, his initial observations were legitimately phrased in the visual terms of his art. The Düreresque quality of de Chirico's monuments (references to *Melancholia* certainly) and the citations from the past that graced his earliest work made him somewhat of a historical commentator. Guston's intimate

familiarity with de Chirico's work—a familiarity that began while he was still in his teens and has remained constant—led him back to de Chirico's own writings which are singularly consonant with his paintings. The Italian artist, during his student years in Germany, had thoroughly assimilated the works of Friedrich Nietzsche, and he alludes again and again to the poetry of Nietzsche in his own writings. Even more striking is the way he synopsized Nietzsche's vision of history in his paintings. In the piling-up of signs spanning many historical epochs he indicates his sympathy with this vision. A classical foot juxtaposed with a modern engineering instrument is evidence enough. Nietzsche's theory that the superior artist must know both the sense of history (and its symbols) and the sense of trans-history, with its dreaming detachment, finds a willing proponent in de Chirico, who admired the German philosopher's aphoristic approach and accepted his judgment that what dignified the ancient Greeks was the fact that they learned, gradually, "to organize the chaos." He frequently echoes Nietzsche's finale to his meditation on the value and disvalue of history: "This is a parable for each one of us: he must organize the chaos in himself by 'thinking himself back' to his true needs." This de Chirico consciously did when he turned his back on his time and pursued the phantom of history in the evocative forms he painted.

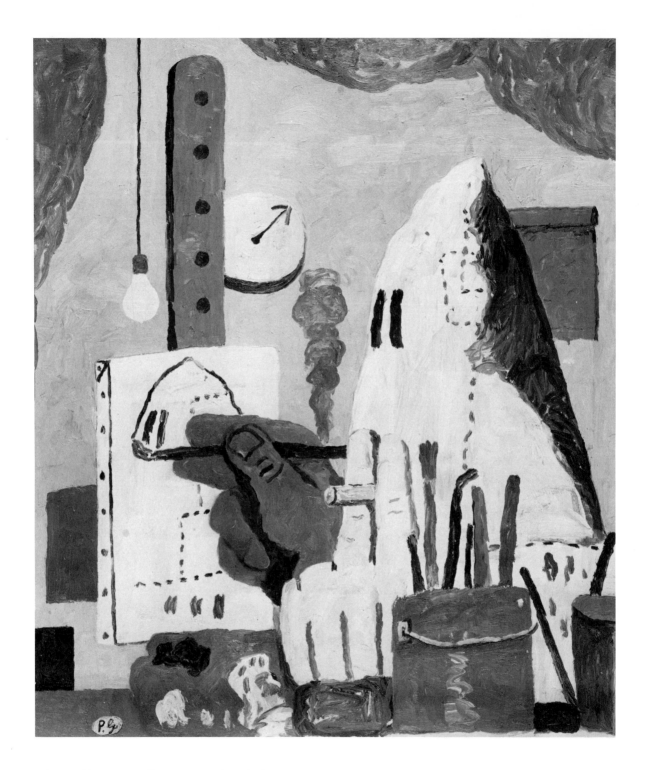

The Studio, 1969. Oil on canvas, 48 x 42 in.

The Studio XI

Yet Guston could not lend himself to the kind of posturing that de Chirico's views too often represent. As James Thrall Soby remarked, "the art of the *scuola metafisica* was mannered, nostalgic and elegiac, as art can be only when it is brought into being by those who have lived with the dead body of a once great tradition."[1] Guston's irritability roused him only toward an exploration of the other voice he had always heard. There was nothing nostalgic about his struggle with himself during the two years following the Jewish Museum exhibition. He worked. He scraped away. He finished no paintings at all, but he did complete a sheaf of remarkable drawings that were as starkly simple as Oriental characters, sometimes merely a line or two of India ink on a pristine white or cream paper. In these, the splendor of Piero's silence is reflected. They are limpid in light as in that first morning of the world portrayed by Piero in *The Baptism*. There are no equivocal loops or warps in these drawings. They are stripped down to a most elemental truth—signs of his delicate feelings about light, space, and their sheer intrinsic beauty.

During the two-year span of 1966–67 Guston did literally hundreds of drawings in ink and brush or charcoal on paper. The period remains in his memory as one of conflict:

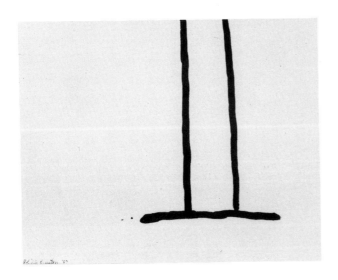

Drawing, 1967.
Ink on paper, 14 x 16½ in.

I remember days of doing "pure" drawings immediately followed by days of doing the other—drawings of objects. It wasn't a transition in the way it was in 1948, when one feeling was fading away and a new one had not yet been born. *It was two equally powerful impulses at loggerheads.* I would one day tack up in the house a bunch of pure drawings, feel good about them, think that I could live with them. And that night go out to the studio to the drawings of objects—books, shoes, buildings, hands, feeling *relief* and a strong need to cope with tangible things. I would denounce the pure drawings as too thin and exposed, too much "art," not enough nourishment, and as an impossible direction with no future. The next day, or day after, back to doing the pure constructions and to attacking the other. And so it went, this tug-of-war, for about two years.

In this combat, the debate took place on the level of drawing, "not only because one's impulses surface more rapidly in drawing but because the drawings seemed to symbolize the issue."

In 1968 he once again set out to disembarrass himself of his own past, and of his culture, just long enough to establish contact with his canvas. Once again, he did not care to step back. He began to paint with acrylic on small panels, and he painted what he called common objects. In the beginning, they were identifiably books, though more like ancient tablets with incised vertical lines or horizontal ledgers. These books reached phantasmic proportions and metamorphosed into buildings, bread, and sometimes canvases. The old impulse to caricature revived. Guston's "common objects" of 1968 were things huddled on the bottom of an abstract place, or they were exactly and primi-

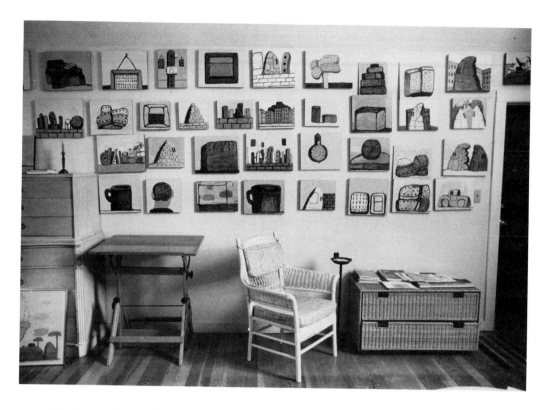

A wall in Guston's Woodstock studio showing several paintings from 1968. (Denise Hare)

tively centered on the canvas. In these initial paintings he retained the emphatic line derived from his drawings, the line that seems to draw itself, unmask, and mock itself. He was impelled to seek that "primitive" urge that Kafka had once found in Kierkegaard. The "objective" realm has become characteristically a realm of grotesques, heavily tinged with irony. Once again, Guston deliberately invoked himself as *Eiron*—he who knows but pretends he knows not. He initiates an inquiry that soon assumes the proportions of a full-scale drama, always assuming that in his dissembling stance as Eiron, truth through artifice will emerge. Guston's sense of irony led to a reversal of process. He did drawings as once he had done paintings, without stepping back, but he began to "see" paintings in a way that no longer permitted the process to determine the meaning. He had had homeopathic doses of strong emotion, and reached catharis. In 1968 he could say that he did not want "emotion or ambiguity to stick to me like seaweed."

The catharsis was hastened by circumstance. During 1968 there were repeated campus demonstrations against the war in Vietnam, often

reaching dangerous antipodes of mass hysteria. Then there was the Democratic convention in Chicago, with its numerous episodes of violence and its undercurrent of mindless chaos. Isolated in the quiet of Woodstock, Guston watched the television reports of bloodied heads and youths trampled by mounted police, and worried. Worry grew to fury and fury impelled him to make an image. It was then that the ominously detached hand and finger appeared, trailing a column of blood. In this *ex voto*, recalling so many visual crosslines of twentieth-century *angst* (de Chirico's impaled gloves: Picasso's distorted hands; the Surrealists' constant play with detached human members, particularly hands), Guston experienced a full resurgence of his youthful outrage. This athletic hand then became a Gogolian protagonist in dozens of small paintings. During the Chicago riots, Guston worked furiously. He painted shoes like buildings, clocks, stony books, buildings like primitive pueblos. Headlike shapes mashed after rioting. Owlish heads, and rapid, choreographed conversations between disembodied hands. Brick walls appeared, reminiscent of his old holocaust allusions to suffocating imprisonment, and with them the familiar hooded figures (not only recalling the Ku Kluxers of his early paintings but also the artists in the scriptoria of the medieval plague years who donned hooded gowns in the vain hope of avoiding the plague). He was off on an irreversible orgy of grotesquerie.

His mood of Ubuism isolated him from the New York art world, but it brought him close to a new friend, the writer Philip Roth. Roth had recently published *Portnoy's Complaint*, and in the combined flood of literary rebuke and popular success felt himself deeply alienated. He withdrew to Woodstock in 1969 where he established a bond with Guston based on their common need to "depart from our culture." Guston was already well into his new mode and was working on large

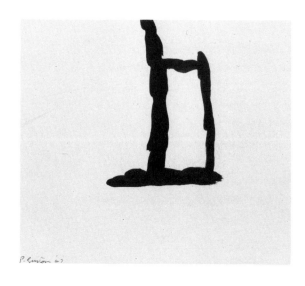

Drawing, 1967.
Ink on paper, 18 x 23 in.

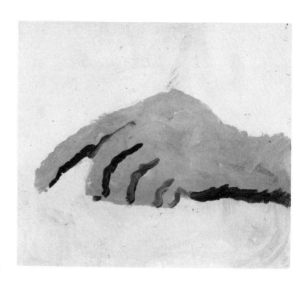

Hand, 1968.
Acrylic on canvas, 18 x 20 in.

oils. He felt he was "onto something" at the time Roth arrived. The only problem, he felt, was time—time enough to paint "all the images and situations that were flooding in on me."

Roth himself with sketching his own burlesque vision of post-Oswald America at the time, a vision that defied the refinements of the literary world he had grown to despise. "The highbrow dreams of another kind of American image," he says. "When I went to Woodstock in 1969, I felt isolated, lonely. Philip knew about solitude and isolation. But he was rather elated. He had this secret in his studio."[2] The two held long sessions in which they discussed mutual enthusiasms, such as Kafka, who, as Roth says, was "a maniac about being pure," and Flaubert (his letters on fame and loneliness), and the stuff of the newspapers. They had certain past experiences in common—for instance, Roth had once been in Iowa and knew the same haunts that Guston had frequented. He shared Guston's fascination with what the latter called "crappola" and accompanied him to a road emporium to examine "acres and acres of junk." At the same time, Guston, having returned from Europe in the summer of 1971, responded with alarm to the situation in America, and could easily relate to Roth's mood. Roth had embarked on *Our Gang*, a satire about the dangerously infantile Nixon regime. In the fall Guston was inspired to do a suite of fierce and cunning parodies of Nixon's life.

Guston's elation, which Roth remarked upon, was based on his temporarily successful exorcism of doubt. The image in its "objective" mask now dominated his painting, and he worked with tremendous

Nixon cartoons, 1971. Ink on paper, each 10½ x 14½ in.

enthusiasm. In March 1969, he felt immersed—the condition he always courted and in which he felt most comfortable. He wrote:

Until now, I haven't felt ready—not to prove anything—just to be ready, or rather, to be in a position to feel I have done something worthwhile. This part is difficult, for of course, pictures and thoughts change, evolve, so that like always with me it seems there is only one picture and one frame of mind, the current one. I don't think I've done as much testing of everything I've thought and done as these last few years. It goes on.

I hope I don't sound sentimental but it is so that much of the time what I am painting seems like a mirage to me—a vast detour I am making and I am left with a sense only of my perversity. I must trust this perversity... and yet, who knows I may again be forced to penetrate that state of reduction and essence. But now, the vast complica-

tions and uncontrollability of imagery keeps me in the studio most of the time.

His state of elation led him to wild hyperbole. In April 1969, he was talking about his work in his most Eironlike voice. He had abandoned esthetics, he said. He was only interested in telling a story. "I want to *see* what it *looks* like," he said, describing his new paintings of hoods flogging each other, bloody hands, clocks, books. "I'd even do billboards," he insisted. "Who *is* a painter, after all?" Man is an image-maker and painting is imagemaking." The abstract painters—what are they telling us? That this is the absolute? Well all right, so is this beer glass. But what *else* is man? There are many things that move him."

The element of defiance and crankiness in his position was fed by increasingly disturbing events to which he felt he must respond. Guston's thoughts turned back to his youth, when he had watched George Grosz condemn his society, and when he himself had participated in exhibitions sponsored by the activist organization Artists Against War and Fascism. All the while he was warming his outrage in the comradeship of Philip Roth. Roth spoke of his own work as farcical, blatant, coarse-grained. He was interested in the "logic of farce, of burlesque, of slapstick." He felt himself to be the victim of an art-for-art's-sake estheticism, and was struggling to break free much as Guston sought to overwhelm his own innate (and what Roth calls "princely") attitude toward "high art." Roth has described his afternoons reading Henry James, "transfixed by James' linguistic tact and moral scrupulosity," and compared them to the coarse and aggressive clowning of his boyhood evenings at the candy store.[3] This can easily be compared to Guston's preoccupation with Piero, and his contrary interest in the lowlife of cartoons. Roth has candidly stated the problem:

As I now see it, one of my continuing problems as a writer has been to find the means to be true to these seemingly inimical realms of experience that I am attached to by temperament and training—the aggressive, the crude and the obscene, at one extreme, and something a good deal more subtle, and, in every sense, refined at the other.[4]

The subversion of purism is not remote from the subversion of the grotesque, which is generically impure. Another burgeoning friendship during the late 1960s kept alive the other side of the dialogue in

Guston, whose attraction to "the state of reduction and essence" would never be totally expunged. The young poet Clark Coolidge, whose work during the late 1960s when he first met Guston was markedly reductive (words disembodied, extracted from context, lining the page with a pristine abstraction opposing the complex syntax of the baroque), began to pay long visits to Woodstock. Coolidge had long been an admirer and a serious viewer of Guston's work. The paintings of the 1950s, such as *Zone* and *Attar*, were essential in his own formation; they "incited" him to write. "What attracted me," Coolidge says, "was Philip's feeling for structures, and his doubt. Negative and positive. Things that go together and things that don't."[5] The two also shared literary enthusiasms (Melville, Kafka, Beckett), an interest in the movies, and a measure of splenetic disgust with the world, the art world, the literary world. In a sense, Coolidge extended the long conversation that Guston's friendship with Morton Feldman had initiated. Feldman's addiction to the "absolute" partook of a grand modern tradition of quintessentiality. Coolidge, in his poems of the late 1960s, seemed intent on arriving at a place as remote from quotidian chaos as Mallarmé's void. In his careful structures of words rendered abstract (through the absence of syntactical links and the paucity of verbs) he sought the greatest abstraction of all, which was to become the title of his first published collection, *Space*. The words, removed from their matrix, fondled, faceted, placed in a "space" that felt right, gather their own momentum. What is true of a Mallarmé poem—that repeated reading discloses forms that can never be precisely transcribed in prose, and never precisely dissected—was true of

Philip Roth, 1973
Ink on paper, 11 x 8½ in.

the poems in *Space*. In later poems, Coolidge moved closer to Guston, particularly to Guston's drawings. He asked himself, under the painter's influence: What if I were to write "the shoe is on the table?" "I was impressed by the fact that Guston could paint a form that relates to car, lampshade, and shoe, and yet not lose the whole physics of form." Coolidge began to take back the verbs and adjectives he had once carefully excised. Solids began to appear, sparingly, in his poetry. The absolute space of the poem began to be qualified by minor details. One word next to another, as in Guston's inventories of clustered forms, took on extensive meanings that could no longer be mistaken for the purity of "concrete" poetry. Yet Coolidge remains very much in the tradition of "high art." If the mocking tone of the burlesque is in his work, his attitude toward the poem as a thing in itself remains seriously respectful of the "sanctity" of the work. Corrosive humor and quixotic rebellion are quickly appreciated but never endorsed in Coolidge's work. His feeling for "stuff" and for objects is affectionate, his are Bloomsdays rather than the doomsdays that shadowed Guston's isolated years in Woodstock.

Coolidge, who was much involved with Guston's "continual process of drawing," and who has, as he says, a predilection for black and white, saw parallels in his process and in Guston's when they first met. As a matter of fact, Guston's own interest in the incomplete, which holds the promise of completion in its very structure, remained important in his process, even when he stepped into the "realm of the objective." The art of the caricaturist is always abstract, leaving its imperatives in the viewer's imagination. Guston had long been engaged in a kind of truncating process that he sometimes identified with "erasure." In the early abstractions, scraped-out forms that left phantoms were his means. But later, erasure transforms itself into a process of omission. The abstract drawings he worked on in 1968 and 1969 were virtual forms, to be completed by the act of seeing. Coolidge himelf practiced a kind of "erasure" through omission as when he arrays suggestive word-endings on the last page of *Space*:

> erything
> eral
> stantly
> ined
> ards
> cal
> nize[6]

In Guston's drawings from 1969 through 1971 a great deal can be

discerned. The range of mood is wide—from comic, affectionate, and tender to downright surly. There he is developing his cast of characters for the grotesque mummery he now "sees" in terms of a long series of episodes. He is telling stories, but he is also refining a vocabulary of forms (the shoes, clocks, and window shades) that he has known intimately all his painting life. In some of the drawings echoes of Krazy Kat predominate (those hot-dog cars with doughnut wheels in which the cigar-smoking hoods cruise). The buildings are represented in comic-strip caveman style. The thickness of the trudging line beckons the thickness of things. But the things are not always explicit. They metamorphose. They make similes. They refuse literal reading. In most of the drawings, erasure yields to emphasis, but never totally.

Around 1970 Guston became, he said, a movie director. "I had impulses to do things and motifs—crazy things like brick fights and figures diving into a cellar-hole to 'thicken the plot.' " In his new whitewashed cinder-block studio he filled the racks with narratives, sometimes drawing on old sources (the memory of Italian hill towns for instance), sometimes on actual objects that he had carefully selected in his wanderings in the immediate countryside—old, homely household utensils, tools, tin cups, railroad spikes. Then there were his "characters"—two, sometimes three, hooded figures, smoking, discoursing in various situations. They are seen in an art gallery gesticulating with thick red hands, commenting on paintings that are paintings of themselves. They ride around in their black cars through deserted squares, hauling grainy hefts of wood for their eventual crosses. Godforsaken villages are their

The Law, 1969.
Charcoal on paper, 18 x 15 in.

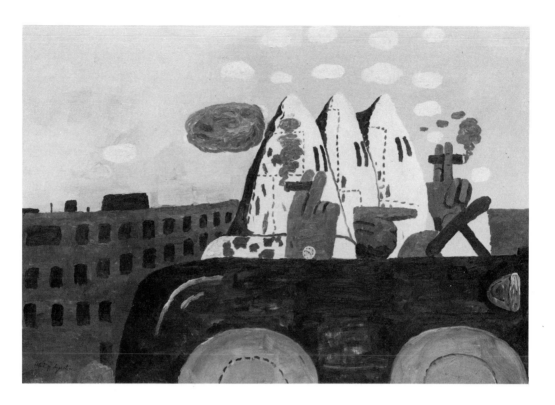

Riding Around, 1969. Oil on canvas, 54 x 79 in.

territory when they are outdoors, but mostly they are encased in their
cells surrounded by the stuffed chairs, fringed lamps, and green win-
dow shades Guston undoubtedly knew from his youth. Occasionally
there would be mounds of pink honeycombed houses, primitive re-
minders of ancient dramas. The forms are unstable, the gestures exag-
gerated, the puffs of clouds in the sky derived from the old cartooning
days. The hoods transform themselves from outright floggers to art
critics (in one picture they stand discussing an all-red painting—
Guston's stab at contemporary art criticism), and from art critics to
the artist himself, who is seen in several sequences painting a self-
portrait. In fact, his identification of himself as a director was accurate
enough, and the director he most resembled was Fellini, whose com-
ments in the late 1960s could stand for Guston's:

Once a film is finished it always contradicts me. Intentions, projects,
represent for me only instruments of a psychological nature that put
me in a condition to realize a film. I have no vocation for theories. I

detest the world of labels, the world that confuses the labels with the thing labelled.... Realism is a bad word.... I see no line between the imaginary and the real. I see much reality in the imaginary.[7]

The realities Guston saw, and which were specifically available to the viewers of his Marlborough Gallery exhibition in the fall of 1970, partook of many spiritual experiences, and many sorrows. The so-called mandarin in him was far from yielding to the stumblebum, as *The New York Times* insisted. For those willing to examine the work closely, there was immense variety and reverberations that went all the way back to the Renaissance, not just to the American comic strip. True, the accents were shifted. Instead of Piero, there is now the unmistakable reference to Signorelli, particularly the apocalyptic frescoes in Orvieto, where Signorelli had filled the vaults with writhing, screaming sinners, portrayed in remarkable diversity. In this eschatological vision, earth colors predominate—siennas, rust reds, dusky oranges, and mossy greens. The shadows are clear, and yet somber, unlike those of Piero. In the midst of the furor, Signorelli stands full and firm, looking out calmly at the spectator, just as in a number of Guston's drawings of hooded figures, the eyes of the artist himself peer out (and still later, with the hood removed, only the eyes are left). Like Goya who wrote "this I have seen," Signorelli places himself as a witness in Hell, as does Guston himself, who once remarked that "Like Babel with his Cossacks, I feel as if I have been living with the Klan, riding around empty streets, sitting in their rooms smoking, looking at light bulbs. . . ."

There are, among the paintings of 1970, bleak and powerful references to the end of the world and to horrors not even Signorelli could have envisioned. But there are also numerous autobiographical references and allusions to various painting traditions that Guston had long sought to reconcile. In the Western and dialectic history of art, there are always alternatives, as in the case of "genre" painting in the North during the Renaissance and its sharp distinction from the idealizing southern modes. Instinctively Guston had focused on painters who had known similar conflicts. His long interest in Watteau for instance

Six comments on the art world: top left: *Wall*, 1969. Oil on panel, 36 x 40 in.; top right: *Red Picture*, 1969. Oil on panel, 24 x 26½ in.; middle left: *Corridor*, 1969. Oil on panel, 24 x 26½ in.; middle right: *Discussion*, 1969. Oil on panel, 30 x 40 in.; bottom left: *The Painter*, 1969. Oil on panel, 24 x 26½ in.; bottom right: *Painter and Model*, 1969. Oil on panel, 30 x 40 in.

164

A Day's Work, 1970. Oil on canvas, 78 x 110 in.

has been as much based on Watteau's eccentric position to his period as on his painterly eloquence as an "echo" to his period.

Watteau had been reared in the Flemish genre tradition and, when he arrived in Paris, he continued to draw his subjects from the streets. His many sketchpads contain vigorous characterizations of ordinary people, as well as incisive notations of the gestures of the Italian actors in the *commedia dell'arte*. Many of Watteau's studies of hands suggest his special interest in the balletic and narrative function of gesture best observed in the *commedia*. Watteau was functioning in a period in which the art establishment (the court) loathed genre painting. But he, and a few others, persisted to the point that a critic complained that "pictures expressing great passions of the soul are replaced by low and coarse works without high thoughts, without dignity, without discrimination. A stable, a tavern, stultified smokers and topers, a cook with all the sordid instruments of her laboratory, a urinologist, a toothpuller: these are the subjects which today delight our connois-

seurs."[8] Watteau was the prototype of the "stumblebum" in his youthful works, and probably in the private works of his last years, long since destroyed. However, the very court that averted its eyes from low-life paintings enacted parodies of low life for its own amusement, as when Louis XIV dressed himself in shepherd's clothes and danced a popular dance. The establishment, at least, saw such painters as Bosch and Brueghel as sources of low comic entertainment. These artists' ascension to the true and timeless grotesque was not noticed in their time.

Yet artists have always sensed the pull of this other tradition in which the follies of mankind appear epitomized and in which the comic subsides once the imagination is engaged in the whole oeuvre. Guston, in his teens, had singled out "a jewel of a Bosch" in his visit to Mexico, and he enacted in his own life certain of the strategies the genre painters employed. Like Brueghel, who is said to have donned disguises in order to participate in the revels of the people he would later paint, Guston had in a sense donned his mask and thrown himself into the life of the streets as a youth. The watcher in him remained distinct from the watched. If at last he paints himself as a grotesque, consisting only of an eye, it is in keeping with the entire tradition of tragicomedy and with its emphasis on irony and alienation. He takes details much as Cervantes did, to persuade us that there is a reality (such as the heavy flatiron or the railroad spikes in his paintings of the 1970s), and then puts them into contexts that persuade us of the irreality of the entire world and the vagaries of the imagination. Cervantes, whom Octavio Paz has called the first great modern writer,

Hooded Self-Portrait, 1968.
Acrylic on canvas, 30 x 32 in.

The Deluge, 1969. Oil on canvas, 77 x 128 in.

makes us wander dazedly with Don Quixote through landscapes that seem real but are spread out in crazy-quilt patterns that cannot be real. Paz contrasts *Don Quixote* with Dante's *Paradiso* and *Inferno*, which are "real, just like Florence and Rome" while the "grisly reality of Castile is a mirage, a piece of witchcraft." In Cervantes

there is a continuous oscillation between the real and the unreal: the windmills are giants, and a moment later they are windmills again. This oscillation doesn't alter anything: people are condemned to being what they are.... Men are no less problematic than things and both than language.... Language is no longer the key to the world; it is a mad word, void of meaning. Or is the opposite true? Is it the world that is mad and Don Quixote the word of reason travelling the roads in the guise of madness? Cervantes smiles: irony and disenchantment.[9]

Guston's retrieval of the tradition of the true grotesque is seen not only in the ostensible motifs (which like the windmills can turn with lightning speed into other hidden motifs before our eyes) but in the very mode of "locating" them. These inventories of things—huddled

together or adjacent to one another or clinging like barnacles to still larger things—are filled with the chaos of Castile as Don Quixote knew it, an aimless and disorienting place in which there are queer symmetries or no symmetries at all. The disguised forms weave their narratives in disjointed terms always favored by the masters of the grotesque, including Goya, Ensor, Beckmann, and others Guston had seriously considered. The witness, Guston, shifts his feet rapidly to get another view, and in so doing, becomes another witness. Who, in fact, is this witness? And from what point of view does he tell his tale? Guston often refers to the Japanese film *Rashomon*, in which several witnesses offer widely divergent accounts of the same event. He is himself all the witnesses in these late paintings and, though their messages seem clear at first glance, they quickly dissolve into perturbing riddles of existence filled with the same anxiety that had prompted his dark paintings of the 1960s.

Flatlands, 1970. Oil on canvas, 70 x 114½ in.

The Desert, 1974. Oil on canvas, 72½ x 115½ in.

The Desert XII

Guston sprang his secret at the Marlborough Gallery in October of 1970. Shock waves disturbed the peace at Woodstock, but he and Musa had already left for Rome, where he had been offered a studio at the American Academy. But he did not spend much time in it. As before, he wandered to the hill towns, to Orvieto again, to Florence, to Venice, and through the ancient parks and streets of Rome itself. A few drawings and some paintings on paper commemorated his pilgrimage: pink and dusty visions of the stylized trees, their umbrella boles against a pinkish sky. The red stones of Rome everywhere, and dim visions of the hill towns. The memories of detached colossal Roman feet. Fragments.

Then, a trip to Sicily, where they had the great good fortune to see a performance of traditional Sicilian puppet plays—vivid excursions into fantasies of chivalric times, loud with exclamations, and full of the exaggerated combats, the braggadocio of the old tradition. This parallel world, with all its dislocations of scale, its syncopated narratives, its allusions simultaneously to past and present, struck a deep chord in Guston. Months later he excitedly described an evening with an aristocratic collector of classical puppets. The secret shock in the shift of scale seemed to strike him with the greatest force. At moments

Fountain in Rome, 1971. Oil on canvas, 30 x 40 in.

the enormous fist of the puppeteer appeared behind the proscenium throwing the scene into a perspective that delighted Guston. That governing hand, larger than life and paraphrasing the image of the working artist arranging the spectacle, had already appeared in his work. Now it was to become an emphatic symbol in his painter's lexicon.

When the Gustons returned to Woodstock in the summer of 1971, they settled down with a certain finality. The lure of the city was less compelling. In the cottage with its comfortable kitchen always warm in winter, its small rooms lined with books and pictures and enlivened by Musa's collection of smallish objects, life took on a rhythm geared to Guston's sense of urgency. The large studio, whitewashed and orderly, was carefully arranged so that Guston could move from drawing table to painting wall with ease. The telephone was often smothered under pillows. Months went by without excursions and without many visitors. In October 1972, Guston terminated his contract with Marlborough, cutting his ties to the New York art world.

He recalled all his work. "About twenty years of work was rounded up and finally has been trucked up here," he wrote the author in December. "I am on my own and at last 'all together.' I need to build more storage space.... It feels strange to be completely cut off from the city. I feel like burrowing in again—to be a miner and not surface for a while."

He did not surface again for many months. He was painting in long, uninterrupted sieges. Throwing off the last mask. In these new paintings, the absence of the hood is notable. From underneath the disguise emerged another character—a naked eye. This eye—the painter's own—is everywhere: disembodied on a canvas, staring from corners, lodged in great tuberlike heads with no other distinguishing human characteristics. The other attribute, the hand, becomes still more active and, with the eye, dominates the imagery. On one of the many levels attained by the new paintings, the artist reduces his meanings to the clearest statement of his "self": it is nothing other than a fusion of eye and hand working on the things of this world. And also the things of the other world—the world of unease ceaselessly conjured in Guston's imagination.

The paintings from 1971 through 1974 show Guston characteristically gathering up the many themes and techniques that had provided continuity for more than forty years of painting. They are executed in two manners. In the one, great washy spaces steal from one plane to another and seem to dematerialize the objects and figures within them, recalling the brooding works of the Jewish Museum show in mood and technique. These paintings frequently stretch over vast horizontal planes and are, as one of his titles suggests, embodiments of the notion of "desolate." In them, certain formal problems find unique solutions and challenge almost every contemporary convention.

In the other mode, Guston remembers the indispensable "intrusions of the sensible world," as Valéry put it. Here he paints firmly delineated and modeled objects. Solid things. Things lodged in the studio, such as cigarette butts, old flatirons, tin cups. And things that live in his fantasy, such as undefinable but solid objects recalling the geometer's forms in *Melancholia*—a sphere (wooden ball, balloon?), rectangular forms (wood scraps, canapes?), and the ubiquitous shoes (in these contexts homely objects, more Van Gogh than Goya). The manner of painting recalls both Picasso and Léger in the period after Cubism, a period that had always interested Guston. The manner is emphatic. The purpose is to present the object as firmly as possible, in order to underscore the strangeness, finally, even of everyday things.

Painter's Forms, 1972. Oil on Masonite, 48 x 60 in.

During this time he read and reread Babel, and enjoyed quoting the Russian writer's remarks to Paustovsky:

> What I do is to get hold of some trifle, some little anecdote, a piece of market gossip, and turn it into something I cannot tear myself away from. It's alive, it plays. It's round like a pebble on the seashore. . . . Its fusion is so strong that even lightning can't split it.[1]

Guston is, like Gogol, concentrating so intensely on the object that it is transformed. And in the transformation resides a great, Panic pleasure. If he arrays his objects, as on *Painter's Table* (Plate 4), one to

another, side by side, in the rhythms peculiar to him (the familiar bunching together of nearly similar forms and the strange shifts in scale), there is a formal satisfaction that overrides the still-life motif and almost reverts to pure painting. If as in the aptly titled *Complications* he remembers de Chirico, bracketing mysterious forms in an infinitely ambiguous space, he also remembers his own games of levitation, prosceniums, incongruous objects. The pleasure in a painterly conundrum is not disguised. What is where? The old question elicits delight. His pleasure is pleasure as he had known it described by Kierkegaard:

The essence of pleasure does not lie in the thing enjoyed, but in the accompanying consciousness. If I had a humble spirit in my service, who, when I asked for a glass of water, brought me the world's costliest wines blended in a chalice, I should dismiss him in order to teach him that pleasure consists not in what I enjoy, but in having my own way.[2]

Without any question, the painter whose dialogue had taken into consideration so many problems has taken distinct pleasure during the 1970s in having his own way. Kierkegaard's views, which Guston had

Complications, 1973. Oil on canvas, 53½ x 79½ in.

cited on so many occasions, extend even to that other prominent element in the paintings of the 1970s, the element of farce. From the days when he painted the hoods flinging bricks, to the days when he depicts himself and his attributes (himself coughing up a few essential symbols whose meanings may or may not be simple), the farcical is always in the wings. Entertainment—the horse laugh—is not foreign, as it was surprisingly not foreign to Kierkegaard:

On the other hand, for the cultivated person who at the same time is free and easy enough to entertain himself independently and has enough self-confidence to know, by himself, without seeking the testimony of others, whether he has been entertained or not, the farce will have perhaps a very special significance, for the fact that it will affect his spirit in various ways, now by the spaciousness of the abstraction, now by the introduction of a palpable reality. But of course he will not bring with him a readymade mood and let everything produce its effect in relation to that, but he will have cultivated his spirit to perfection and will keep himself in the state where not one single mood is present, but the possibility of all.[3]

But on the other hand—as there is always the other hand in Guston —high spirits give way to darker thoughts in many of the paintings. The allusion to de Chirico in *Complications* is one kind of allusion. There is another kind. In those landscapes filled with *terribilità*, in which vertical legs are terminated by heavy shoes with every nail clearly indicated, recalling the de Chirico towers, recollection is tainted with contemporary horror. Where de Chirico made historical palimpsests of thirteenth-century towers and twentieth-century factory chimneys, Guston isolates another kind of historical memory. And he alters the concept of time. Clocks, which appeared early in his work, possibly in deference to de Chirico, now reappear. Crazy ticking. "It is a real place to me," he wrote in August 1974, "this world I am painting. I feel as if I lived there, its forms defined. All I really need is *time* and more time to 'reveal' . . . I pretend I am away (and so I am!) all sorts of tricks to gain the necessary continuity of TIME." The clocks become larger and larger, and the light bulb (occupying the defining space the way Picasso's light bulbs did in the 1930s) hangs more and more precariously, its beaded chain swinging like a metronome.

It was no use pretending that the outside world was outside. It came to Guston, as it often had in the past, through the printed word, and stirred his feelings. Goya, the blackest and most fantastic Goya,

Desolate, 1973. Oil on canvas, 78¼ x 110½ in.

reentered his thoughts. After the coup in Chile he wrote, "Our whole lives (since I can remember) are made up of the most extreme cruelties of holocausts. We are the witnesses of the hell. When I think of the victims it is unbearable. To paint, to write, to teach in the most dedicated sincere way is the most intimate affirmation of creative life we possess in these despairing years."

Blows rain down in the word. When Nadezhda Mandelstam's second volume, *Hope Abandoned*, was published, Guston wrote of Joseph Brodsky's review:[4]

One paragraph I must quote since it is saturated with what I or I should say *we* wake up with daily: "Mme. Mandelstam should be believed when she speaks of the moral degradation of mankind and says that this degradation is devoid of national character and is not determined by concrete political processes. To justify existence, I repeat, Russian literature had done more than any other, and if a Russian writer says today that we are all criminals, it pays to listen

carefully. When a Russian refuses consolation, it means that things are bad, it means that there really is no consolation. This is a book about how to live without consolation. Without consolation one can live only on love, memory and culture. . . ."

I feel such identity with this—I feel this is what my recent paintings are about in a way. Another quote: "The species on the way to extinction, in the long run, is victorious. For its victory is the *language created* by it, which determines the life of the so-called 'survivor' of the combat." I feel that "language created" which I underline could be "*form created*". . . .

In the complex, often labyrinthine processes of Guston's thought, he has never doubted the enduring significance of created form. Throughout his oeuvre, with all its returns to the very beginning, there is a constant and readable striving to discover the immanent structures of painting in itself, insofar as its history reveals it. A poem, he often quotes Valéry as saying, must not vanish into meaning. "Form created" is the ultimate goal, even when it is reached through a juxtaposition of seemingly contrary elements. If there is a tragic undertone in this "survivor's" work, it is, as he himself has said, not separate from a certain formal exhilaration. He has compared himself to the Hasidic dancers who get up to dance in the spirit of despair. But they *do* dance.

Even in the most disturbing paintings of his recent period, Guston leaps into little ceremonial dances—those flourishes of his brush that can only be seen as tributes to beauty. If he paints himself in *Solitary* —a great mound of a head, really only an eye, smoking in some godforsaken landscape in which a pile of—what? wood? coffins?—sits somewhere, a hundred miles away from his head, the painting is awash with tender pinks and the pleasure of curious formal relationships. In *Painting, Smoking, Eating*, a synopsis of Guston's reduction to essentials, there is a twofold, tense situation. Clearly the painter dominates, in the arresting arrangement of forms (piled-up shoes, soles revealed) crowding the upper foreplane, and setting off a lavishly painted plate of French fries. Into this arrangement, so striking in its summary of all Guston's idiosyncratic compositional habits, the unnerving head of the painter thrusts itself. The same grotesquely caricatured head becomes a monument in *The Desert* flanked by its cat-o'-nine-tails and its pyre of boots. The painter, then, is there to disrupt a world of esthetically arranged forms, is, in fact, the unwelcome prophet dedicated to disturbing the status quo.

In a sense, Guston has consciously set out to disturb the status quo,

a task that often takes the form of resistance to his time. The current avant-garde art world he sees as static and conventional. He speaks of the artist who wills to be subversive in society, "but if the subversion is to art itself, that is not enough. It leads to shibboleths."[5] The subversion he practices is a critical subversion, which places him in a position counter to society, a position he feels can lead to "vigorous forms, and paradoxically, to the continuity of art itself." He tempts the world, and he piques the world. He pits anecdote, the quotidian, against the mask, the abstract. Time against timelessness. He courts disdain because, as Octavio Paz has pointed out, a rebel needs to experience one half of his destiny: punishment. Without it, it is hard for him to fulfill the other half: awareness.

Meanwhile he goes on meditating about the nature of an image. "The vice called surrealism," he quotes Louis Aragon, "is the immoderate and passionate use of the drug which is the 'image.'" He feels with equal intensity the pull of images such as "the object painted on

Painting, Smoking, Eating, 1973. Oil on canvas, 77½ x 103½ in.

a store window, on a truck, on a placard in a parade, to be seen instantly from a distance," and phantom images, "the enigma of the clear and visible rhythm of the role of forms in space." A moment when one side in this tug of war cedes slightly is seized, and a painting results. Sometimes it is a fixed image, but enigmatic, as in one of the strangest of all his paintings, *The Canvas*—a canvas more like a stone tablet leaning against a brick wall, with the artist's own eye transfixed. A painting frozen in time and space, yet immoderate and passionate, as Aragon said, and evoking myriad uneasy associations. This painting and quite a few others during the 1970s take on the aspect of an autocritique. The painter critically scrutinizes himself and his caste, sometimes sardonically, as when he dons a hood and paints a self-portrait or shows other hoods viewing a vernissage, and sometimes metaphysically, as in *The Canvas*. He depicts himself as Picasso did late in his life, as a creature of foolishness and fooling, *faute de mieux*, but also as one whose destiny is to create (but not *will*) images. To reveal.

The paintings of 1974 and 1975 are still more revealing. Guston does not abandon his commitment to narrative, but the story he unfolds becomes more intensely metaphorical. He has established a place by means of his small horde of suggestive images: the cave, the room, the lamp and bulb, the clock, the hand, etc. These we encounter from painting to painting and learn to gauge their meanings in each new context. Yet, in these paintings, Guston jumps the boundaries of meaning as Goya had in *Los Disparates*. His old penchant for ambiguity is brought to its apogee.

As before, he works in two modes. In the one, great accumulations

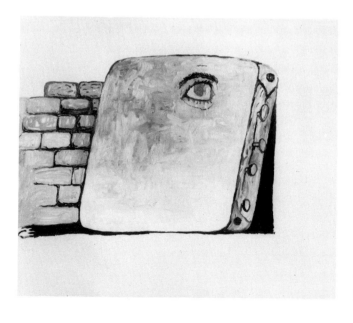

The Canvas, 1973.
Oil on canvas, 67 x 79 in.

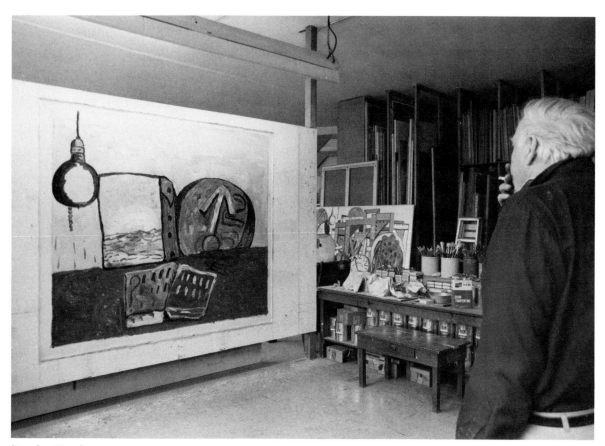

(Denise Hare)

of forms are conjured by the increasingly grotesque head of the painter, his brow deeply furrowed. He remembers. The governing hand of the fateful maker is in monumental scale, and, in a crazy allusion to Piero, is seen flagellating paintings. Between the hand with its rope-knout and the contemplating head of the painter lies a tundra, vast, incommensurable, in which a sinking clock, a bulb, and a sun are arrayed in a complicated spatial arrangement among a stack of painter's stretchers. Below, there is emptiness, measured out by a scale of painter's colors arrayed as though on a palette.

In another painting Guston assumes the hieratic gravity of an Egyptian. He is seen with his creased brow and bloodshot eye in massive profile. One cigarette in the foreplane held in his hand establishes a horizontal and another, protruding from his lips, establishes a second plane. The massive foot on a canvas in the background provides still another clear spatial recession. Here Guston plays with what he once

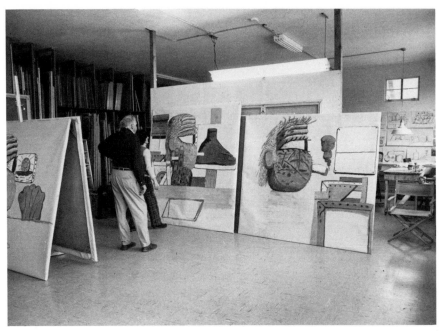

(Denise Hare)

designated as "the mystery of when you deal with forms in front of forms, as in a deck of playing cards." The overlaps are puzzling and seem to move in and out of focus. By the green shade in the background we know it is Guston's "place." But the formal allusions refuse to declare themselves blatantly. They are, in the most paradoxical way, esthetic—beautiful.

In the other mode, Guston achieves the strange fixity of image that corresponds so profoundly to the ideals of the Surrealists. The conjunction of forms, juxtaposed as wildly as ever Lautréamont could have dreamed, are painted with a conviction that defies their imaginary character. In the moment of dream apprehension, they become more real than real. Tangible and palpable on some level of our psyche, yet clearly fantastic images, these paintings overcome us and create that rare condition Coleridge identified as the suspension of disbelief. The overt symbolism of a huge painting, in which a towering canvas leans incongruously against a clock on a horizon below which is an open book, is reinforced by the suggestion of the endless sea on the canvas, and the hanging electric bulb in the sky. Yet these monuments against infinity tell an inchoate story that will tease the mind everlastingly.

Still more arresting—in fact, haunting—is a frankly metaphysical

painting in Guston's most monumental manner. On a fine linen ground, so fine that it has no grain at all, a thin, evenly applied gray simulates the even inscrutability of the empty mirror. An empty mirror (in itself fantastic since we can only imagine it) sets the psychological tone for the powerful image soaring up from a barely indicated groundline. This image is, like many of Guston's, already a familiar occupant of his "place": it is the tombstonelike portrait of a stretched canvas. On the canvas there is only a hint of the sea and an archway into infinity painted a strange orangelike color, an afterglow color, as irreal as anything Guston has ever conjured. Grasping this monumental object is the familiar hand, its fingers painted firmly, and its thumb jutting up into the mirrored sky on a scale that suggests once again the ancient Roman colossi. This self-portrait (for that hand is unmistakably the artist's own) extends Guston's long soliloquy on the mysterious function of painting.

How he sees himself, and by association the artist, anywhere, anytime, is part of the mystery of his late works, and can only be disentangled from the web of consideration at peril of losing the real meaning of a lifetime's work. "I must quote you something from an essay by Evgeny Zamyatin," he writes in September 1974:

No revolution, no heresy, is comfortable and easy. Because it is a leap, it is a rupture of the smooth evolutionary curve and a rupture is a wound, a pain. But it is a necessary wound: most people suffer from

(Denise Hare)

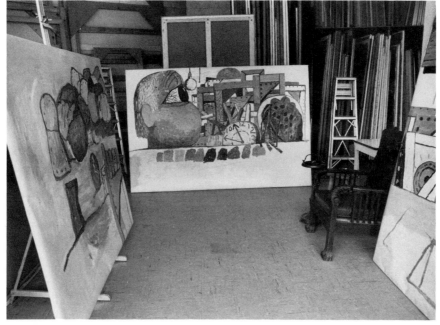

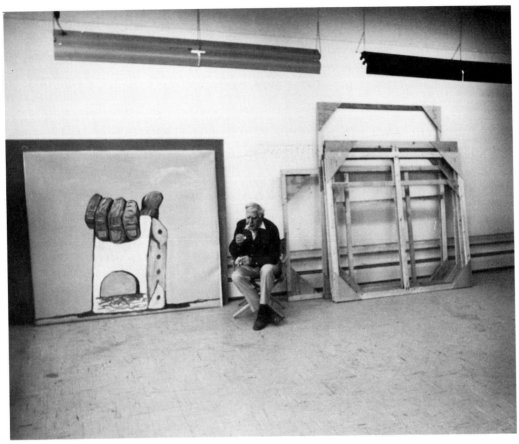

(Denise Hare)

hereditary sleeping sickness, and those who are sick with this ailment (entropy) must not be allowed to sleep or they will go to their last sleep, the sleep of death.

This same sickness is common to artists and writers: they go contentedly to sleep in their favorite artistic form which they have devised, then twice revised. They do not have the strength to wound themselves, to cease to love what has become dear to them. They do not have the strength to come out from their lived-in, laurel-scented rooms, to come out into the open air and start anew. To wound oneself, it is true, is difficult, even dangerous. But to live today as yesterday and yesterday as today is more difficult for the living.

Guston adds: "I jumped out of my skin, as you can imagine, when I read this." Yes, he says, to form and structure. But, he says, and but again . . .

Afterword

Guston is painting today in the silent Woodstock studio. There can be no question of "summing up" for this book. Yet, I cannot help but ask myself, as if I were writing a hundred years from now, writing tomorrow as though it were today: What would be a central or consistent internal metaphor in his life's work? Or rather, what is it finally *about*? Such a question belongs only to critical history. Paintings are not *about* anything; they are mysteriously themselves, self-consistent throughout history, warding off successive interpretations, and surviving rhetoric. Yet it is of some interest to speculate about "about." And my own speculations keep circling around the significant (that is to say, indispensable) conflict between estheticism and the world, or the events of the world. Guston has had so many relationships to his time that the future historian will have a field day. Still, the central relationship seems the crucial one of taking up the challenge implicit in his time, clearly spelled out in the history of twentieth-century painting, which longs to be explicit and at the same time abstract; longs to be concrete and at the same time ambiguous, ephemeral, caught in the toils of cosmological process (as the nineteenth century was caught in the toils of the historic process). The twentieth century posed its question, which was very nearly this: Is there any beauty, in and of

itself, or is there "meaning" in painting that denies esthetic value? And Guston answered: Yes, but . . . *Yes*: an affirmation of the meaning not so much of painting pictures, but of creating images. *But*: on the other hand, yes to the obstacles and intrusions of the world too.

In August 1974, during a painting lull, which always leaves him in a state of near-despair, Musa showed Guston a quotation that he promptly lettered on a large sheet and put up over a table (the respository of so many of his most intimate thoughts and images):

I hold my inventive capacity on the stern condition that it must master my whole life, often have complete possession of me, make its own demands on me, and sometimes for months together put everything else away from me. . . . Whoever is devoted to an art must be content to deliver himself wholly up to it and to find his recompense in it.

Guston is now there, in the efficient cinder-block studio, painting. To use one of his favorite phrases, "It goes on."

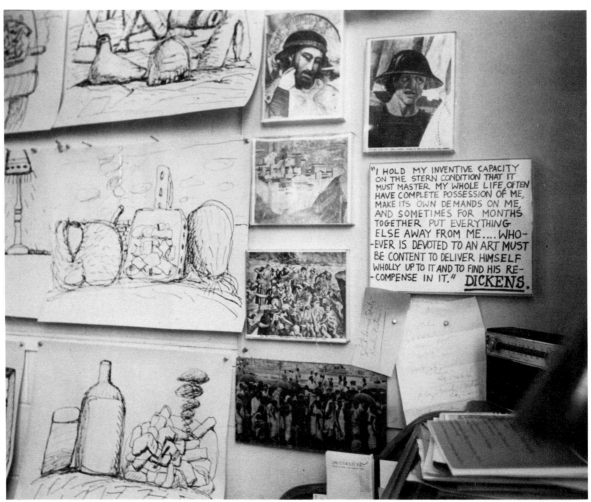

(Denise Hare)

Notes

All quotations from Philip Guston, unless otherwise noted, are from conversations with and letters to the author; they have been checked by Philip Guston and are printed here with his permission.

Introduction

1. Philip Guston, lecture at the Cooper Union, New York, March 1974.
2. Philip Guston, "On Bradley Walker Tomlin," in catalogue issued by the Whitney Museum of American Art, New York, 1957.
3. Guston, lecture at Cooper Union, op. cit.
4. Philip Guston, quoted in "Painter and His Identity," by Walter Barker, *St. Louis Post-Dispatch*, February 13, 1966.
5. Philip Guston, quoted by Morton Feldman, *The New York Times*, February 2, 1964.
6. Philip Guston, quoted in "Dialogue with Philip Guston," by William Berkson, *Art & Literature* (Winter 1965), pp. 56–59.
7. Philip Guston, quoted in "The Philadelphia Panel," *It Is* (Spring 1960).
8. Philip Guston, quoted in interview with Karl Fortess, 1966, taped for Archives of American Art, Washington, D. C.
9. Wolfgang Kayser, *The Grotesque in Art and Literature* (Bloomington:

10. "Poetry and Abstract Thought," *The Collected Works of Paul Valéry*, vol. VII (New York: Pantheon, 1958).

Chapter I

1. Nathanael West, *The Day of the Locust* (New York: New Directions, 1950).
2. Jiddu Krishnamurti, *Life in Freedom* (New York: Liveright, 1938).
3. George Grosz, *A Little Yes and a Big No* (New York: Dial Press, 1946).
4. Jay Martin, *Nathanael West: The Art of His Life* (New York: Farrar, Straus and Giroux, 1970).
5. Fletcher Martin, letter to the author, October 21, 1974.
6. Jay Martin, op. cit.
7. Wallace Stevens, quoted in "Cubism and the Arensbergs," by Fiske Kimball, *Art News Annual*, 1955.

Chapter II

1. Fletcher Martin, op. cit.
2. "Art War Breaks Out," Los Angeles *Times*, May 26, 1933.
3. George Biddle, letter of May 9, 1933, quoted in *Federal Relief Administration and the Arts*, by William F. McDonald (Columbus: Ohio State University Press, 1969).
4. James Brooks, interview with the author, August 1973.
5. For a full account, see Jane de Hart Mathews, *The Federal Theatre, 1935–1939* (Princeton: Princeton University Press, 1967).

Chapter III

1. Anton Refregier, quoted in Francis V. O'Connor, *Art for the Millions* (Greenwich, Conn.: New York Graphic Society, 1971).
2. Ruth Green Harris, "Public Taste in Murals," *The New York Times*, 1939.
3. Quoted in "The New Deal Art Projects" by Olive Ryford Gavert, in O'Connor, op. cit.

Chapter IV

1. Stephen Greene, letter to the author, January 29, 1973.
2. JoEllen Rapee, interview with the author, May 1, 1973.
3. Erwin Panofsky, *Albrecht Dürer*, vol. I (Princeton: Princeton University Press, 1943).
4. Gustave Janouch, *Conversations with Kafka* (New York: New Directions, 1971).

5. Max Brod, *Kafka: A Biography* (New York: Schocken, 1960).

6. Gustave Flaubert, letter to Louise Colet, August 8, 1846, in *The Selected Letters of Gustave Flaubert*, Francis Steegmuller, ed. (New York: Farrar, Straus and Young, 1953).

7. Flaubert, letter to Louise Colet, August 9, 1846, op. cit.

8. Flaubert, letter to Louise Colet, January 16, 1852, op. cit.

9. Flaubert, letter to Louise Colet, August 8, 1846, op. cit.

10. Flaubert, letter to Louise Colet, August 26, 1853, op. cit.

11. Flaubert, letter to Edmond and Jules de Goncourt, July 3, 1860, op. cit.

Chapter V

1. Charles Baudelaire, "Les Phares," *Flowers of Evil and Other Works* (New York: Bantam, 1964). Translation by Wallace Fowlie.

2. For an interesting discussion, see Eileen Souffrin-Le Breton's "Banville et la poétique du décor," in *French 19th-Century Painting and Literature*, Ulrich Finke, ed. (New York: Harper and Row, 1972).

Chapter VI

1. Guston, quoted in "Guston: Meaning out of Monumentality," by Rosamond Frost, *Art News* (February 1945).

2. Walter Read Hovey, "Repose and Dignity Mark Top Painting of Carnegie Exhibit," *Pittsburgh Post-Gazette*, October 12, 1945.

3. Greene, op. cit.

4. In the same issue, *Life* ran a picture story, "The Ku Klux Klan Tries a Comeback," showing graphic characterizations of hooded figures with bulky white cotton work gloves going through clownish gestures before an electric light cross. There is also a hangman's noose in the background.

5. Mary Holmes, "Metamorphosis and Myth in Modern Art," *Perspective* (Winter 1948).

6. Robert Phelps, interview with the author, May 1973.

7. Flaubert, letter to Louise Colet, January 16, 1852, op. cit.

Chapter VII

1. Fyodor Dostoyevsky, quoted in Albert Camus, *Myth of Sisyphus* (New York: Knopf, 1955).

2. Albert Camus, *Myth of Sisyphus* (New York: Knopf, 1955).

3. Brod, op. cit.

4. Boris Pasternak, *Safe Conduct* (New York: New Directions, 1958).

5. Henry Cowell, "Current Chronicle," *The Musical Quarterly* (January 1952), pp. 123–36.

6. James Lawler, "Paul Valéry and the Visual Arts," *Critiques III* (New York: Cooper Union, Fall 1974).

7. V. I. Pudovkin, *Film Technique and Film Acting* (New York: Grove, 1970).

8. Federico Fellini, quoted in interview with Gideon Bachmann, 1959, in *Interviews with Film Directors*, by Andrew Sarris (New York: Bobbs-Merrill, 1967).

Chapter VIII

1. Paul Valéry, *Degas, Manet, Morisot* (New York: Pantheon, 1960), p. 147.

2. Paul Brach, "Affirmation," *Art Digest* (January 15, 1953).

3. Fairfield Porter, *Art News* (February 1953).

4. Lawrence Alloway, "Notes on Guston," *Art Journal* (Fall 1962).

5. William Seitz, "Philip Guston," introduction to exhibition catalogue at the Rose Art Museum, Brandeis University, February 27–March 27, 1966.

6. *Time*, January 7, 1952.

7. Morton Feldman, "After Modernism," *Art in America* (November–December 1971).

8. Ibid.

9. Philip Guston, statement, *It Is* (Spring 1958).

10. Feldman, op. cit.

Chapter IX

1. Teilhard de Chardin, *The Phenomenon of Man* (New York: Harper and Row, 1961).

2. Philip Guston, "Piero della Francesca: The Impossibility of Painting," *Art News* (May 1965).

3. Morton Feldman, "The Anxiety of Art," *Art in America* (September–October 1973).

4. Robert Creeley, "Philip Guston: A Note," *Black Mountain Review* (Spring 1956).

5. Stanley Kunitz, "After the Last Dynasty," *Poetry* (October–November 1962).

6. Stanley Kunitz, "Open the Gates," *Selected Poems, 1928–58* (Boston: Little, Brown, 1958).

7. Kafka, quoted in William Berkson, "Dialogues with Philip Guston," op. cit.

8. Philip Guston, "Faith, Hope, and Impossibility," *Art News Annual XXXI* (October 1966).

9. Susanne K. Langer, *Philosophical Sketches* (Baltimore: Johns Hopkins, 1962).

10. Hilton Kramer, "Abstractions of Guston Still Further Refined," *The New York Times*, January 1, 1965.

11. Guston, in interview with Karl Fortess, op. cit.

12. David Sylvester, "Philip Guston," *The New Statesman*, February 15, 1963.

13. John Russell, "Beyond Nature," *The Sunday Times* (London), January 20, 1963.

Chapter X

1. Kayser, op. cit.

2. Charles Baudelaire, "On the Essence of Laughter," in *The Painter of Modern Life and Other Essays*, by Jonathan Mayne (London: Phaidon, 1964).

3. Nathanael West, quoted in Jay Martin, op. cit.

4. Nathanael West, *Miss Lonelyhearts* (New York: New Directions, 1946).

5. West, *The Day of the Locust*, op. cit.

6. Vladimir Nabokov, *Nikolai Gogol* (New York: New Directions, 1944).

7. Konstantin Paustovsky, "Reminiscences of Babel," *Partisan Review*, vol. 28, nos. 3–4, (1960).

8. Isaac Babel, "Guy de Maupassant," *Collected Stories* (New York: Meridian, 1960).

9. Isaac Babel, "Kolyvushka," *Lyubka the Cossack and Other Stories* (New York: New American Library, 1964).

10. Guston, "Piero della Francesca," op. cit.

11. Guston, "Faith, Hope, and Impossibility," op. cit.

Chapter XI

1. James Thrall Soby, *The Early Chirico* (New York: Dodd Mead, 1941).

2. Philip Roth, interview with the author, May 1973.

3. Philip Roth, "Reading Myself," in *Reading Myself and Others* (New York: Farrar, Straus and Giroux, 1975).

4. Ibid.

5. Clark Coolidge, interview with the author, May 1975.

6. Clark Coolidge, *Space* (New York: Harper and Row, 1970).

7. Fellini, op. cit.

8. Pierre Schneider, *The World of Watteau* (New York: Time-Life Books, 1967).

9. Octavio Paz, "The New Analogy," *Critiques* (New York: Cooper Union, 1972).

1. Paustovsky, op. cit.
2. Soren Kierkegaard, *Either/Or* (Princeton: Princeton University Press 1959). Translation by W. Lowrie.
3. Ibid.
4. Joseph Brodsky, "Beyond Consolation," *The New York Review of Books*, February 7, 1974, quoted by Guston in letter to the author.
5. Philip Guston, conference at Boston University, Fall 1973.

Bibliography

I. Statements and Writings by the Artist

1956 "Statement," *12 Americans*, New York, The Museum of Modern Art, 1956, p. 36, illus.

1957 "Statement," *Bradley Walker Tomlin*, New York, Whitney Museum of American Art, 1957, p. 9.

1958 "Statement," *It Is*, no. 1, Spring 1958, p. 44, illus.

1958 "Statement," *Nature in Abstraction*, New York, Whitney Museum of American Art, 1957, p. 9.

1958 "Statement," *The New American Painting*, New York, The Museum of Modern Art, 1958–59, pp. 40–43, illus.

1962 "Statement," *Philip Guston*, Amsterdam, Stedelijk Museum, illus.

1965 "Piero della Francesca: The Impossibility of Painting," *Art News* vol. 64, May 1965, pp. 38–39, illus.

1966 "Faith, Hope, and Impossibility," *Art News Annual*, XXXI, October 1966, pp. 101–103, 152, 153, illus.

1973 "On Drawing," *Boston University Journal*, Fall 1973, illus.

II. Books about the Artist

Arnason, H. H. *Philip Guston*. New York: The Solomon R. Guggenheim Museum, 1962.

Ashton, Dore. *Philip Guston*. New York: Grove Press, 1959.

Hunter, Sam, and Rosenberg, Harold. *Philip Guston, Recent Paintings and Drawings*. New York: The Jewish Museum, 1966.

III. *Articles about the Artist*

Alloway, Lawrence. "Ashton on Guston." *Arts Review* vol. 13, no. 14, 1961, pp. 17, 20.

 "Notes on Guston." *Art Journal*, 1962, pp. 8–11.

 The Nation, November 30, 1974.

Aronson, David. *Boston University Journal*, Fall 1973, pp. 21–31.

Art in America. "Painters and Poets," October–November 1965.

Art News. "Guston's Social Security Mural: Completed Despite War," vol. 42, March 1943, p. 8.

 "Critics' Choice, The Armory," October 1945.

Artforum. "Special Issue: The New York School," September 1965.

Ashton, Dore. "Art: The Age of Lyricism." *Arts and Architecture*, March 1956, pp. 14–15, 43–44.

 "Art." *Arts and Architecture*, September 1956, pp. 4, 5, 13, 35, 36.

 "Art." *Arts and Architecture*, June 1956, pp. 3–10.

 "The American Signature." *XXe Siècle*, March 1958, p. 9.

 "Art." *Arts and Architecture*, May 1958, pp. 5, 28–29.

 "Some Lyricists in the New York School." *Art News & Review*, 1959.

 "Perspectives de la Peinture Américaine." *Cahiers d'Art*, 1960, pp. 212–14.

 "Philip Guston." *Evergreen Review*, September–October 1960, pp. 88–91.

 "Philip Guston." *Metro*, 1961, pp. 33–41.

 "American Vision at the Marlborough." *Studio International*, September 1964, p. 119.

 "La Voix du Tourbillon dans l'Amérique de Kafka." *XXe Siècle*, May 1964, p. 95.

 "Philip Guston, the Painter as Metaphysician." *Studio International*, February 1965, pp. 64–67.

 "Exhibition at the Jewish Museum." *Arts and Architecture*, April 1966.

 "La Amerika de Philip Guston." *Plural*, February 1974, pp. 47–50.

 Essay for catalogue, "New Paintings," Boston University, 1974.

Baker, Kenneth. "Philip Guston at Boston University." *Art in America*, 1974, pp. 114, 115.

Barker, Walter. "Painter and His Identity." *St. Louis Post-Dispatch*, 1966.

Benedikt, Michael. "New York Letter." *Art International*, April 1966, pp. 79–80.

Berkson, William. "Philip Guston: A New Emphasis." *Arts Magazine*, February 1966, pp. 15–18.

 "Art Chronicle." *Kulchur*, August 1962, pp. 36–38.

 "Dialogue with Philip Guston." *Art and Literature*, Winter 1965, pp. 56–59.

 "The New Gustons." *Art News*, October 1970, pp. 44–47.

Big Sky, No. 4, cover and six drawings, 1972.

 No. 5, drawings and notes, 1973.

Boston University Journal. "Conversations. Philip Guston and Harold Rosenberg: Guston's Recent Paintings," 1974.

Brach, Paul. *Art Digest*, January 1, 1952, p. 18.

 "Affirmation." *Art Digest*, January 15, 1953, p. 18.

Breeskin, Adelyn. "Trois Peintres Américains." *L'Oeil*, July–August 1960, pp. 54–59.

Burn, Guy. "Guston." *Arts Review*, January 26, February 9, 1963, p. 10.

Campbell, Lawrence. Review. *Art News*, January 1975.

Canaday, John. "Philip Guston, Abstractionist." *The New York Times*, December 30, 1959.

Chamberlain, Betty. Review. *Art News* vol. 54, February 1956, p. 47.

Cimaise, Serie VI, no. 3, January, February, March 1959, illus.

Coleman, Roger. "Philip Guston at Whitechapel." *Art News and Review*, 1963, illus.

Creeley, Robert. "Philip Guston: A Note." *Black Mountain Review*, Spring 1956, illus.

Edwards, F. "Apollon Och Minotauros." *Paletten*, no. 1, 1957, pp. 7–18.

Feldman, Morton. "Some Elementary Questions." *Art News*, April 1967, pp. 54–55, 74, illus.

 "After Modernism." *Art in America*, November–December 1971, pp. 68–77, illus.

 "Give My Regards to Eighth Street." *Art in America*, March 1971.

Fortune. "Brave New World, F.O.B." August 1943, pp. 124, 126–27, illus. by the artist.

 "Troop Carrier Command." October 1943, pp. 130–35, illus. by the artist.

Frankfurter, Alfred. "Directions in U.S. Painting." *Art News*, 1939, illus.

Frost, Rosamond. "The Corcoran Carries On." *Art News* vol. 44, no. 4, April 1–14, 1945, pp. 14, 42 (color).

 "Guston: Meaning Out of Monumentality." *Art News*, no. 43, February 1, 1945, p. 24, illus.

Gosling, Nigel. "Another Pilgrim from America." *The Observer*, January 20, 1963.

Gruen, John. Review. *New York* magazine, November 9, 1970, p. 62. illus.

Harris, Ruth G. "Public Taste in Murals." *The New York Times*, 1939, illus.

Harrison, Jane. "Retrospective at Whitechapel." *Arts* vol. 37, no. 7, April 1963, p. 27.

Henning, E. B. "Some Contemporary Paintings." *Cleveland Museum Bulletin* vol. 49, March 1962, pp. 52–53, illus.

"Paths of Abstract Art." *Cleveland Museum Bulletin* vol. 47, October 1960, pp. 199–201, illus.

Hess, Thomas B. "Inside Nature." *Art News* vol. 56, no. 10, February 1958, pp. 40–44, 60–65, illus.

Review. *New York* magazine, December 9, 1974.

Holmes, Mary. "Metamorphosis and Myth in Modern Art." *Perspective*, Winter 1948, pp. 77–85, illus.

Hunter, Sam. "Philip Guston." *Art in America*, 1954.

"Philip Guston." *Art International* vol. 6, no. 4, May 1962, pp. 62–67, illus.

It Is. "The Philadelphia Panel." Spring 1960, illus.

Janson, H. W. " 'Martial Memory' by Philip Guston and American Painting Today." *St. Louis Museum Bulletin* vol. 27, nos. 3–4, 1942, pp. 34–41, illus.

"Philip Guston." *The Magazine of Art* vol. 40, no. 2, February 1947, pp. 54–58, illus.

Kainen, Jacob. Review. *The Washington Post*, May 23, 1971.

Kaufmann, Edgar. "Coming Home to the Carnegie." *Art News* vol. 44, no. 13, October 15–31, 1945, pp. 10, 12–13, illus.

Kozloff, Max. "Art." *The Nation* vol. 194, no. 20, May 19, 1962, pp. 453–55.

Kramer, Hilton. "Abstractions of Guston Still Further Refined." *The New York Times*, January 1, 1965.

"Mandarin Pretending to be a Stumblebum." *The New York Times*, October 25, 1970.

Life. "Carnegie Winner's Art Is Abstract and Symbolic." May 27, 1946, pp. 90–92 (color).

Lynton, Norbert. "London Letter." *Art International* vol. 7, no. 2, February 1963, pp. 69–70.

Melville, Robert. Review. *Architectural Review* vol. 133, no. 794, April 1963, p. 289, illus.

Mullins, Edwin. "Guston and the Imaginative Experiment." *Apollo* vol. 77, no. 13, March 1963, pp. 229–30, illus.

New York Times. "Art Commission Approves Mural." March 16, 1941, illus.

"Group Shows." September 28, 1947, illus.

Newsweek. "Long Journey." May 7, 1962, p. 94, illus.

Nordland, Gerald. "Philip Guston." *Frontier*, April 1961, p. 24.

"Review at Mid-life." *Frontier*, July 1963, pp. 23–24, illus.

O'Hara, Frank. "Growth and Guston." *Art News* vol. 61, no. 3, May 1962, pp. 31–33, 51–52, illus.

Phillips, Michael. Review. *The Boston Review of the Arts*, December 15, 1970.

Raleigh, Henry P. "Image and Imagery in Painting." *The Art Journal*, Spring 1962, illus.

Raynor, Vivien. "Guston." *Arts* vol. 36, no. 10, September 1962, p. 50.

Roberts, Keith. "Exhibition at the Whitechapel Gallery." *Burlington Magazine* vol. 105, no. 720, March 1963, p. 136.

Rosenberg, Harold. "Liberation from Detachment." *The New Yorker*, November 7, 1970.

Russell, John. "The 'New American Painting' Captures Europe." *Horizon* vol. 2, no. 2, November 1959, pp. 32–41, illus.

"Guston's Last Tape." *The New York Times*, November 9, 1974.

Sandler, Irving. "Guston: A Long Voyage Home." *Art News* vol. 58, no. 8, December 1959, pp. 36–39, 64–65, illus.

Review. *Art News* vol. 60, March 1961, p. 10.

Seldis, Henry. "Giant Retrospective of Philip Guston's Works." Los Angeles *Sunday Times*, June 9, 1963, p. 13, illus.

Smith, Roberta. Review. *Artforum*, February 1975.

Steinberg, Leo. "Fritz Glarner and Philip Guston Among '12 Americans' at The Museum of Modern Art." *Arts* vol. 30, June 1956, pp. 42–45, illus.

Suro, Dario. "Philip Guston," *Cuadernos*, September 1958.

Sylvester, David. Review. *New Statesman* vol. 65, no. 1666, February 15, 1963, pp. 247–48.

"New York Takeover." *The Sunday Times* (London), April 26, 1964, illus.

Tyler, Parker. Review. *Art News* vol. 57, no. 2, April 1958, p. 12.

Wohl, Helmut. "Philip Guston and the Problems of Painting." *Harvard Art Review*, Spring/Summer 1967, pp. 28–30, illus.

Yates, Peter. "Philip Guston at the County Museum." *Arts and Architecture* vol. 80, no. 9, September 1963, pp. 4–5, 31–32, illus.

List of Illustrations

Index